capri or cape cod?

kate spade

NEW YORK

places to go

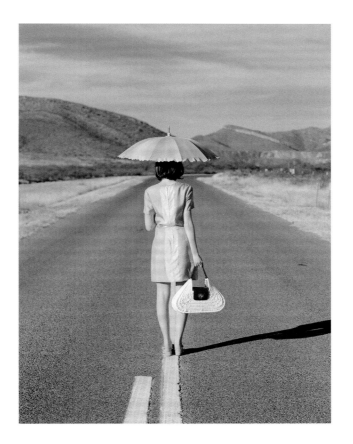

people to see

kate spade

NEW YORK

abrams, new york

pack caramels. a universal expression of goodwill.

Library of Congress Control Number: 2014930721

ISBN: 978-1-4197-1392-7

Text copyright © 2014 kate spade new york
See page 230 for photography copyright information

Printed and bound in China
10 9 8 7 6 5

Abrams books are available at special discounts when purchased in quantity for premiums and promotions
as well as fundraising or educational use. Special editions can also be created to specification.
For details, contact specialsales@abramsbooks.com or the address below.

115 West 18th Street
New York, NY 10011
www.abramsbooks.com

CONTENTS

what makes for a bon voyage

PACKING PHILOSOPHY:

Pick a color & try to stick to it!

MOST IMPORTANT THING IN MY CARRY-ON:

I pad & headphones

ROOM WITH THE BEST VIEW:

Paris, overlooking the Jardin des Tuileries

PLANE, TRAIN OR AUTOMOBILE?

All 3, whatever gets me there fastest

AIRPORT SHOP GUILTY PLEASURE:

Cadburys chocolate

FAVORITE FOREIGN PHRASE:

Un coup de Champagne s'il vous plait!

I CAN'T LEAVE the beach WITHOUT shells.

THE ONE THING I BUY EVERYWHERE:

Vintage jewelry

NEXT PLACE I'D LIKE TO VISIT:

Africa

BEST PART ABOUT COMING HOME:

Seeing the pups, Stan & Lulu

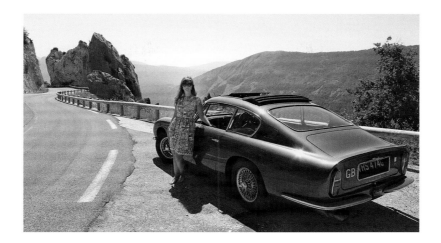

one of my earliest memories as a child is standing on a train platform and waving good-bye to my grandmother who had decided to travel around the world. at age 60! everywhere she stopped over the next two years, from tonga to tibet, she would send me a beautiful doll dressed in a traditional local costume. my passion for adventure began right then and there. through her gifts, the world seemed like a fascinating place and i couldn't wait to explore it.

over the years, it's been magical seeing things i've read about come to life—like the swan-shaped pedal boats in rio de janeiro and monet's water garden in giverny. i've had the fortune to live in so many places that, at times, i've felt like a snail with my house on my back. today manhattan is my home sweet home, but i've still got my wanderlust—the world is just too full of natural wonders, vintage treasures and talented artisans creating the most imaginative things to be sitting behind a desk. i get my best ideas when i travel. even if i visit the same place twenty times, it always feels new and full of possibilities.

to this day, i can't go anywhere without bringing something back, even if it's from a local news-stand. i love seeking out the local specialty—like pearls in hong kong and batiks in bali—and i bring an extra, empty suitcase with me in order to get it all home. perhaps i can thank my grandmother for that inspiration.

travel adds so much color to our daily lives at kate spade new york that we wanted to share that love with you. this book, then, is a compilation of all the places, people and things that spark our wanderlust, feed our curiosity and inspire us to treat every day as an adventure.

i hope this inspires your own journey, wherever it takes you.

Deborah Lloyd

chief creative officer, Kate Spade & Company

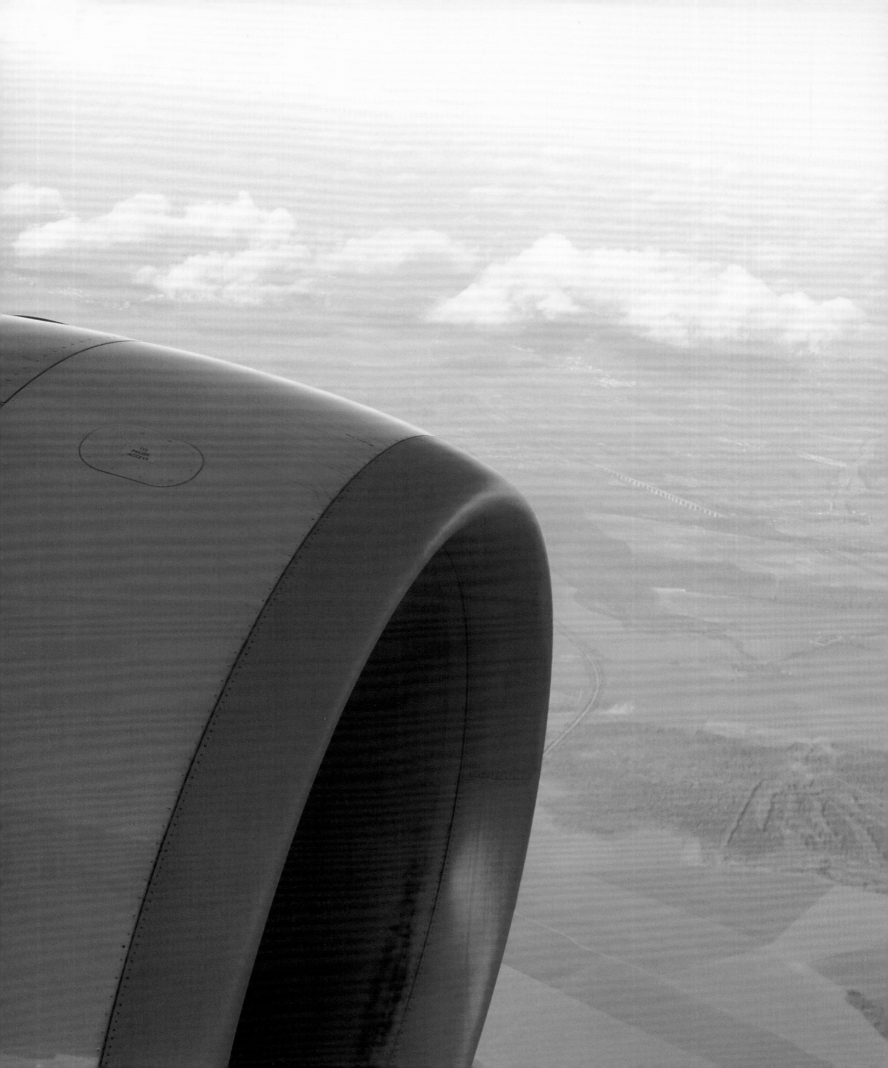

ESCAPE THE ORDINARY

*every time we step out of our routine, we set out on a voyage
of discovery. it may be across town to explore a new art gallery, or across
the world to experience an ancient tea ceremony. short or long haul,
big adventure or small, we seize the opportunity to look around, eyes wide
with wonder, and ask, "could you be any more fascinating?" it's the answers
we get in return—through new places, new foods, new languages,
new rhythms, new people—that inspire and change us. escaping the
ordinary is an extraordinary thing. we highly recommend it.*

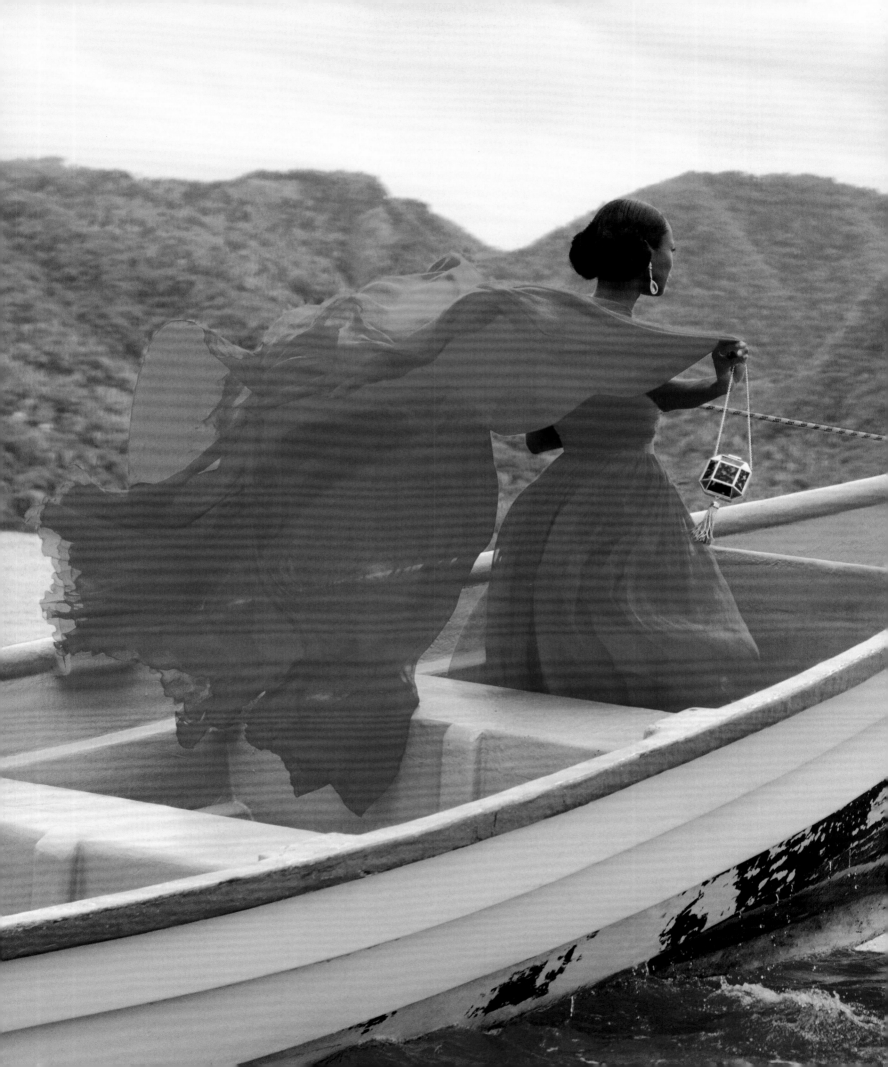

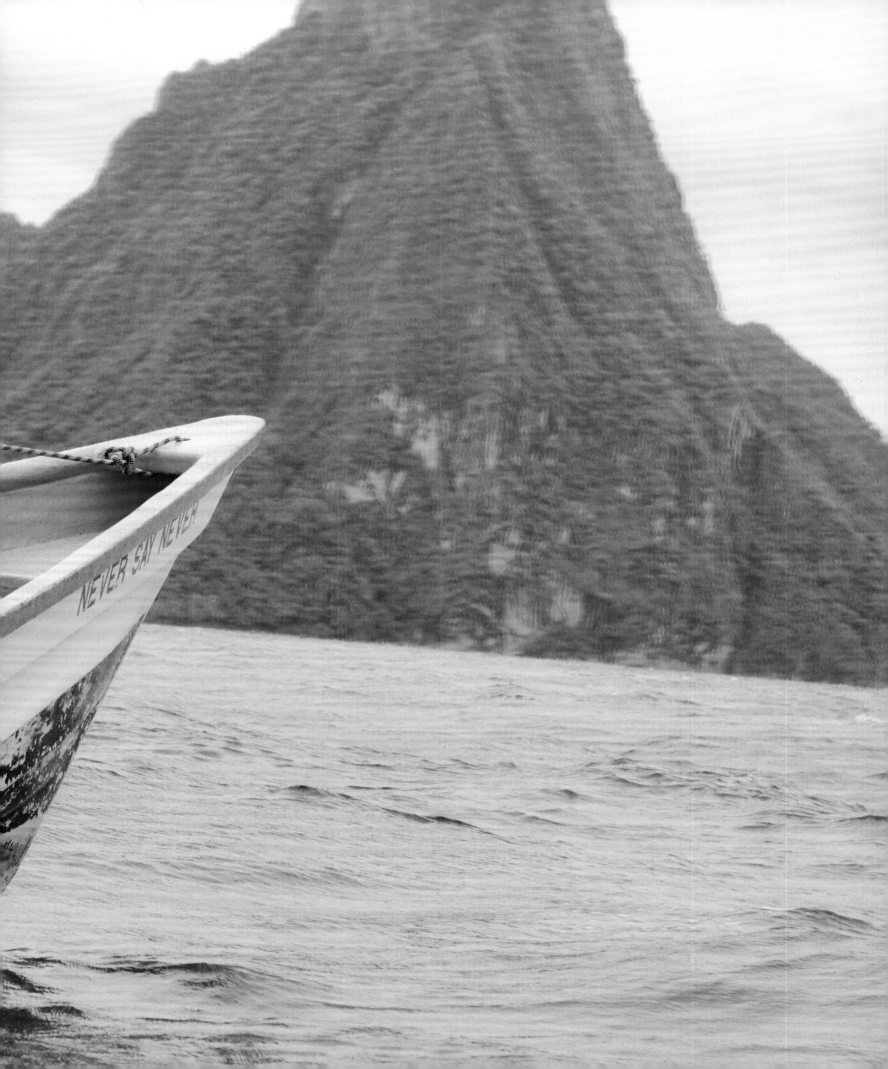

"A NEW DRESS
DOESN'T GET
YOU ANYWHERE.
IT'S THE LIFE
YOU'RE LIVING
IN THE DRESS."

— *diana vreeland*

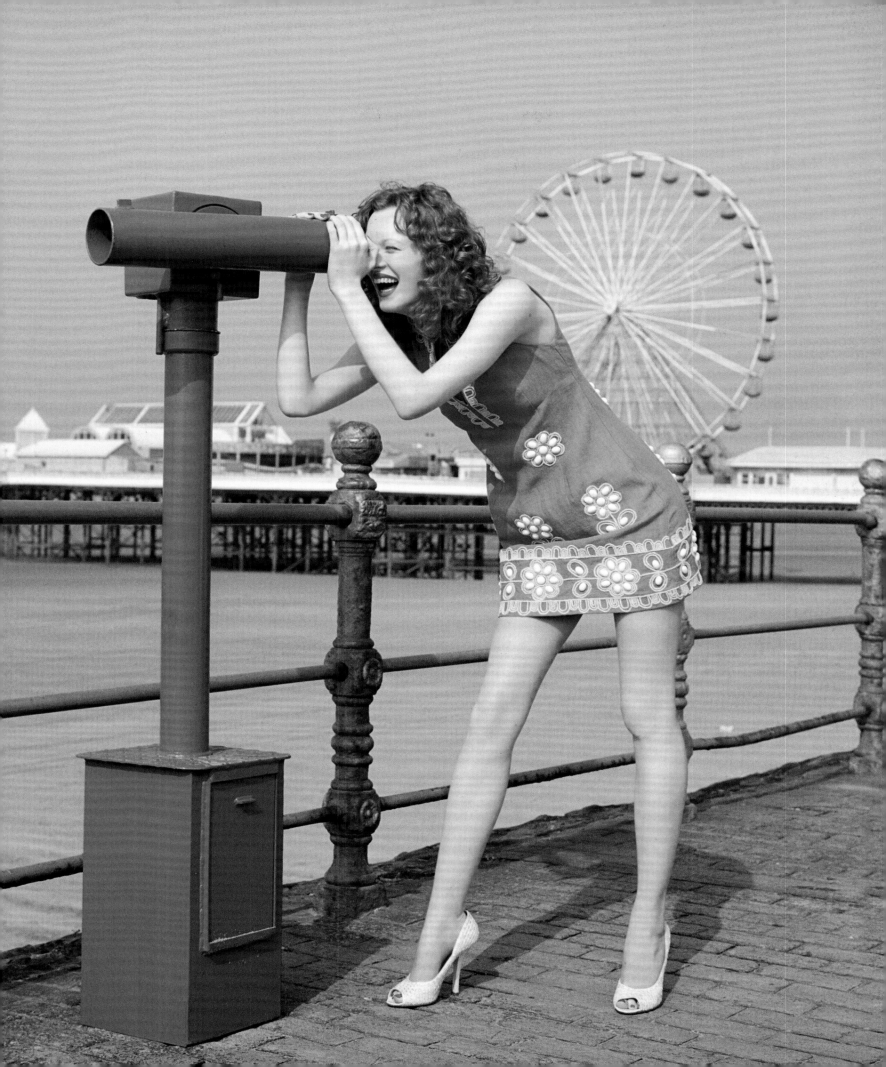

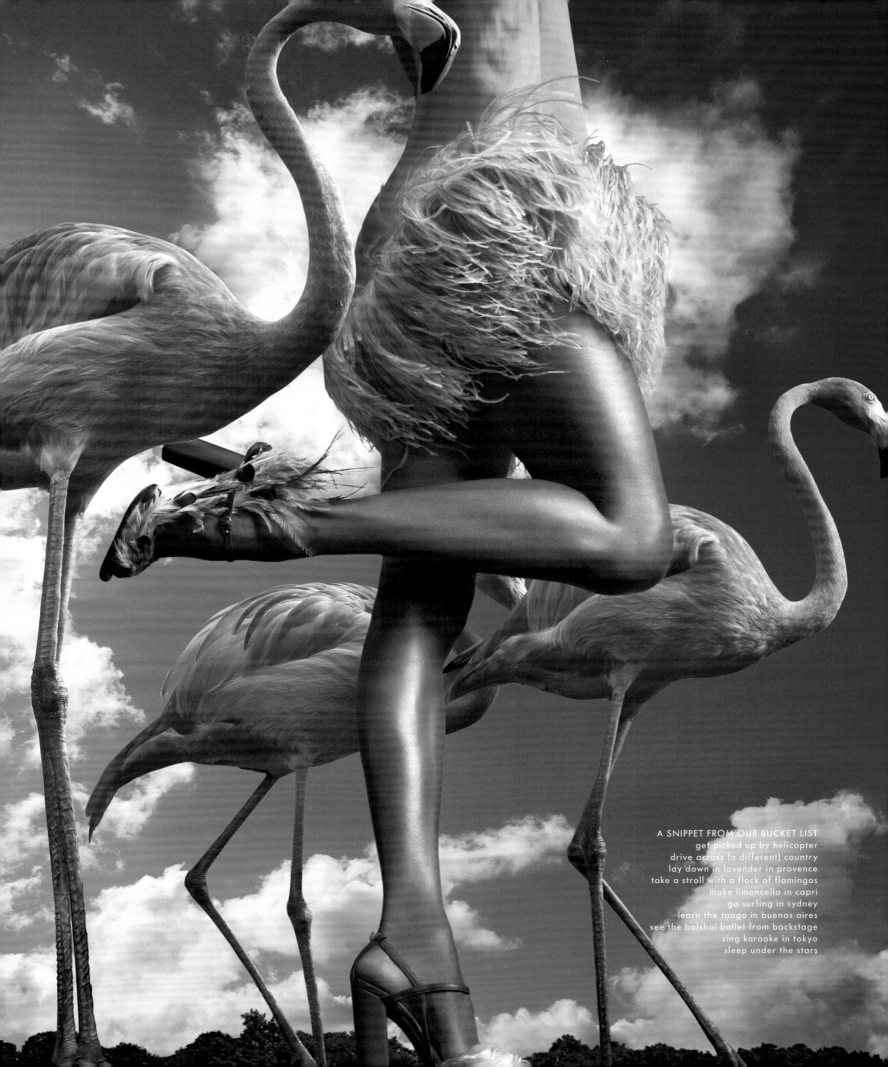

A SNIPPET FROM OUR BUCKET LIST
get picked up by helicopter
drive across (a different) country
lay down in lavender in provence
take a stroll with a flock of flamingos
make limoncello in capri
go surfing in sydney
learn the tango in buenos aires
see the bolshoi ballet from backstage
sing karaoke in tokyo
sleep under the stars

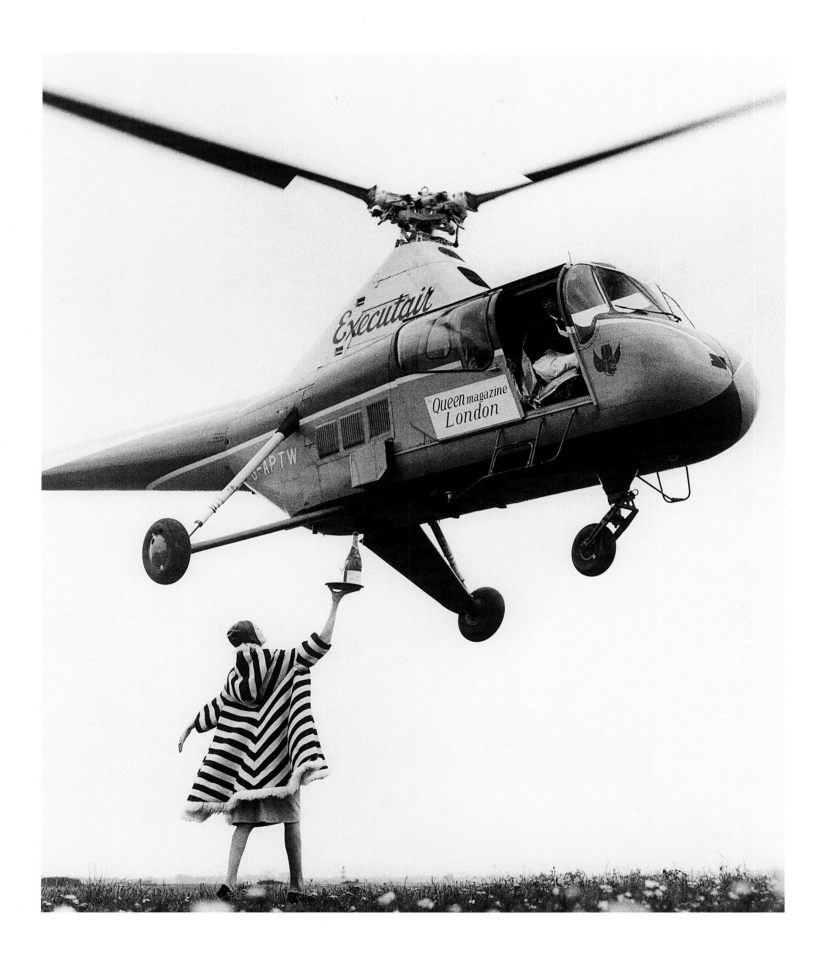

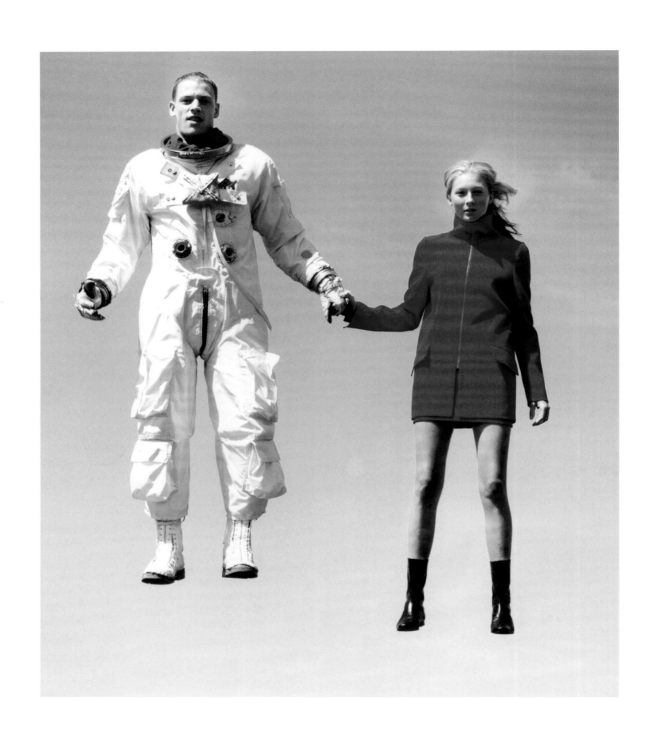

"the world only exists in your eyes—your conception of it.
you can make it as big or as small as you want to." —F. SCOTT FITZGERALD

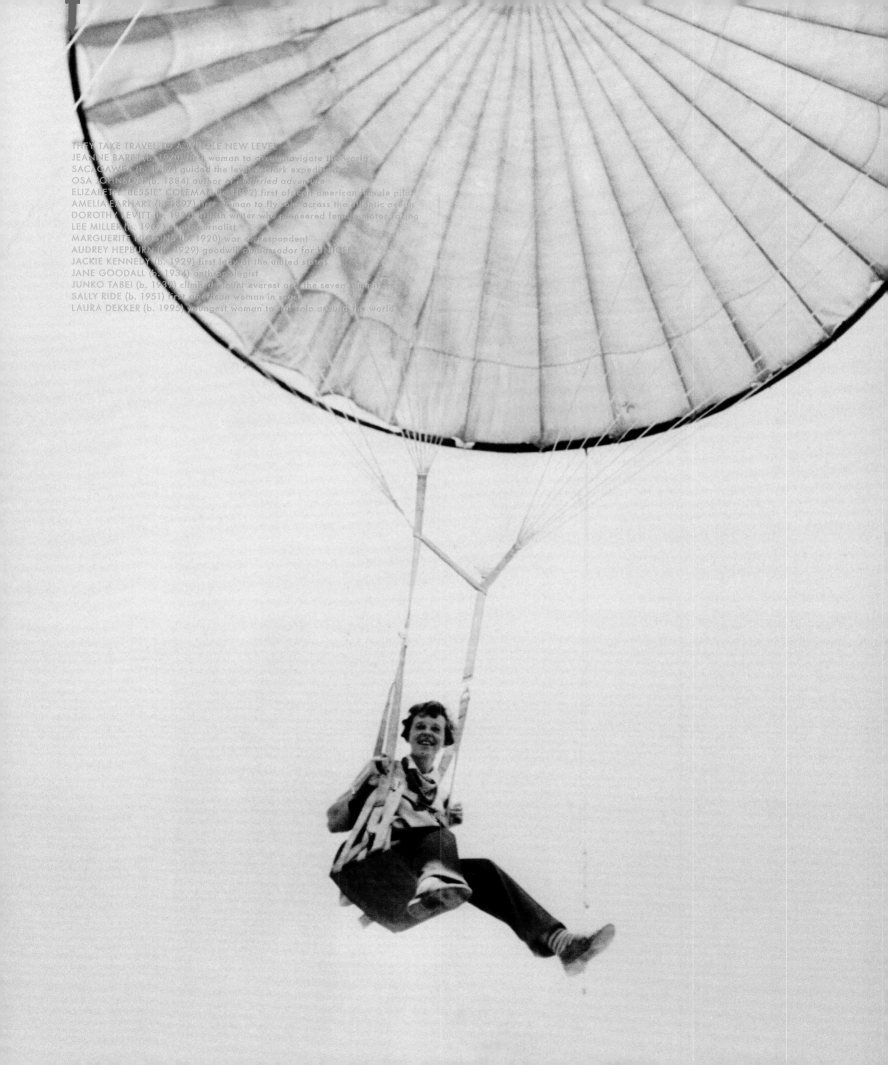

THEY TAKE TRAVEL TO A WHOLE NEW LEVEL
JEANNE BARET (b. 1740) first woman to circumnavigate the world
SACAGAWEA (b. 1788) guided the Lewis & Clark expedition
OSA JOHNSON (b. 1884) author of I Married Adventure
ELIZABETH "BESSIE" COLEMAN (b. 1892) first african american female pilot
AMELIA EARHART (b. 1897) first woman to fly solo across the atlantic ocean
DOROTHY LEVITT (b. 1882) british writer who pioneered female motor racing
LEE MILLER (b. 1907) photojournalist
MARGUERITE HIGGINS (b. 1920) war correspondent
AUDREY HEPBURN (b. 1929) goodwill ambassador for UNICEF
JACKIE KENNEDY (b. 1929) first lady of the united states
JANE GOODALL (b. 1934) anthropologist
JUNKO TABEI (b. 1939) climbed mount everest and the seven summits
SALLY RIDE (b. 1951) first american woman in space
LAURA DEKKER (b. 1995) youngest woman to sail solo around the world

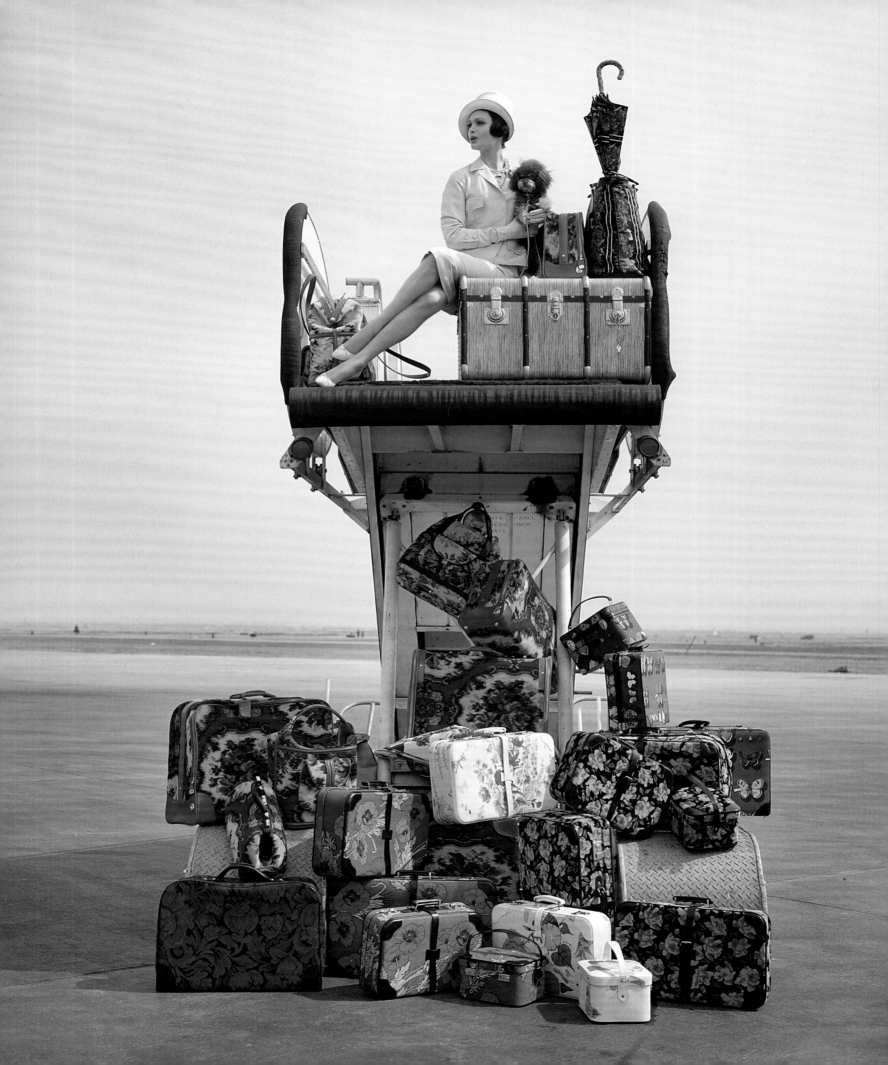

BAGS PACKED!

just a glimpse of a leather-trimmed canvas duffle or a suitcase
topped with a slice of bright ribbon (that's our preferred mode of bag labeling)
is all it takes to send us daydreaming of a getaway. we've even
got the art of packing our off-duty finest down to an unscientific science.
in the spirit of the great escape we prefer to travel light. for what's a
vacation if not a chance to leave (almost) all of it behind?

holiday magazine ran from 1946 to 1977 and employed some of the best writers and photographers of the era to cover one theme per issue, separately, however they liked. essential reading.

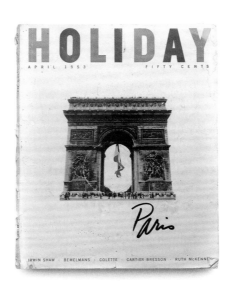

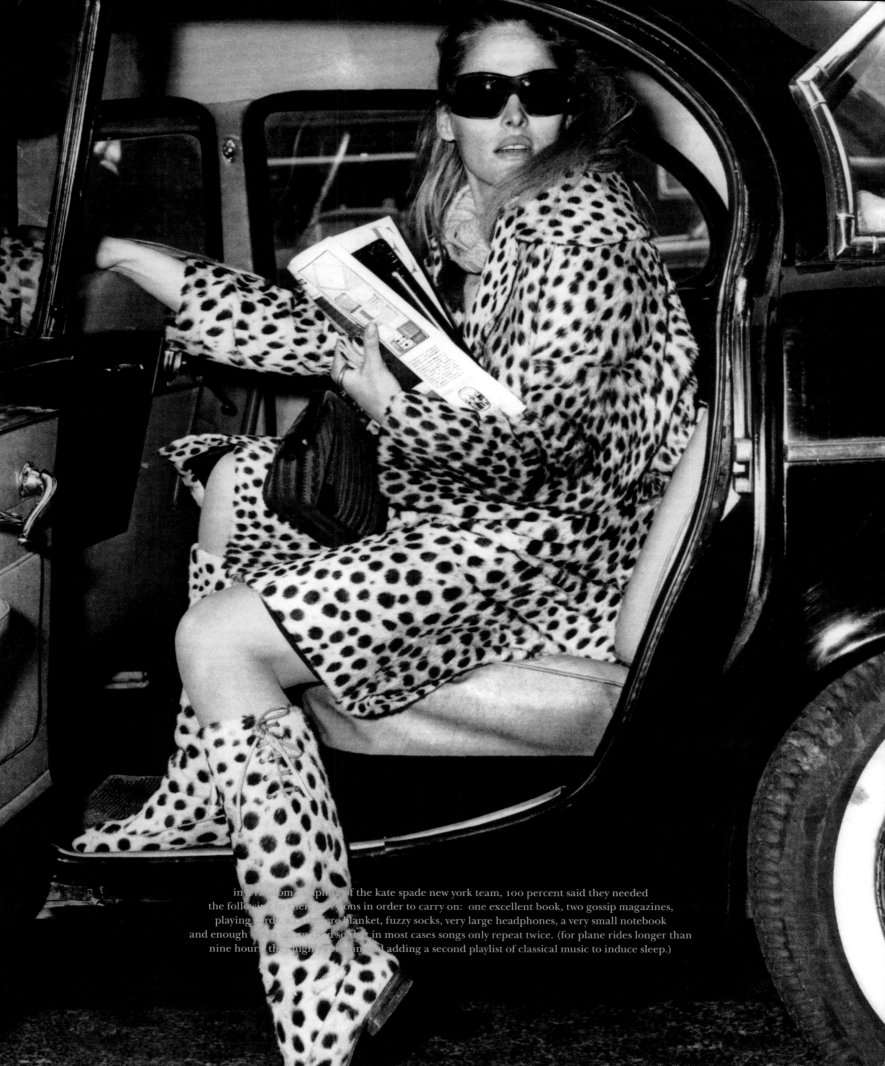

in an informal sampling of the kate spade new york team, 100 percent said they needed
the following in their carry-ons in order to carry on: one excellent book, two gossip magazines,
playing cards, a cashmere blanket, fuzzy socks, very large headphones, a very small notebook
and enough songs on an ipod so that in most cases songs only repeat twice. (for plane rides longer than
nine hours, they highly recommend adding a second playlist of classical music to induce sleep.)

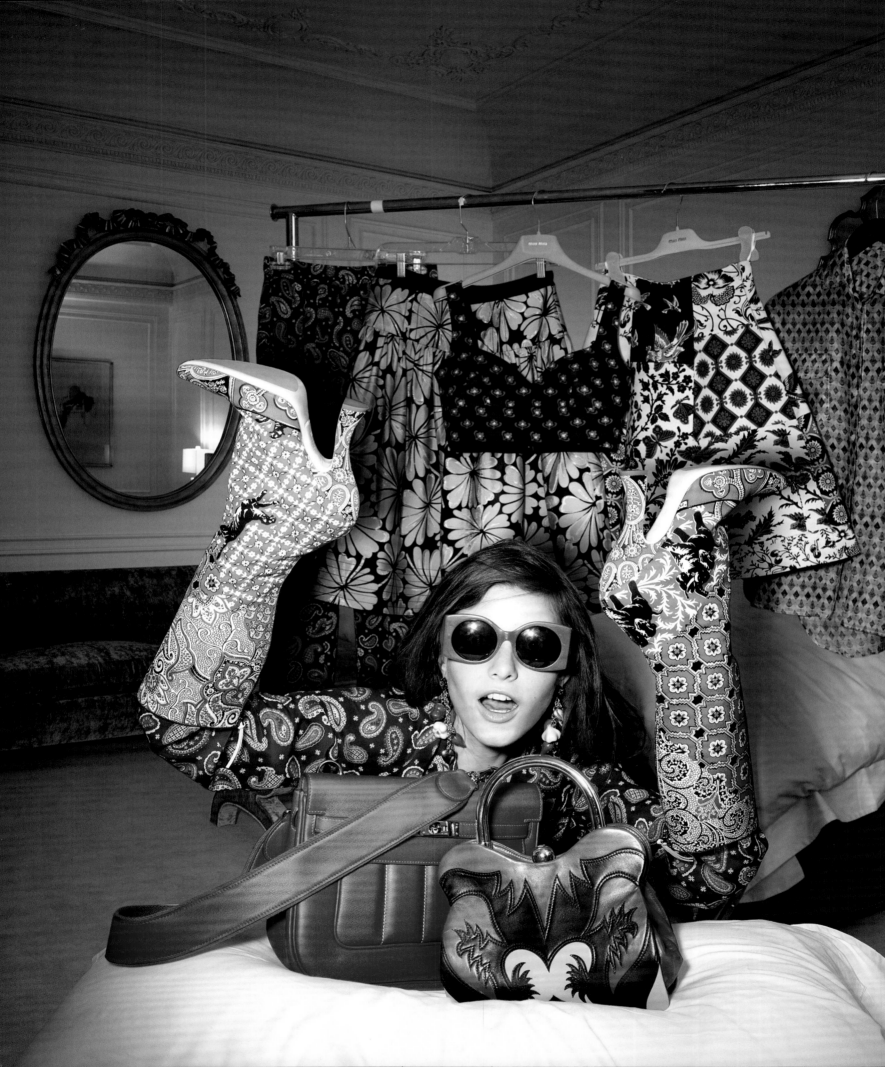

OUR THOUGHTS ON PACKING

PHILOSOPHY NO.1
let's celebrate

PHILOSOPHY NO.2
pattern pick-n-mix

PHILOSOPHY NO.3
black, white, a pop of color

PHILOSOPHY NO.4
never fully dressed without a dress

PHILOSOPHY NO.5
buy it all when you get there

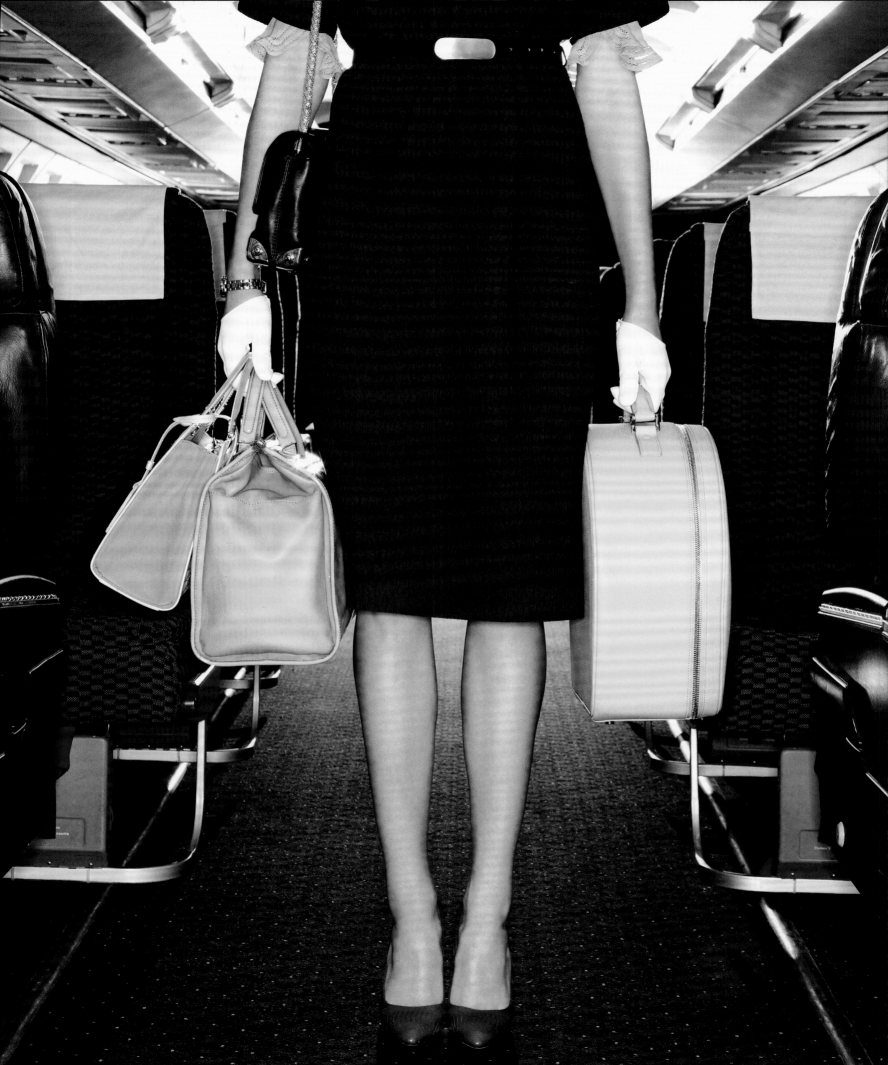

"IS THAT ALL
YOUR LUGGAGE?"

"NO, THAT'S
MY CARRY-ON."

— *overheard at fa'a'ā international airport, tahiti*

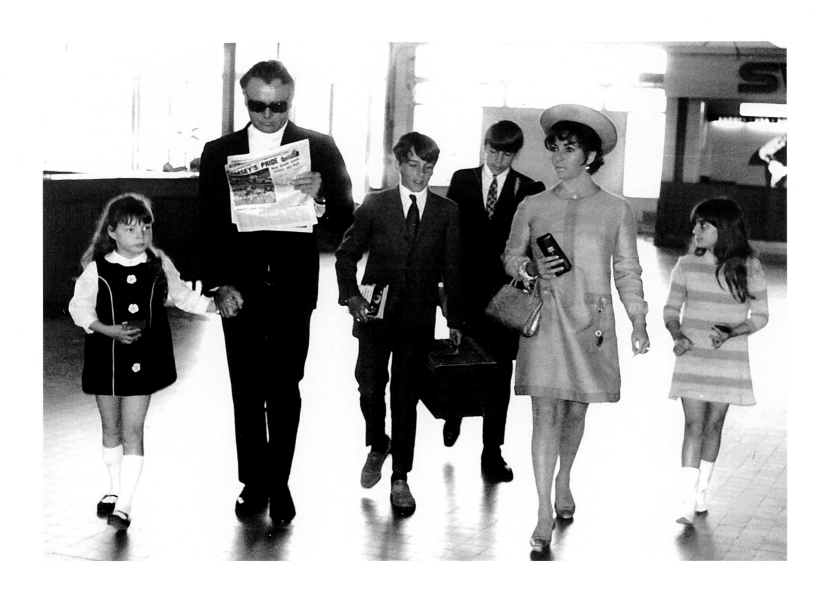

when it came to packing for a trip, elizabeth taylor (above, with richard burton and
family at nice airport in the late 1960s) thought outside the box (opposite).

NEW YORK

IDL

20⁷/24

Holland-America Line

First Class

PACIFIC COAST–EUROPE
SERVICE
VIA PANAMA CANAL

TRANSATLANTIC LUXURY SERVICES

SEAT NO.
NO. DE PLACE

BRITISH OVERSEAS AIRWAYS CORPORATION

ALITALIA

Wt. this piece 16 KGS

CHECKED TO:
PISA

AIRLINE/FLIGHT
AZ 158

Via
ROME

AIRLINE/FLIGHT
AZ 493

SABEN

CABI

KOL

QANTAS FORM NO. 383
PRINTED IN AUSTRALIA

ANTAS

21

40-53-18

SAS

To London
LON

Airline/Flight
SK SK1

Baggage strap tag
BRITISH EUROPEAN AIRWAYS
Issued by

Weight
this
piece 17

KGS

Final flight

to

ATH

T242

Athens

34-86-7

to
Museumpleir
AMSTERDA

KLM

FLIGHT BA 505 | Seat Row | | Seat |
m. WILSON

B·O·A·C BOARDING PASS

ISSAIR

to be
ed in

TO:
ZÜRICH

PLACE OF DEPARTURE AND DATE OF ISSUE

BAGGAGE STRAP TAG

CAIRO

Wils

SCONTRINO
BAGAGLIO

VOLO - Flight
AZ-284

DA
Tran

Ian Fleming's Thrilling Cities

A look behind the scenes of the world's most fabulous places by the creator of James Bond.

Push Pin Studios

functionally speaking, luggage labels were used first by ships and trains to dispatch luggage to where it was bound. in the mid-1800s, hotels got into the act. by the 1900s, the stickers had turned into status symbols and designers were commissioned to create pint-sized, poster-worthy artwork. like a passport full of exotic stamps, a well-labeled suitcase signified a curious traveler with a bevy of interesting stories to tell. if we were to judge this ian fleming book by its milton glaser–designed cover, we'd bet the tales were pretty thrilling indeed.

"FOR THE FIRST TIME I WAS REALLY PROUD OF WHAT I WAS AND WHERE I CAME FROM...

...i was recognized." in 1973, five designers from new york took a group of models to france for a friendly runway competition with five parisian designers at versailles to raise money for restoring the monument. the event catapulted american fashion into the international limelight. but it was the bold, energetic models—many of them african american and included pat cleveland, bethann hardison and BILLIE BLAIR, seen arriving at charles de gaulle airport (right)—who emerged as the real stars.

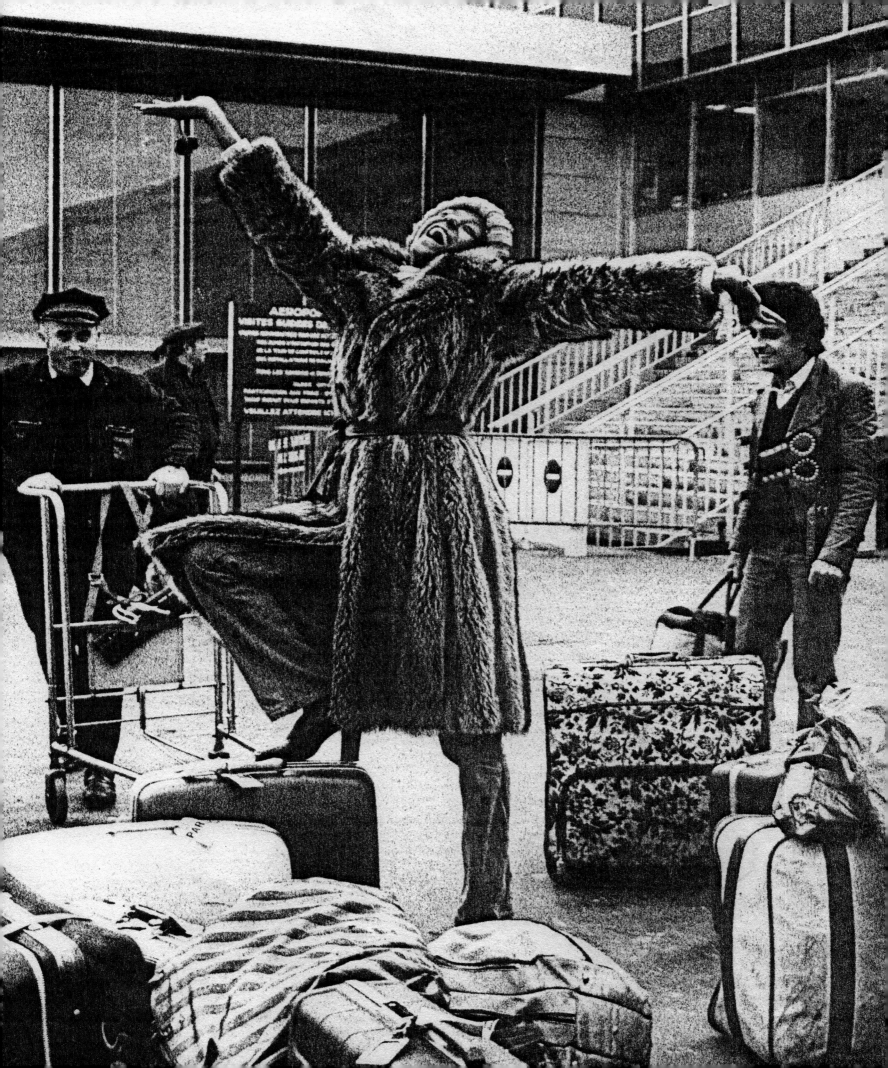

ENJOY THE RIDE

it's the starting of the engine, the getting there, the any-moment-now that
we relish. "there" could be (almost) anywhere, and "getting there" (almost) anyhow.
some of the greatest stories ever told are the ones that unfold between departure and
arrival, whether we keep our eyes on the road or lose our head in the clouds.

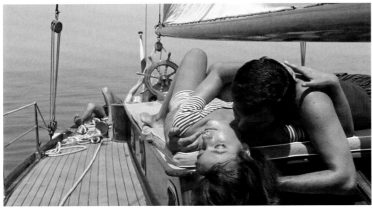

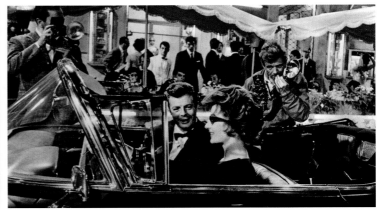

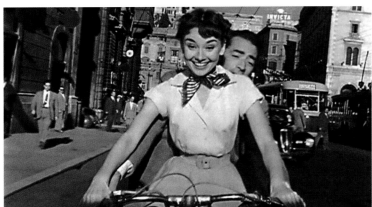

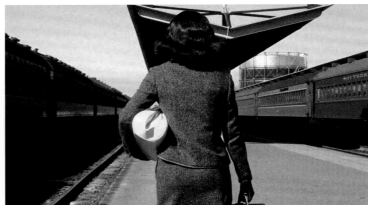

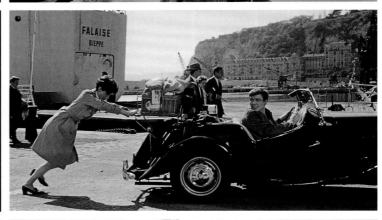

LEGRAND

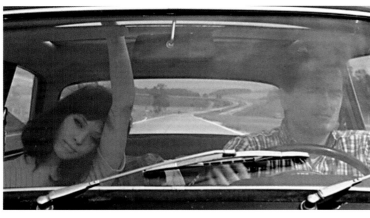

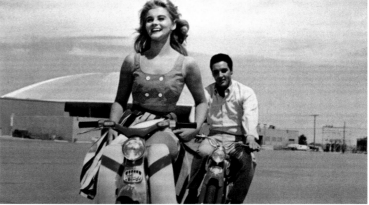

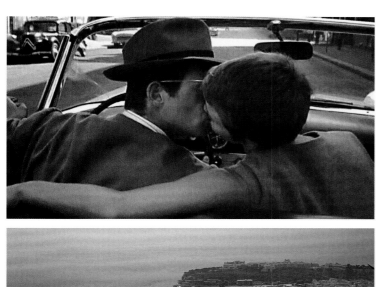

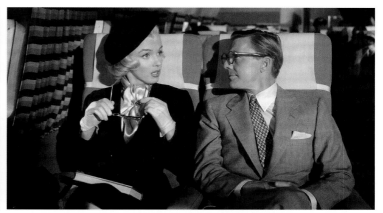

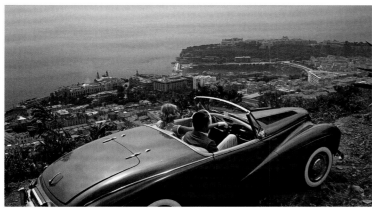

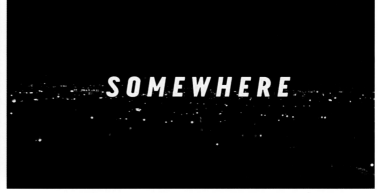

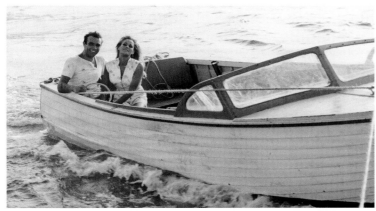

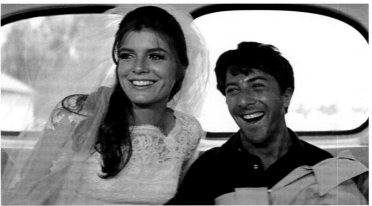

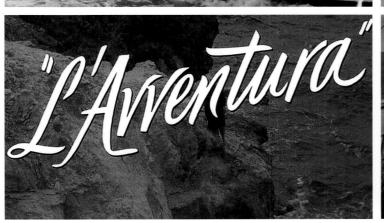

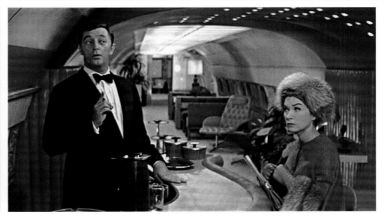

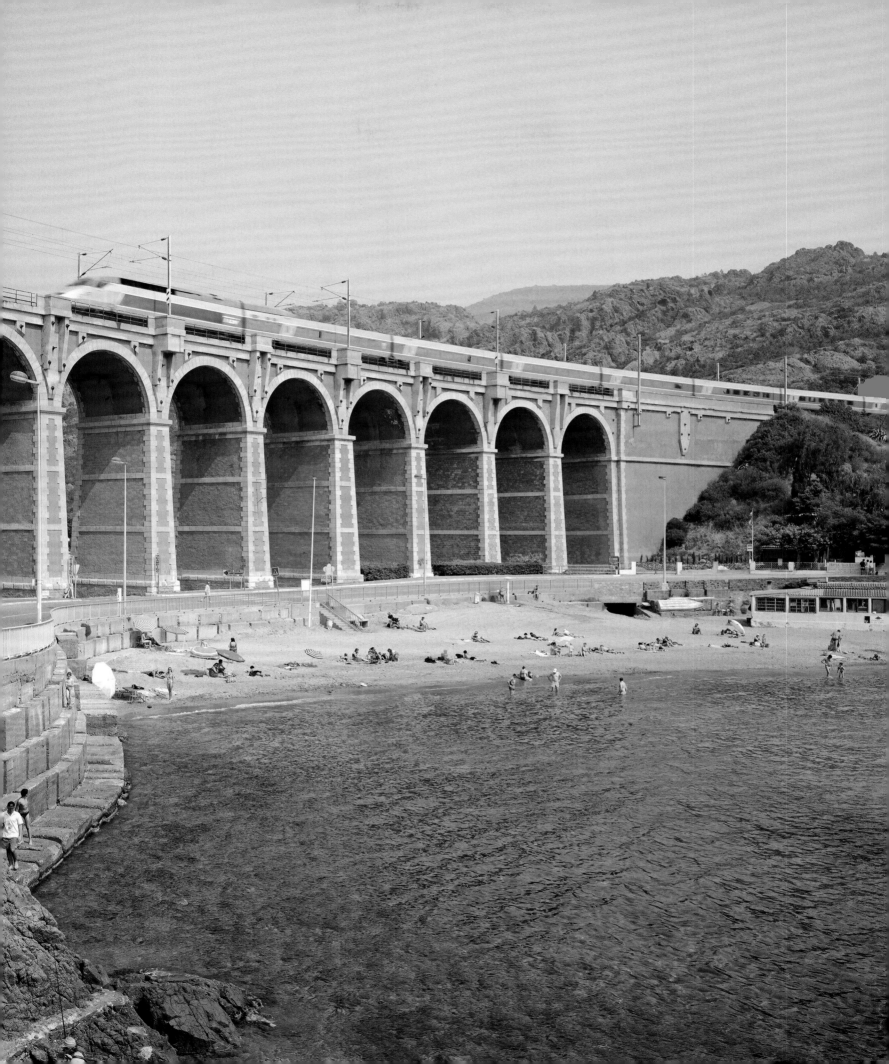

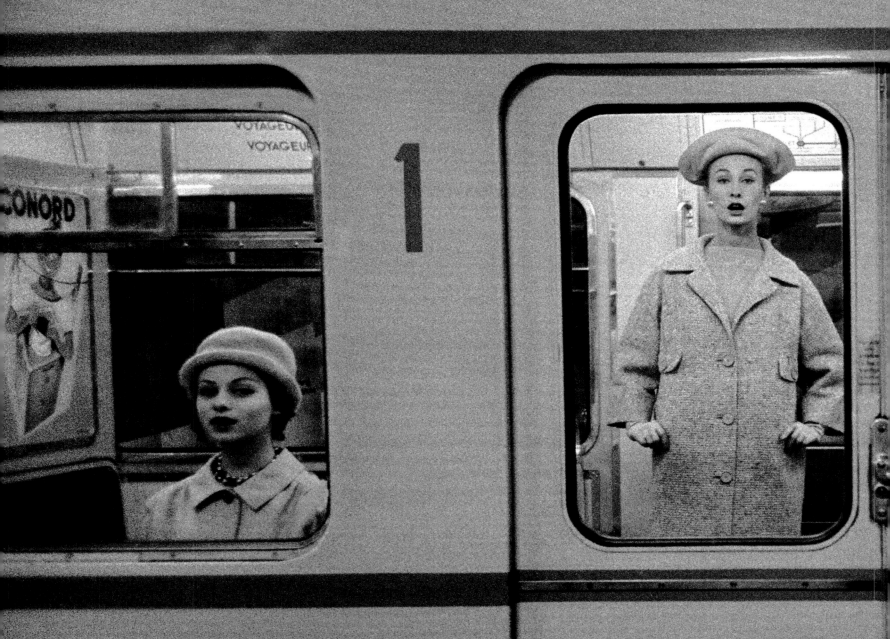

"i never travel without my diary. one should always have something sensational to read in the train." —OSCAR WILDE

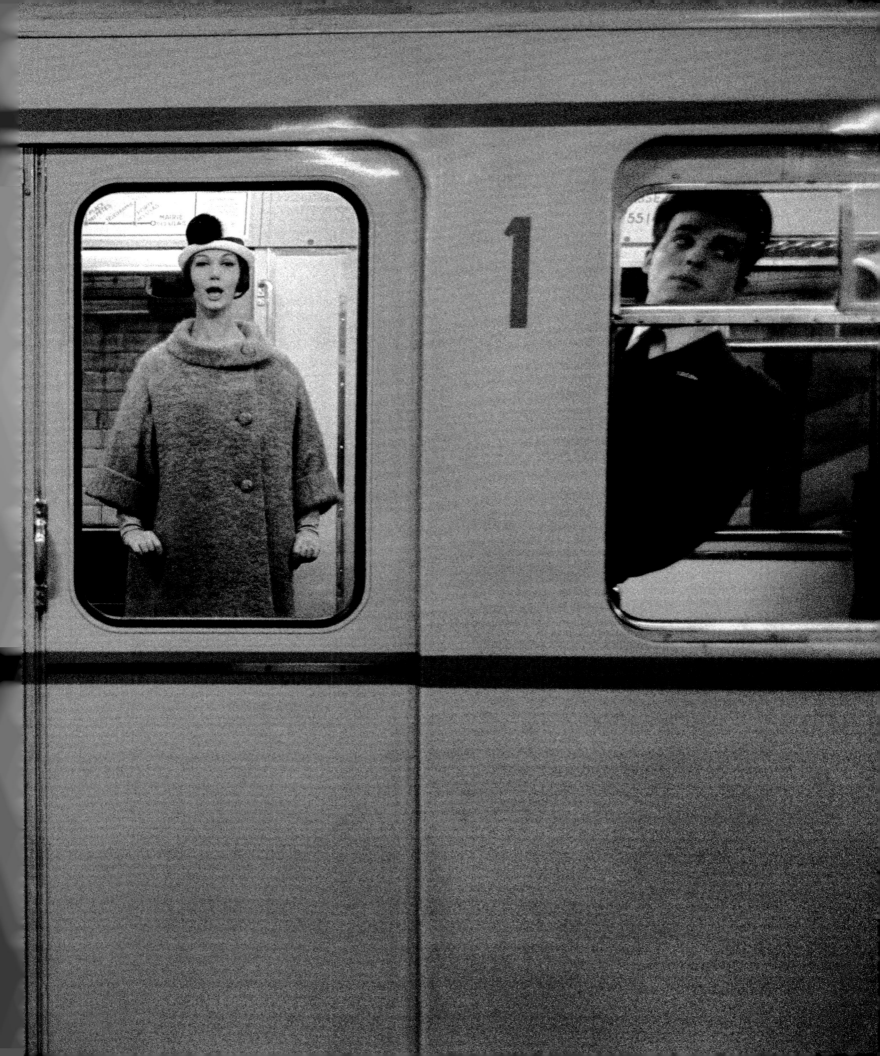

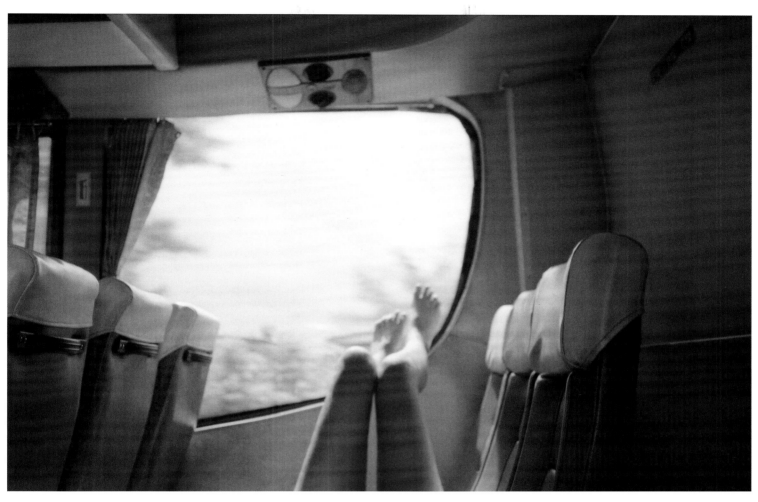

TUNING IN TO TUNE OUT
"king of the road" by roger miller
"west coast" by coconut records
"dreaming" by blondie
"start me up" by the rolling stones
"day tripper" by the beatles
"roadrunner" by the modern lovers
"roam" by the b-52's
"ramble on" by led zeppelin

"I HAVEN'T
BEEN
EVERYWHERE
BUT IT'S
ON MY LIST."

— *susan sontag*

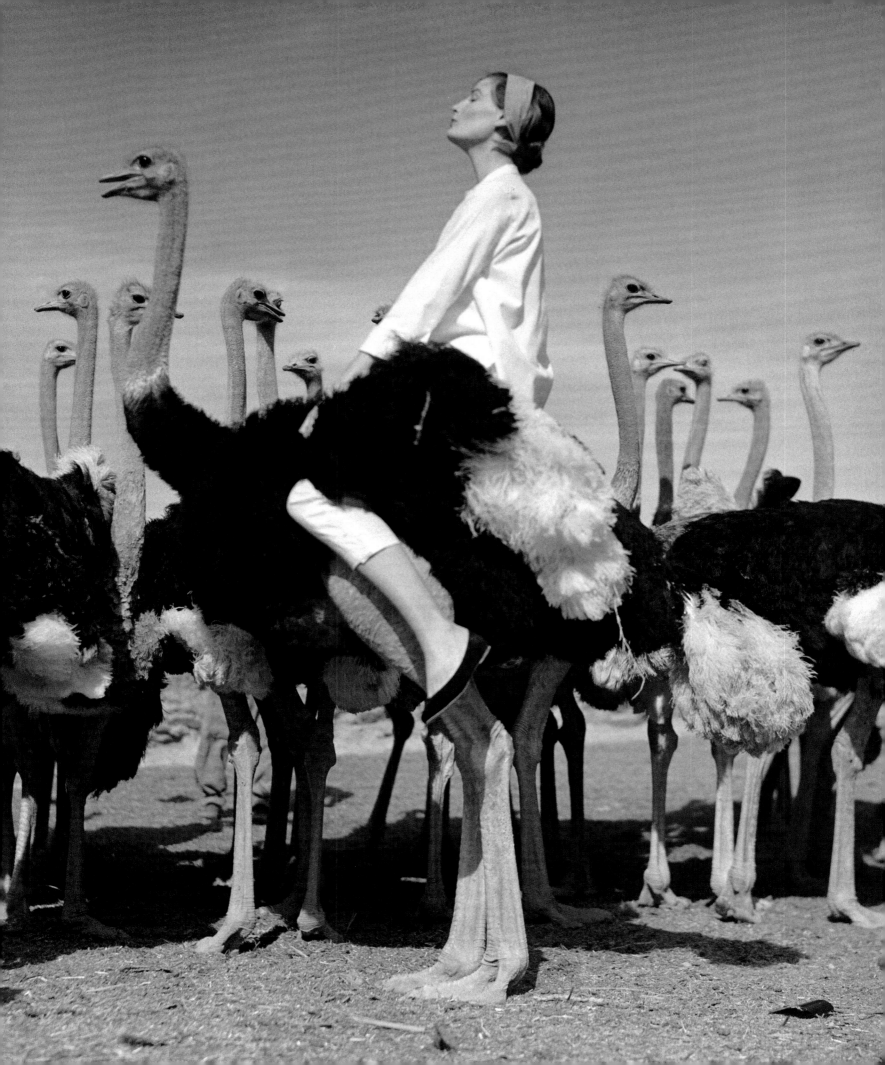

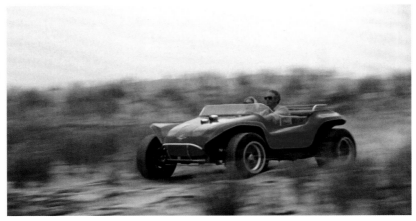

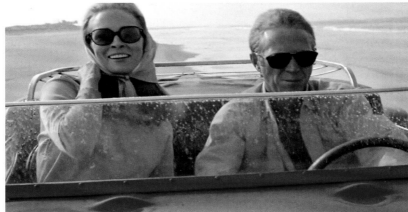

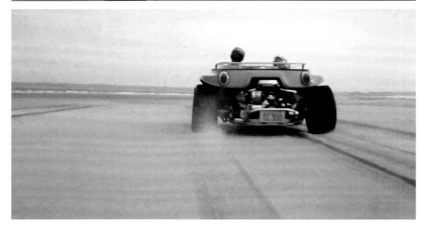

ONE (CAR GAME) FOR THE ROAD
punch buggy in the east. slug bug in the west. the first beetle touched rubber to
U.S. roads in 1949 but no one knows who, exactly, threw the first punch. volkswagen invented
an inventor, the fictitious zachariah davis, for their punch dub campaign in 2009.

THE RULES
1. +1 point for every beetle you're first to call. one slug to the player of your choice.
2. -1 point for every beetle you call out that's already accounted for. two slugs to you.
3. play nice.

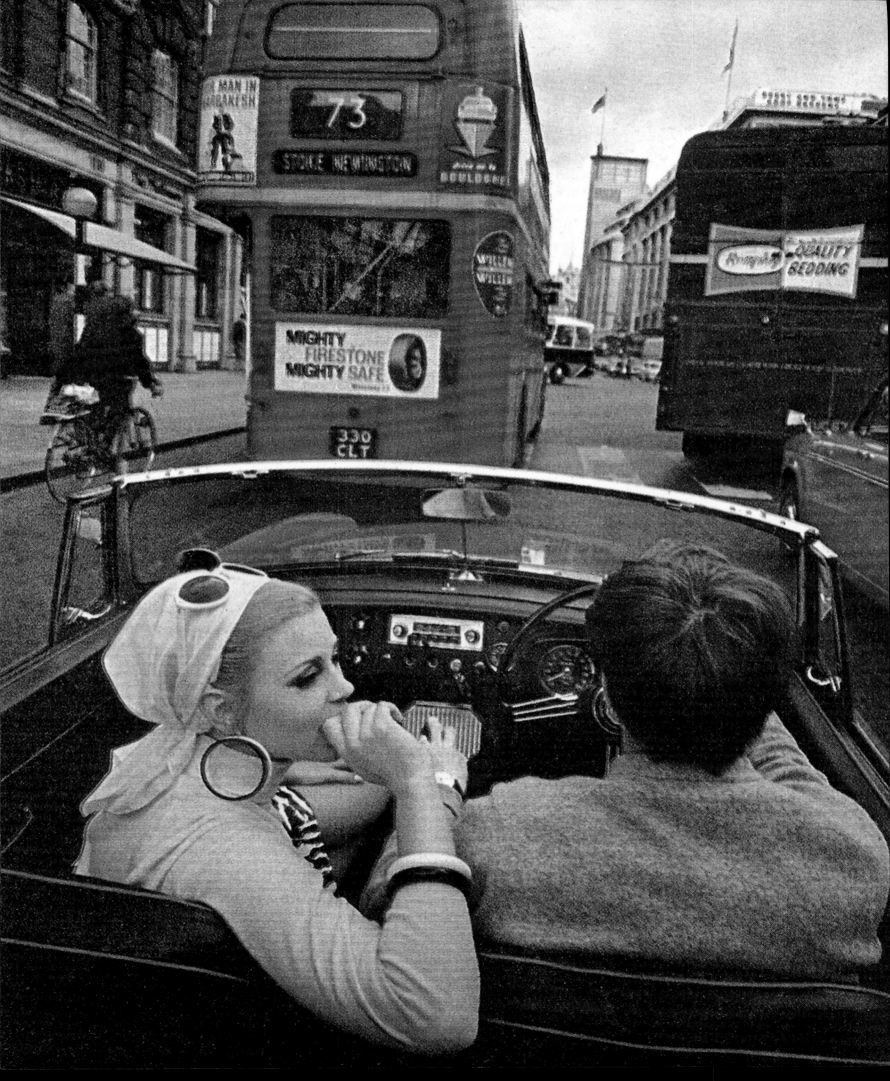

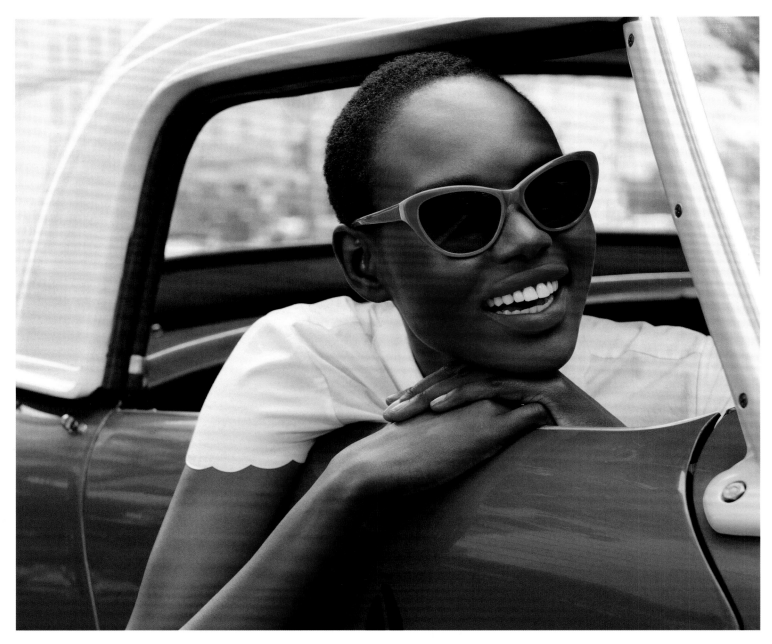

LET'S TAKE THE SCENIC ROUTE
1. monterey to morro bay on the pacific coast highway in california
2. key largo to key west on u.s. highway 1 in florida
3. san antonio to new breunfels on the texas bluebonnet trail
4. haarlem to naaldwijk on the flower route of the netherlands
5. west glacier to st. mary on going-to-the-sun road in montana
6. bordeaux to biarritz on the atlantic coast of france
7. penzance to land's end in england
8. anchorage to resurrection bay in alaska
9. mossel bay to storms river mouth in south africa
10. te anau to milford sound in new zealand
11. baddeck to cheticamp in canada
12. salta to mendoza in argentina
13. kahului to hana in hawaii
14. salerno to positano in italy
15. memphis, tennessee to vicksburg, mississippi

views from a car window

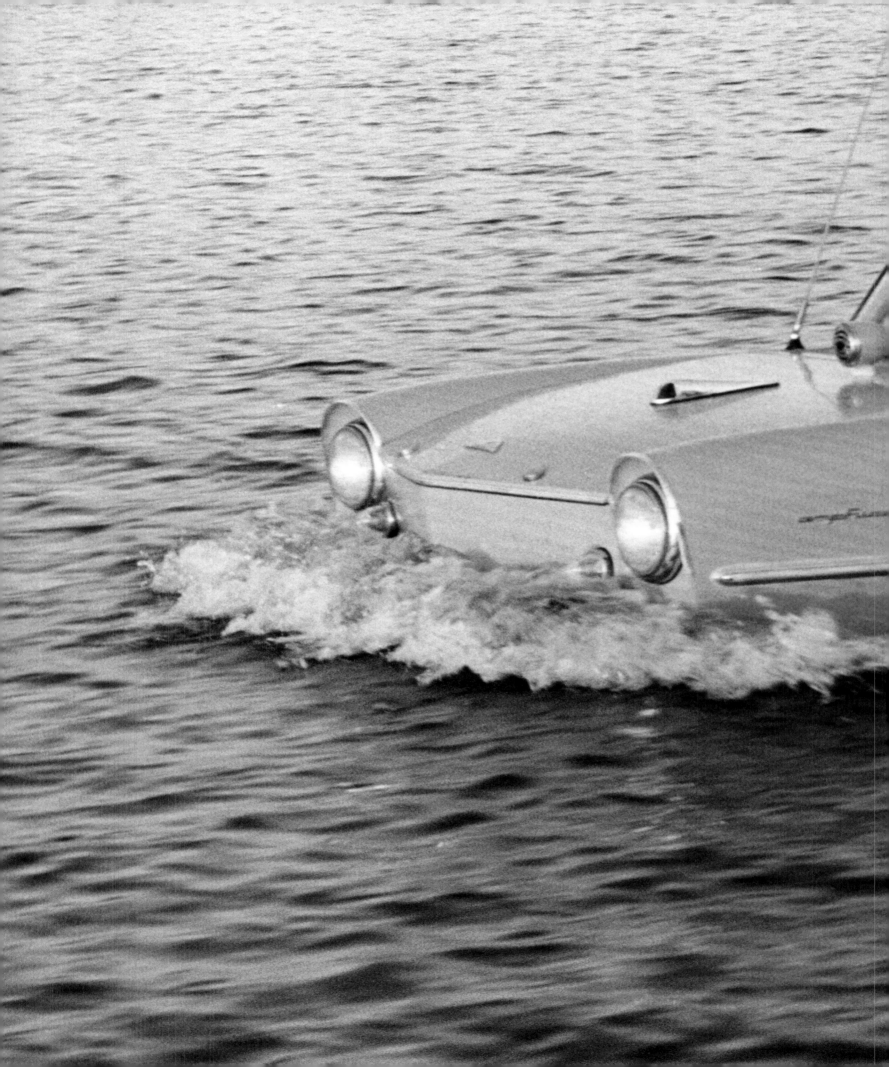

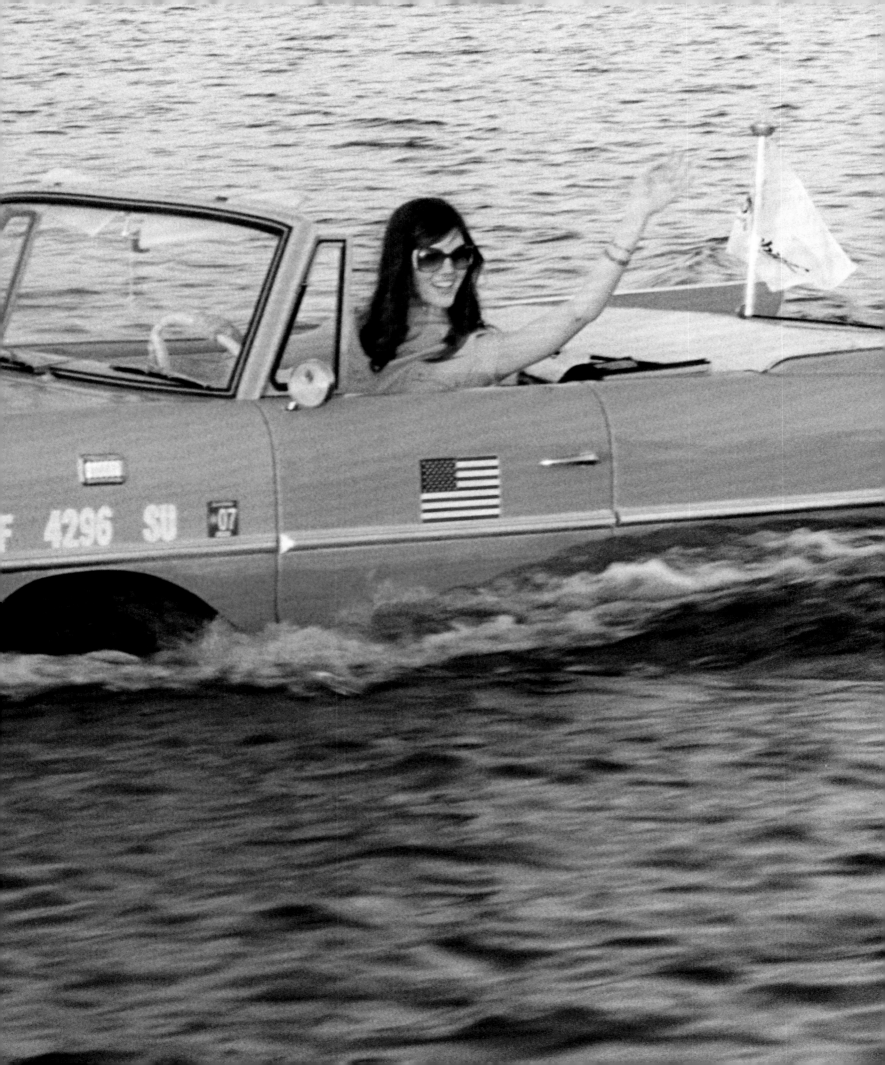

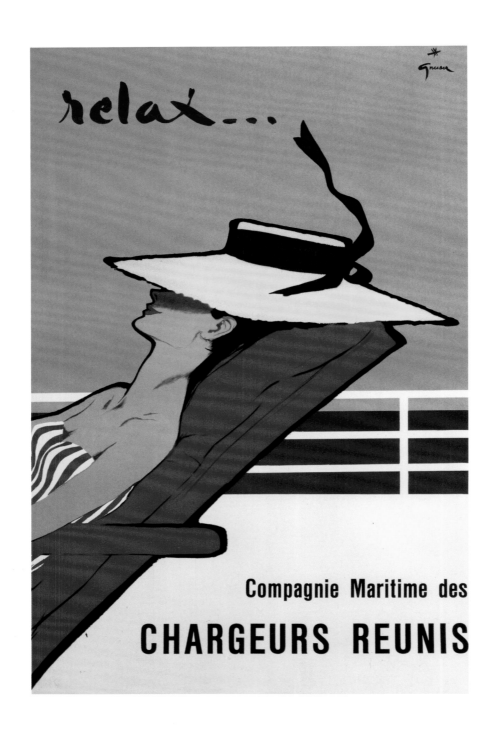

"twenty years from now you will be more disappointed by the things you didn't do than by the ones you did. so throw off the bowlines, sail away from the safe harbour, catch the trade winds in your sails. explore. dream. discover." — H. JACKSON BROWN JR.

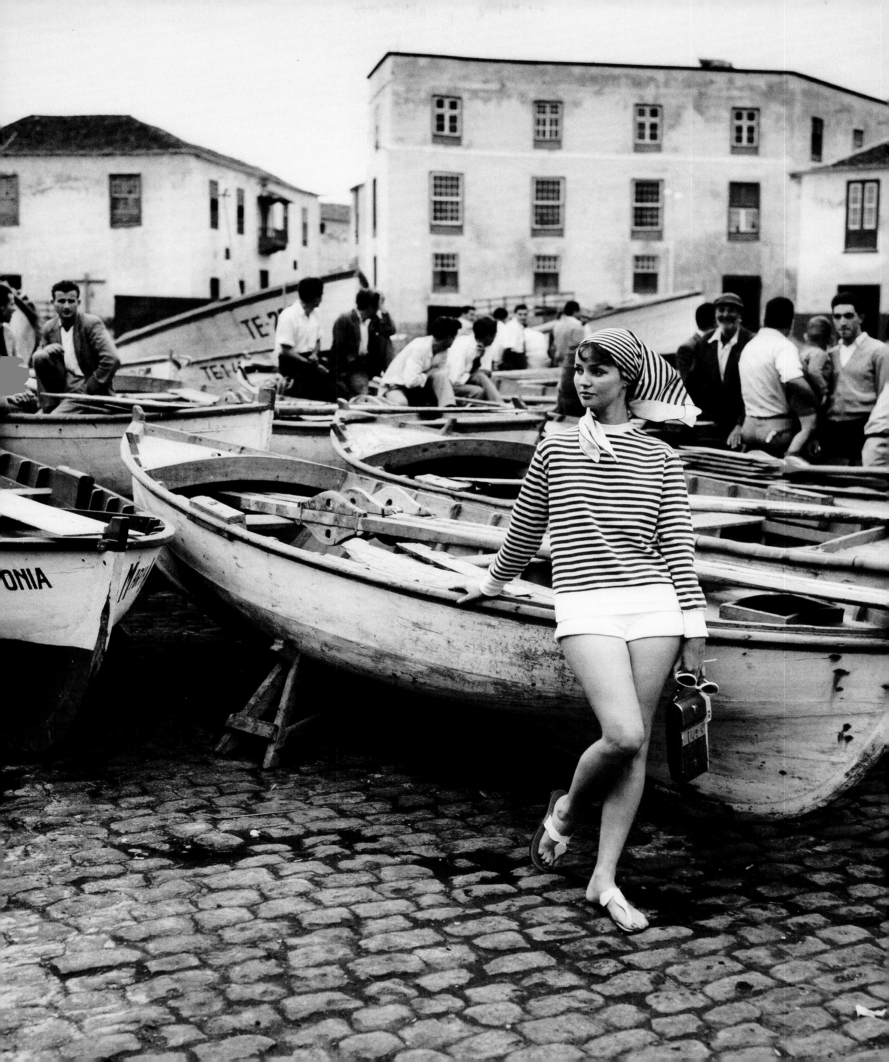

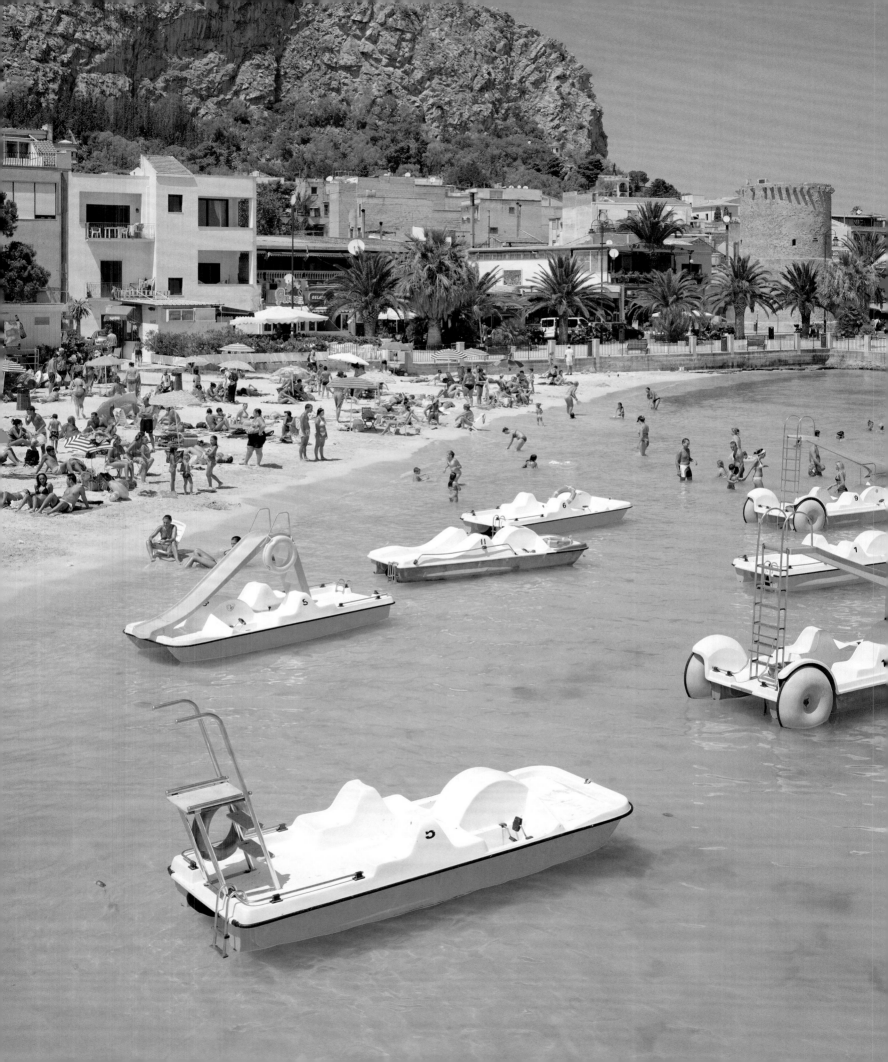

raise the sails, raise our spirits. there's nothing like the call of the sea and its salty breeze—whomever we happen to be sharing it with.

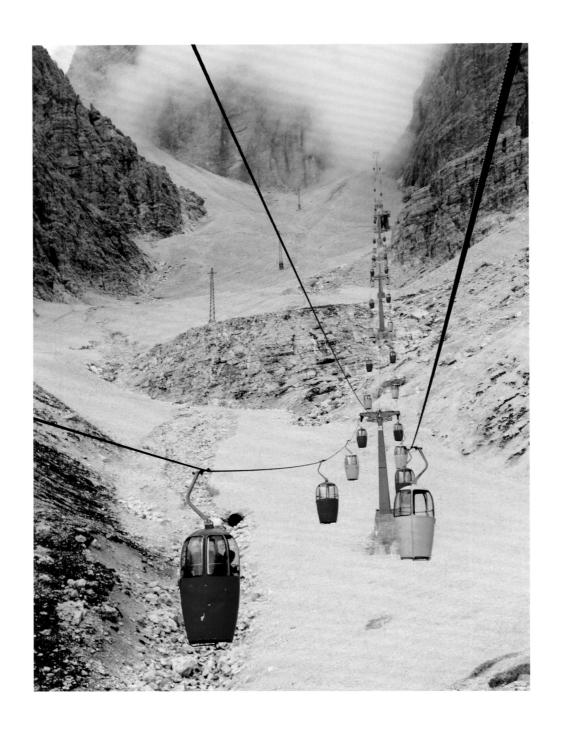

"two roads diverged in a wood, and i—i took the one less traveled by, and that has made all the difference." —ROBERT FROST

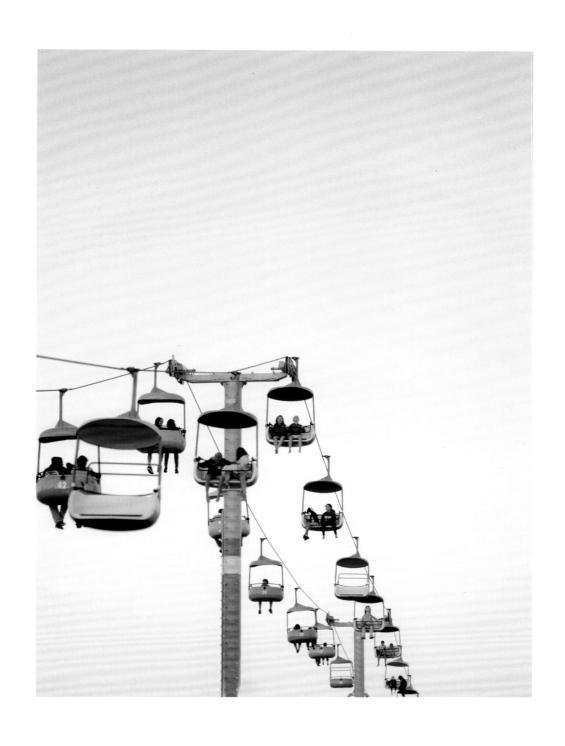

"we do not take a trip. a trip takes us." — JOHN STEINBECK

IF WE HAD AN AIRLINE...
"ladies and gentlemen, the captain has turned on
the fasten seat belt sign. please stow your agendas
in the seat pocket in front of you and any office
work in the overhead bin. make sure your seat backs
and folding trays are in their full upright position.
the captain will allow sunhats to be worn during
this flight. we would like to remind you that this is
a non-snoring flight. any tampering with the lighting
to improve ambiance is unfortunately prohibited.
thank you for flying air kate spade."

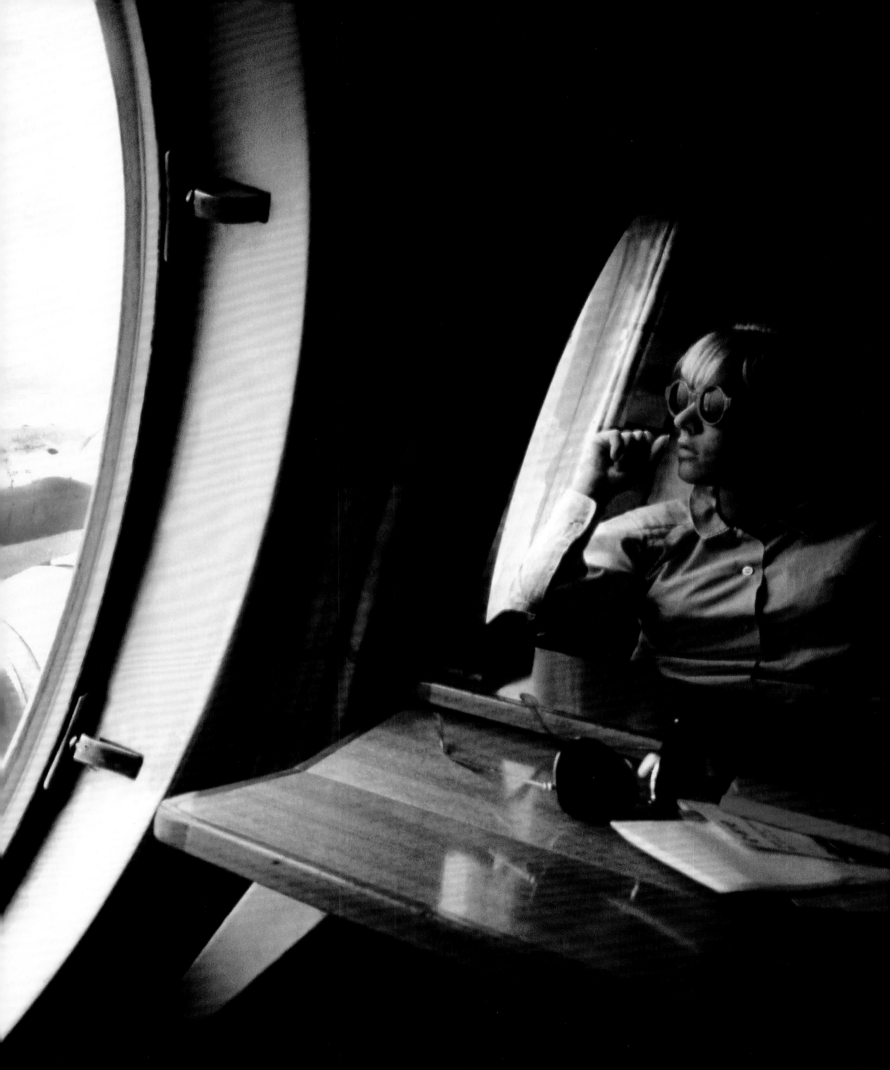

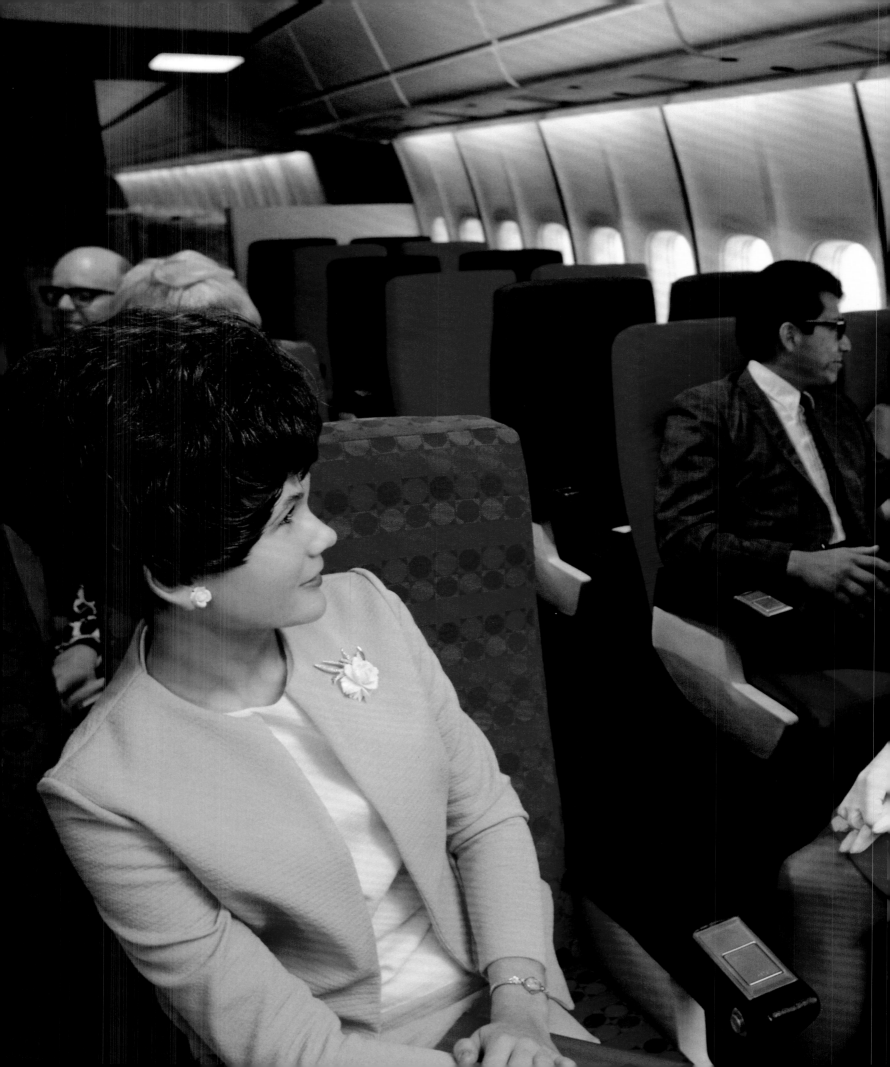

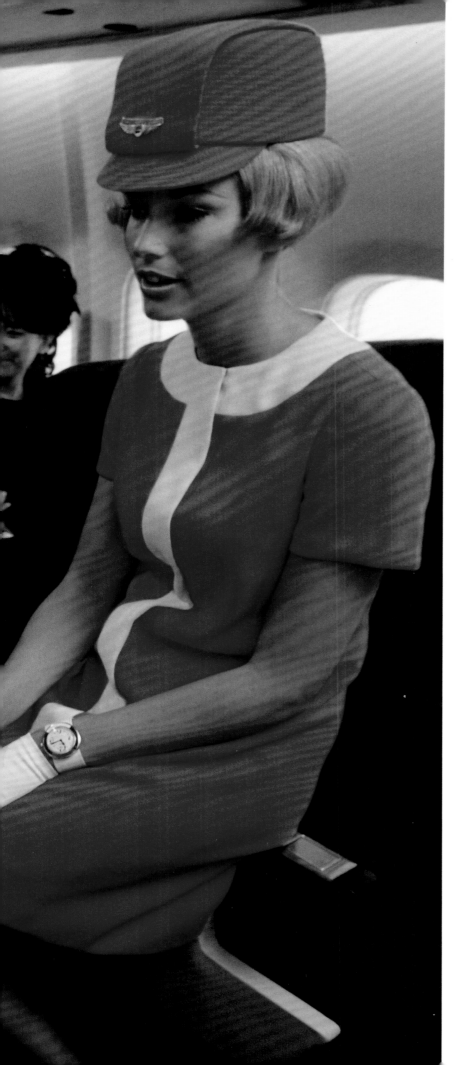

OUR IN-FLIGHT READING LIST
the beautiful fall by alicia drake
a moveable feast by ernest hemingway
the paris wife by paula mclain
a spy in the house of love by anais nin
on the road by jack kerouac
to kill a mockingbird by harper lee
the goldfinch by donna tartt
the cement garden by ian mcewan
i married adventure by osa johnson
just kids by patti smith
the art of travel by alain de botton
the beach book by gloria steinem
the paris review interviews, vol. 1
scoop by evelyn waugh

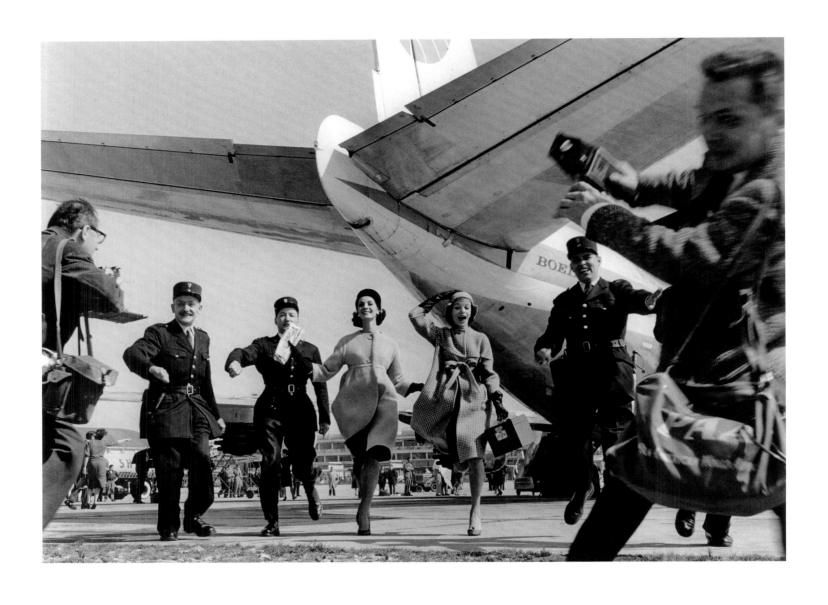

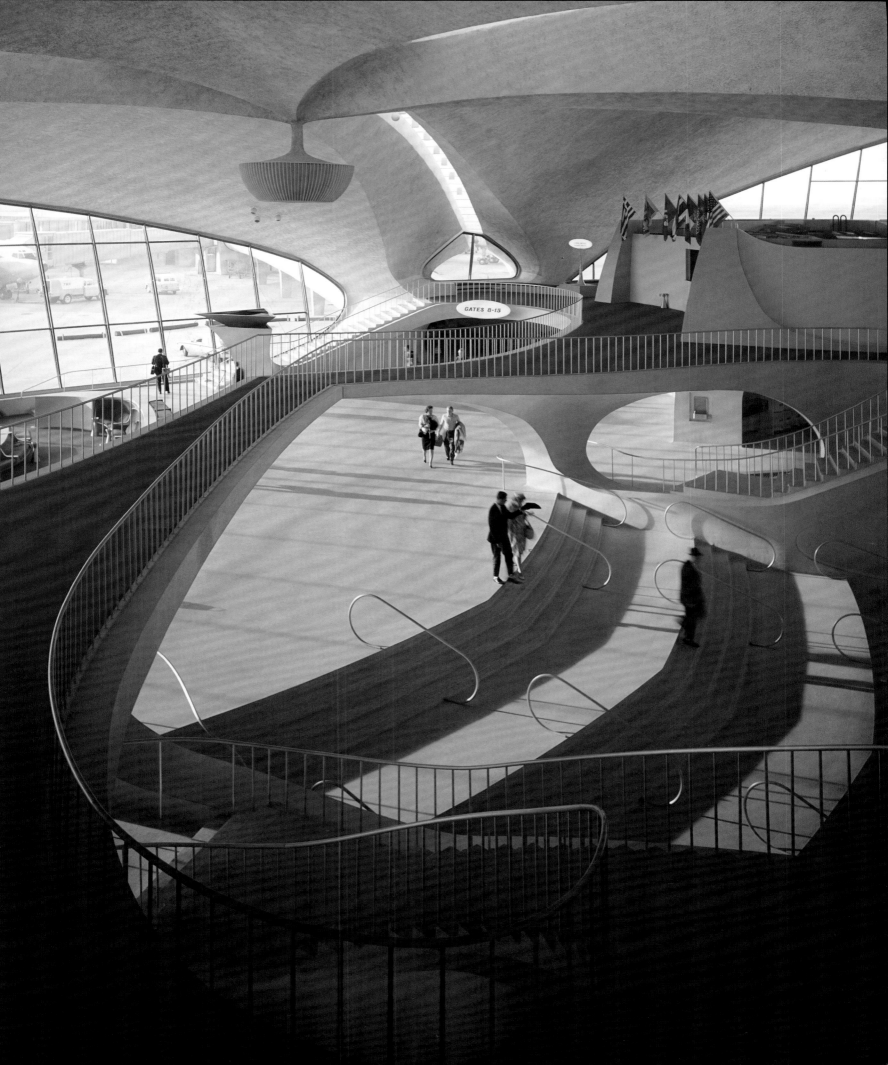

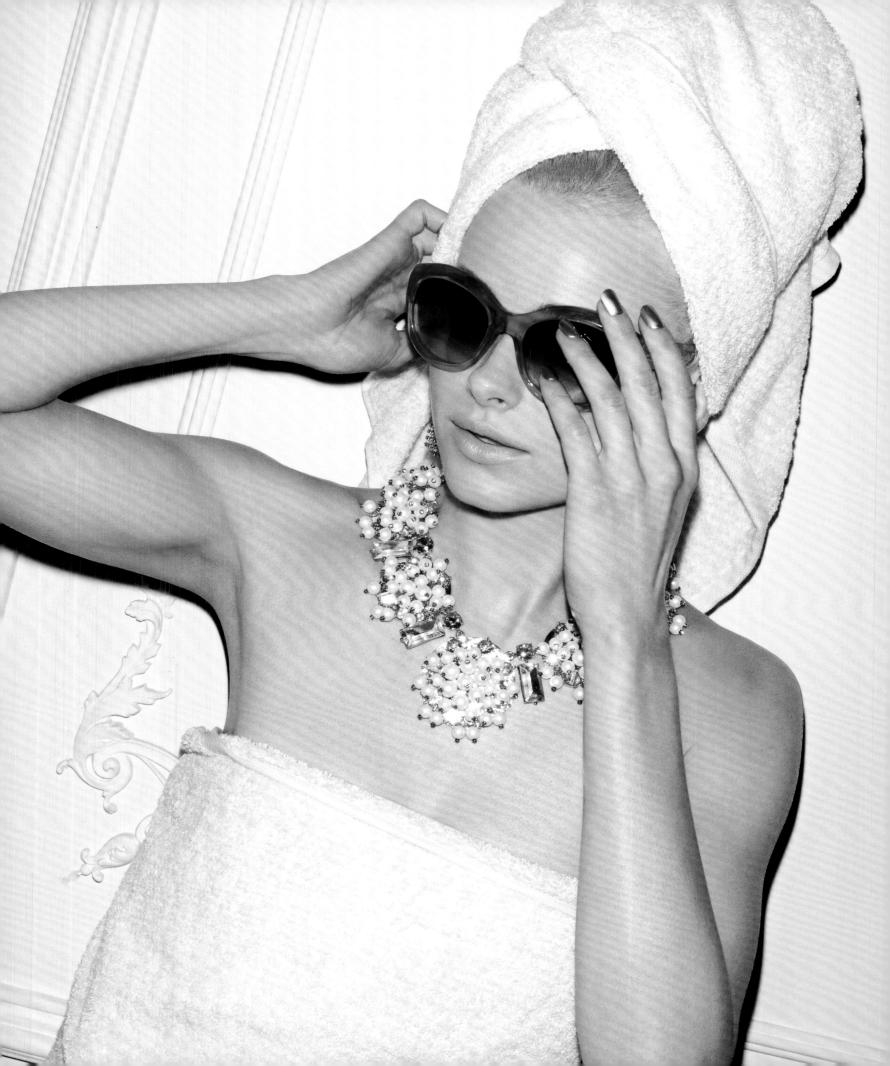

LIVING THE HOTEL LIFE

*the ding of a bell. the click of a room key. the rush of water filling a
bathtub. the rustle of bed linen. they're the sounds we hear at home, but in a hotel,
they sound so much more glamorous. maybe it's because we know someone else is
tidying up and aligning our mini bottles of shampoo. or because a hotel's history or
thoughtful decor can feel like a film set where we're playing the leading role.
wherever the magic comes from in this place we temporarily call home, we gladly
check in our cares upon arrival. it's all music to our ears.*

"to awaken quite alone in a strange town is one of the pleasantest sensations in the world."
british explorer DAME FREYA STARK woke up happy, then, a lot. she traveled enough to write two
dozen books between the 1930s and 1980s on her adventures in the middle east. she was also
one the first westerners to venture across the southern arabian desert.

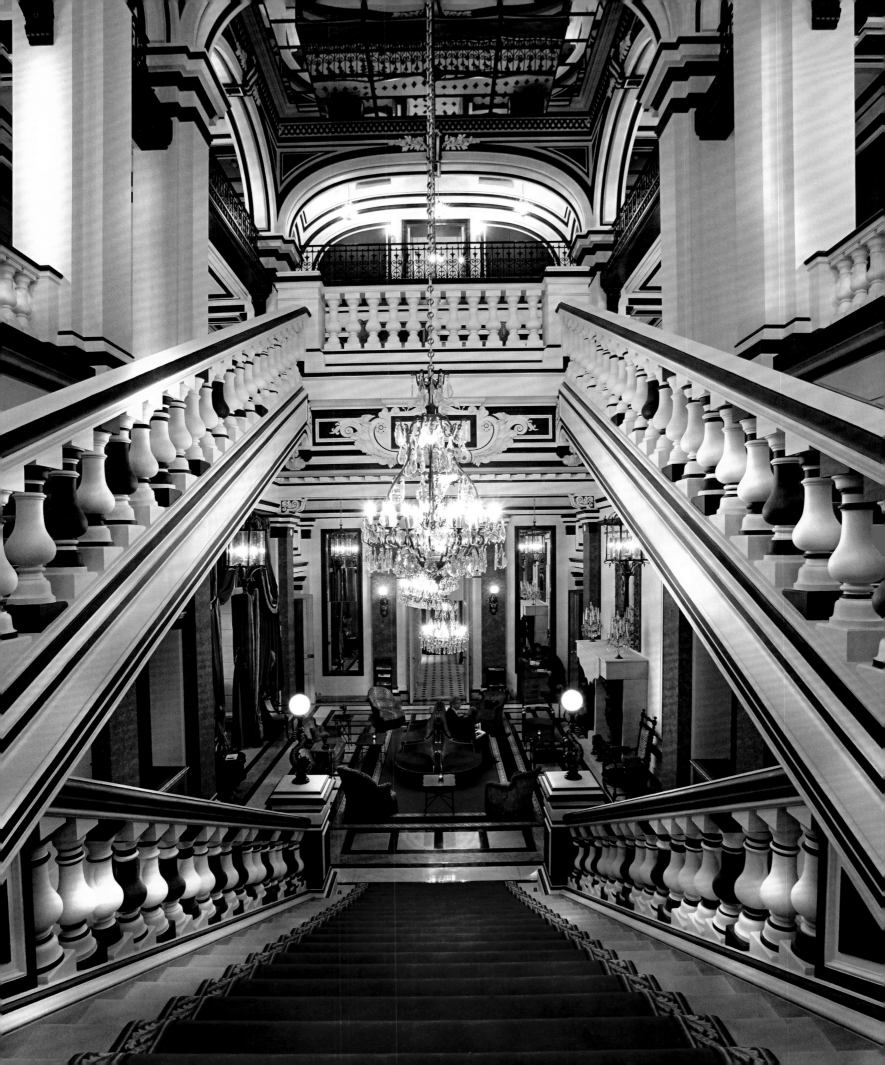

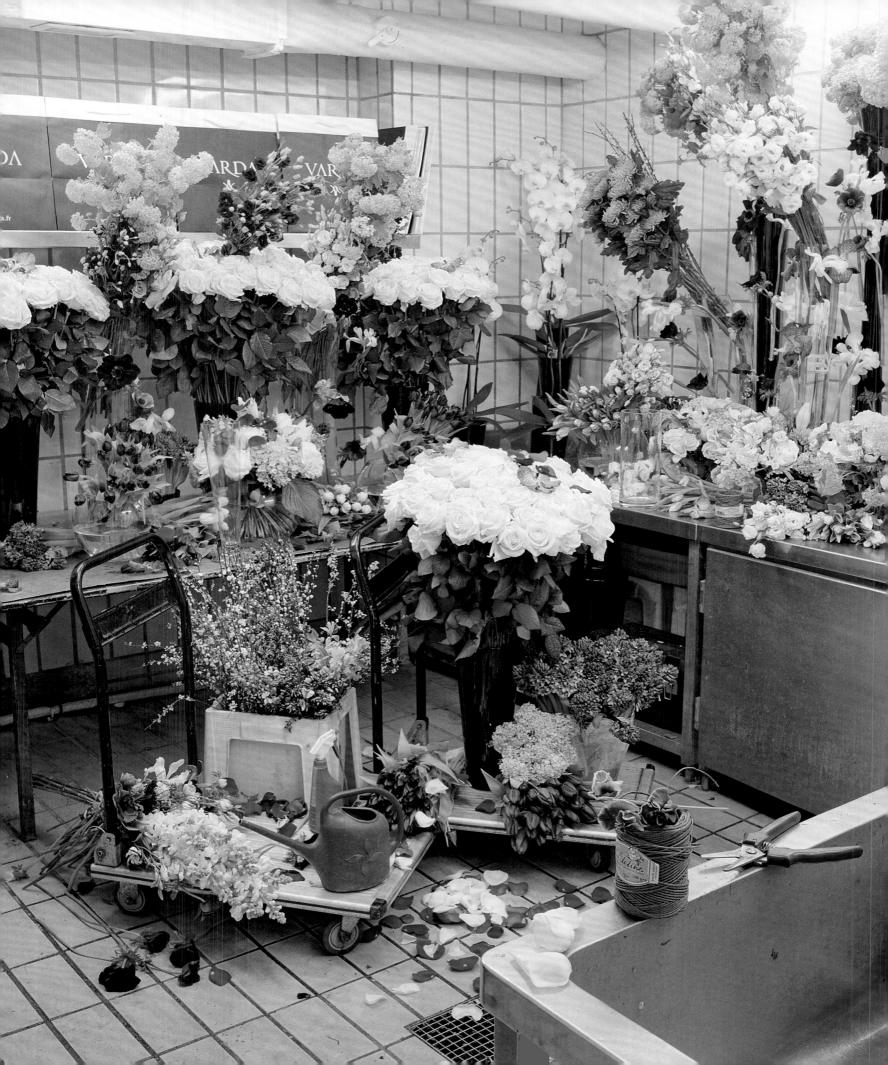

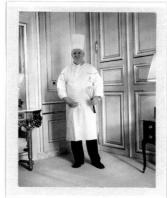

Jean François Girardin
chef de cuisine

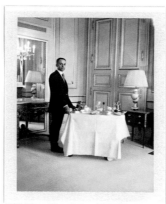

Philippe Nicoux
Maître d'Hôtel

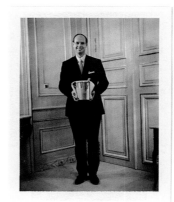

ROBERT MIDDLETON
Director of Bar Vendôme

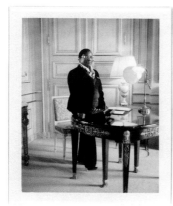

Geneviève Gbozo
standardiste

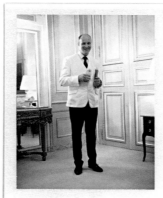

COLIN FIELD (Hemingway bar)
Head Bartender

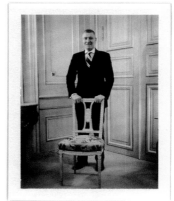

MANFRED JAUTSCH
Guest Relation

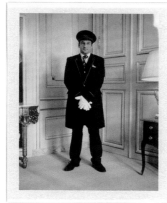

BAUDRY jean-jacques
voiturier

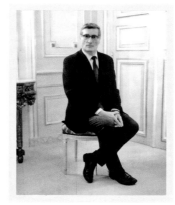

YVES GRIFFET
Cashier

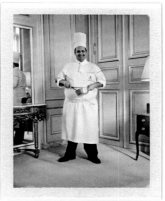

Olivier Desquest
Chef Pâtissier adjoint

around 500 employees and 10,000 weekly blooms (from the flower room, opposite) make
the ritz in paris a magical place to lay one's head. tim walker captured a few of them in signed
polaroids and photos before the hotel closed for renovation in 2012.

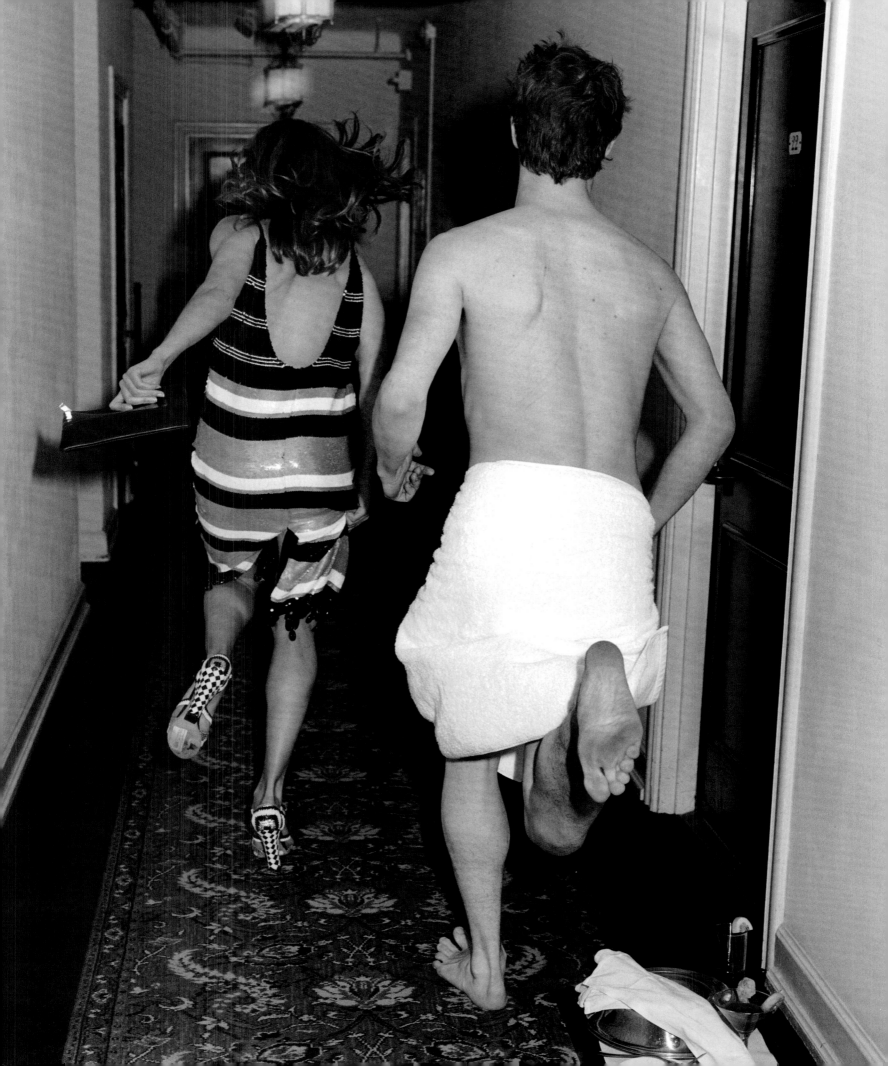

A.M. HOMES may have called the chateau marmont *"a fantastical folly in the land of make believe"*—being that it's a gothic-style chateau modeled after a french royal retreat, in the middle of west hollywood—but it's actually proven to be quite the inspirational setting. authors dorothy parker, jay macinerney, f. scott fitzgerald, and hunter s. thompson; director tim burton; and photographers bruce weber and helmut newton are just a handful who have produced work while in residence. sofia coppola even set her 2010 film *somewhere* there.

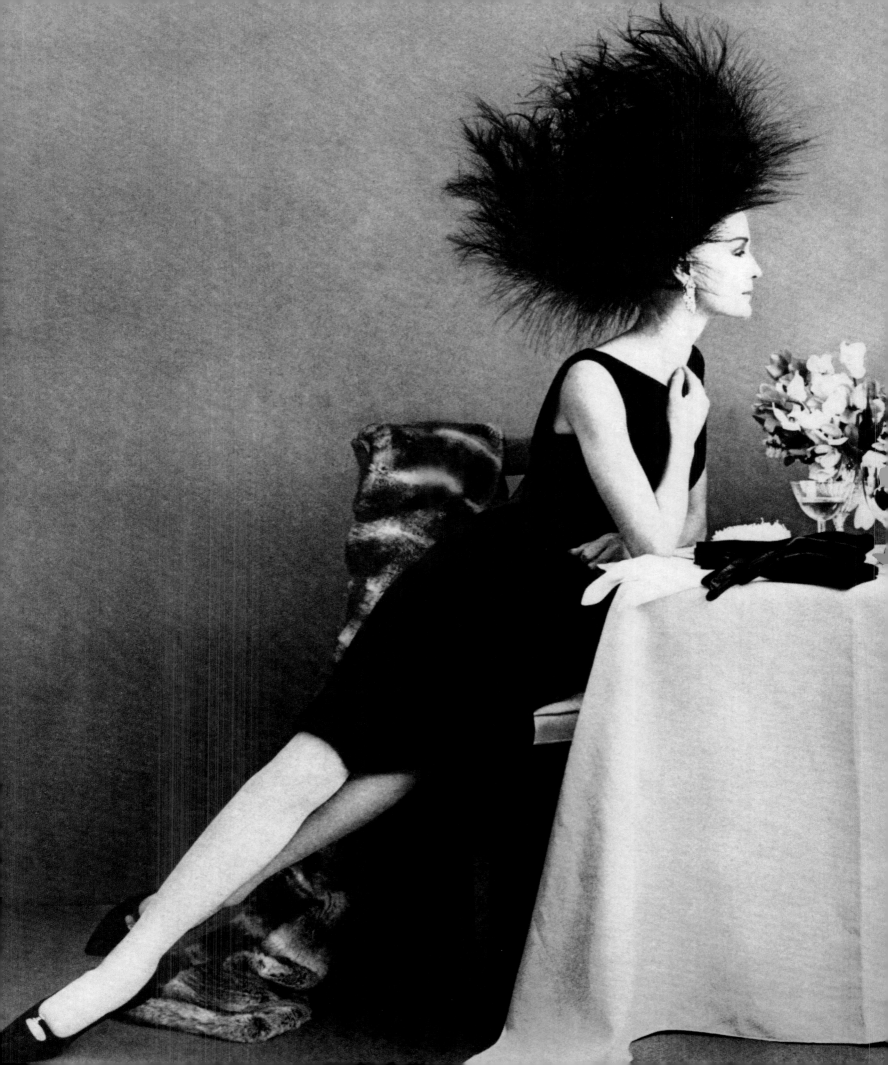

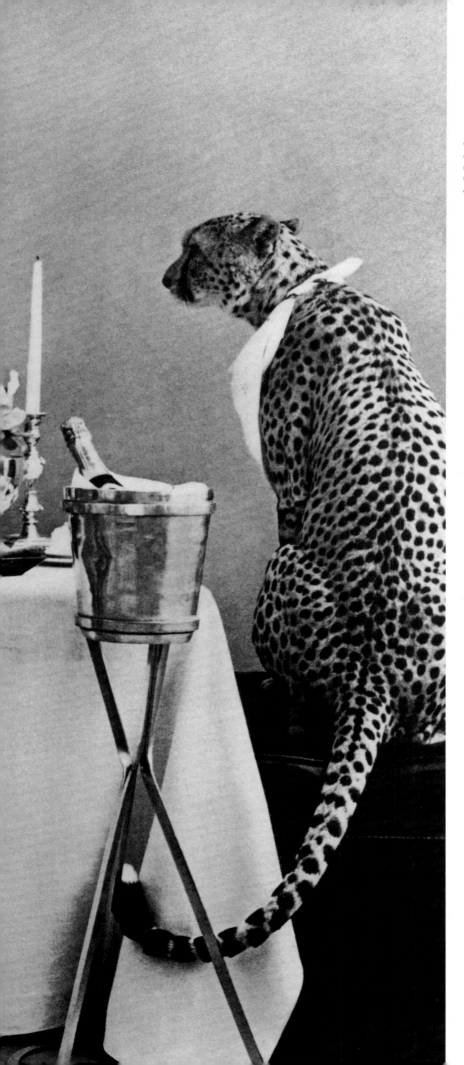

OUR FAVORITE MIDNIGHT SNACKS
club sandwich, vanilla ice cream, mini champagne
rosti, smoked salmon, a crisp sancerre
toasted peanut butter and banana sandwich, glass of milk
cheeseburger, french fries, ketchup, mustard, mayo

"I STAYED IN A REALLY OLD HOTEL LAST NIGHT. THEY SENT ME A WAKE-UP LETTER."

— *steven wright*

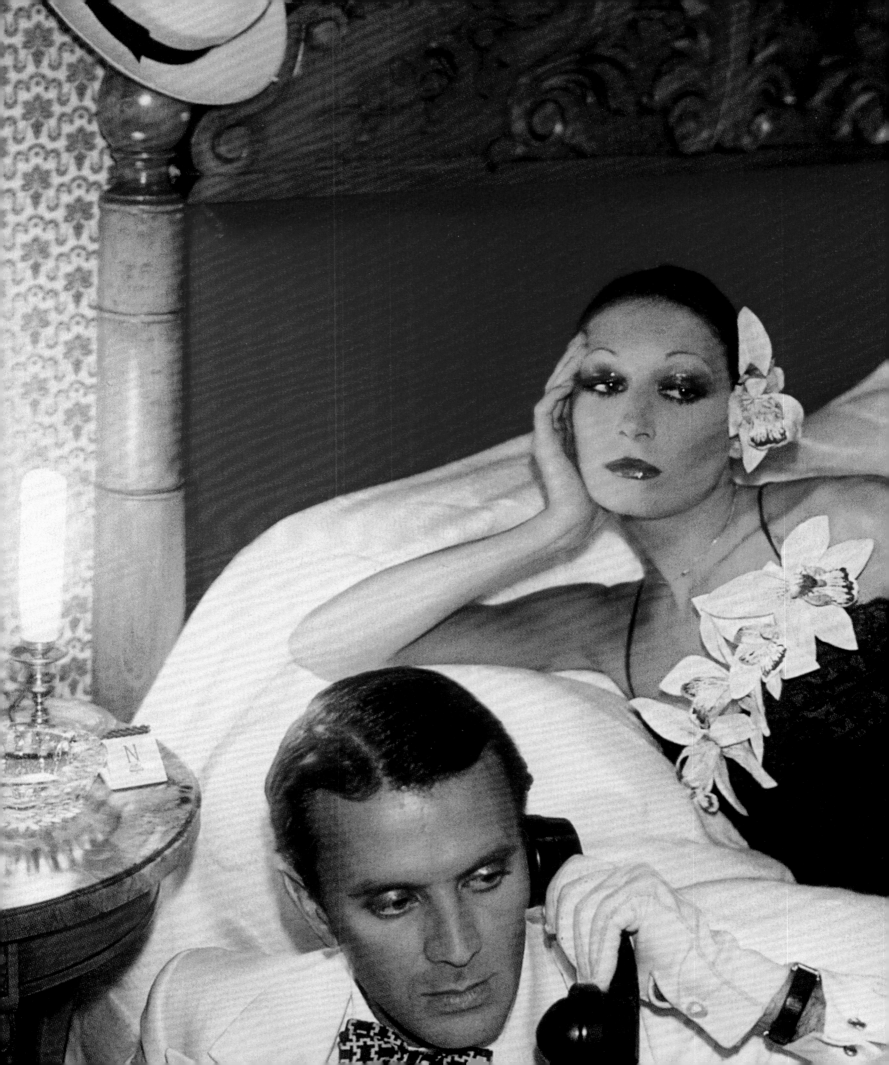

MOMENTS IN HOTEL HISTORY
the great, the gauche, and the too good to be true

1.
claridge's banned audrey hepburn
from the lobby for wearing
pants so she used the employee
entrance instead.

2.
to carry out her project,
the hotel, in 1981, french photograper
and conceptual artist sophie calle took
a job as a chambermaid at a hotel in
venice so she could explore the personal
belongings of its guests.

3.
according to legend,
john f. kennedy used the carlyle
hotel's underground tunnels to enter
and exit the hotel unnoticed. (it was
also dubbed the "new york white house"
during his presidency.)

4.
tony curtis called the
hotel bel air "the best wife he ever had."
he was married six times.

5.
salvador dali tipped the staff
at le meurice in paris with signed
lithographs.

6.
jack kerouac penned *the subterraeans*
and *tristessa* at the marlton hotel
in new york city.

7.
kate (moss) and johnny (depp)
took a bath at the chateau marmont.
in champagne.

8.
dezi arnaz kicked off a craze
for rumba at the clay hotel in
miami's south beach.

9.
marilyn monroe always ordered
the following for breakfast: two raw eggs
whipped into a glass of warm milk.

10.
originally, the 16,309-crystal
chandelier currently inside le negresco's
royal lounge was supposed to go to
czar nicholas II. the october revolution
prevented baccarat from making
the delivery.

11.
during sessions of the algonquin
round table, lunch included free celery
and popovers.

12.
six-year-old eloise first took up
(fictional) residence in the "room on
the tippy-top floor" of the plaza hotel
in new york city in 1955.

13.
a few years later, truman capote
served the following with champagne
at his black and white ball at the
plaza: scrambled eggs, sausages,
biscuits, spaghetti with meatballs,
and chicken hash.

14.
and finally...both katie
(barbra streisand in *the way we were*)
and carrie (sarah jessica parker
in *sex and the city*) approved of their
ex-boyfriends' new girlfriends
outside the hotel.

15.
in the wee hours of
january 2, 1972, tuxedo-clad mobsters
robbed the pierre taking home
$11 million in loot, making it the biggest
hotel heist of all time.

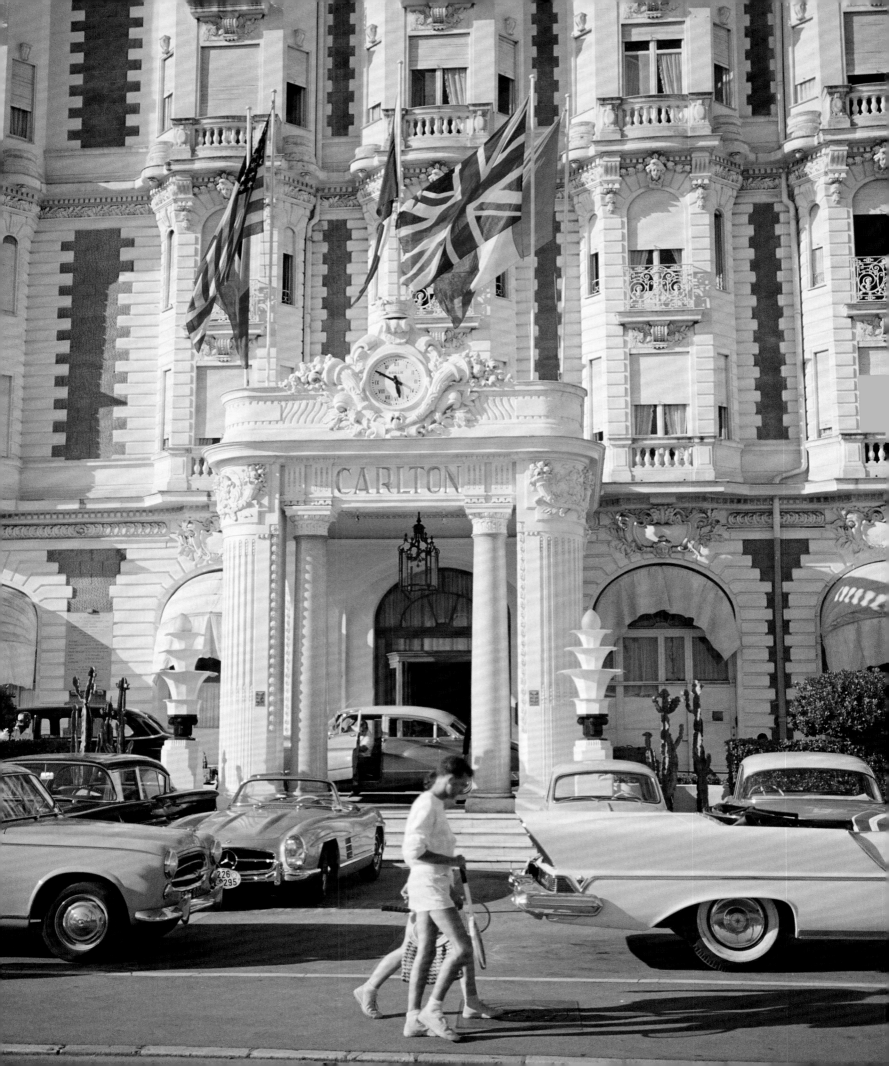

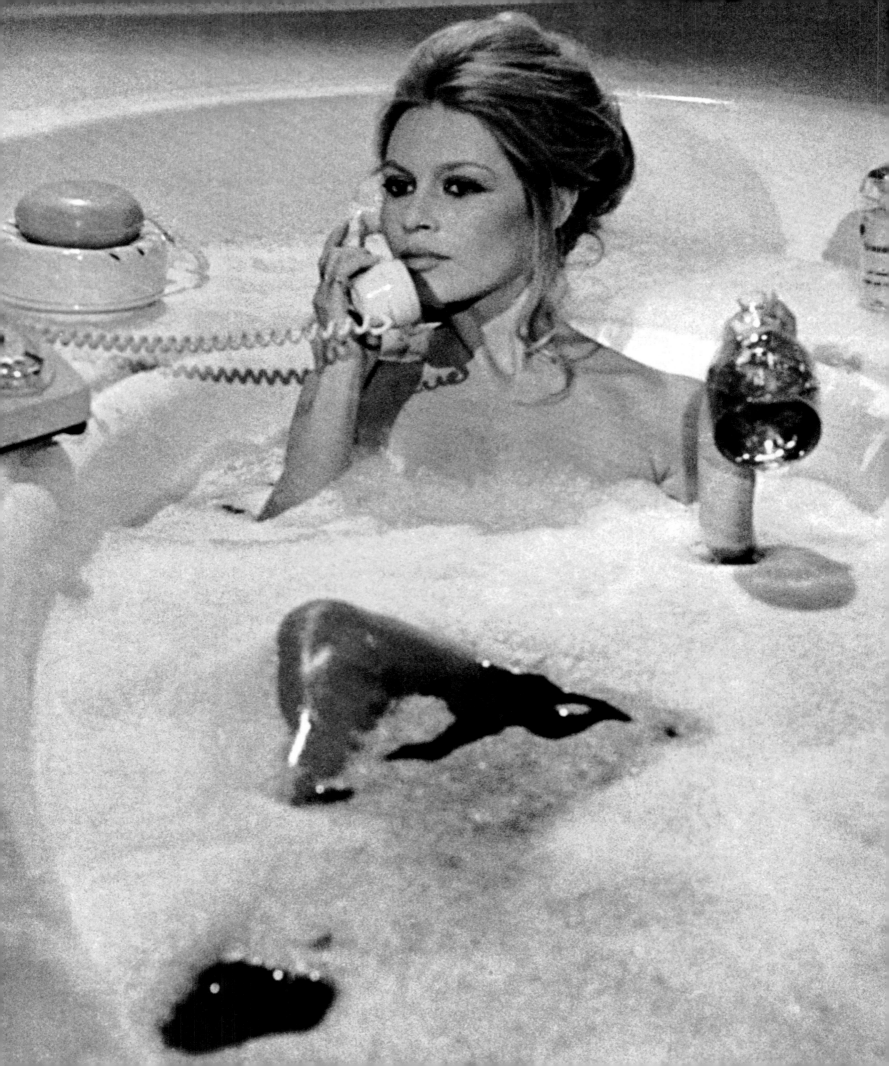

*THE NOVELTY OF A NOM DE PLUME**
the ultimate in incognito

when your sunglasses aren't big enough to hide behind, take a cue from zelda zonk
(aka: marilyn monroe) and leave your top secret alias with the concierge or maitre'd.
on one particular train ride from sydney to perth, we came up with these:

apple addison
peach fredericks
clover jones
ladybug bly
rainy beauregard
sunny caulfield
coco goldenrod

* (1-2) favorite fruit + street where you grew up. (3-4) lucky charm + last name of your favorite adventurer.
(5-6) element of nature + beloved fictional character's last name. (7) favorite design legend + favorite crayon color.

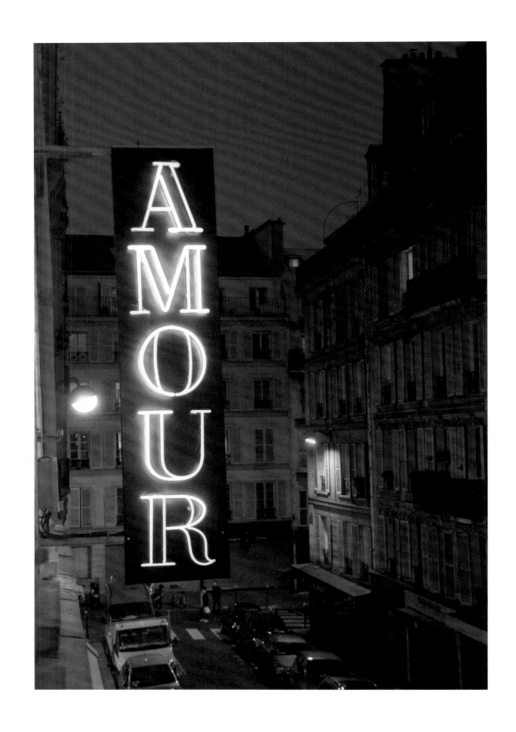

you don't have to spend a million dollars for a million dollar view.
we're quite chuffed with the ones at the hotel amour in paris and the holiday inn in mexico city.

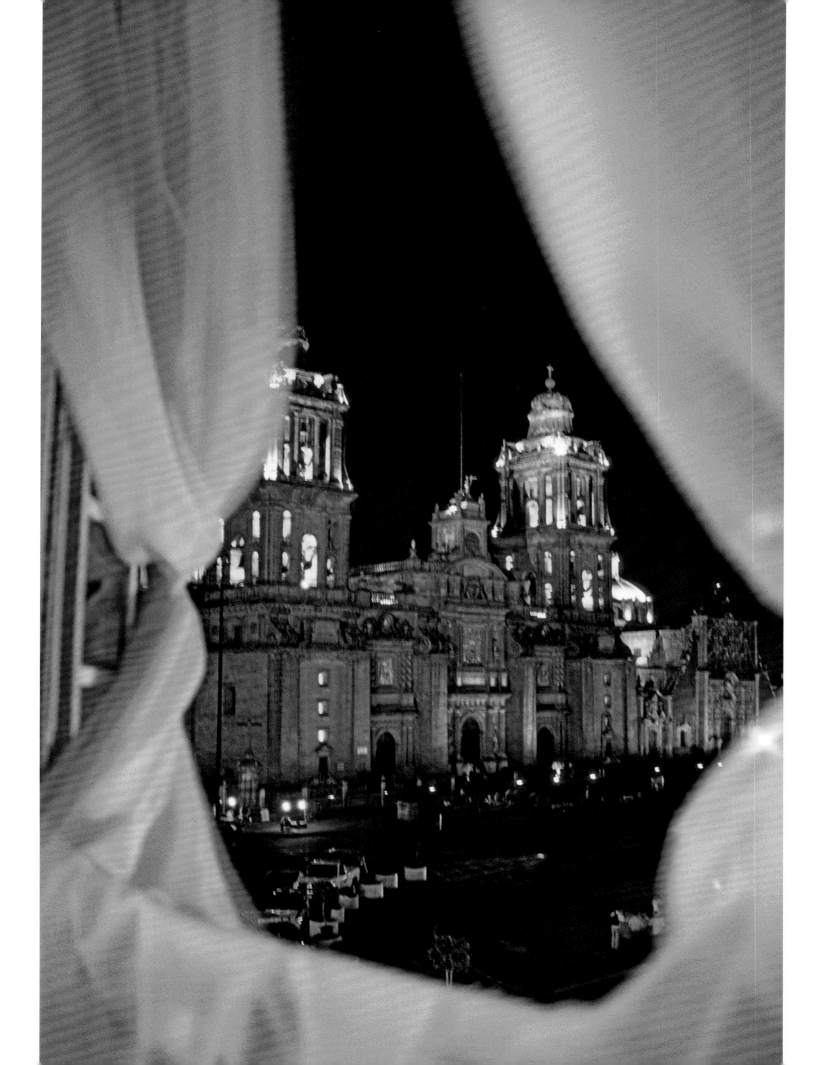

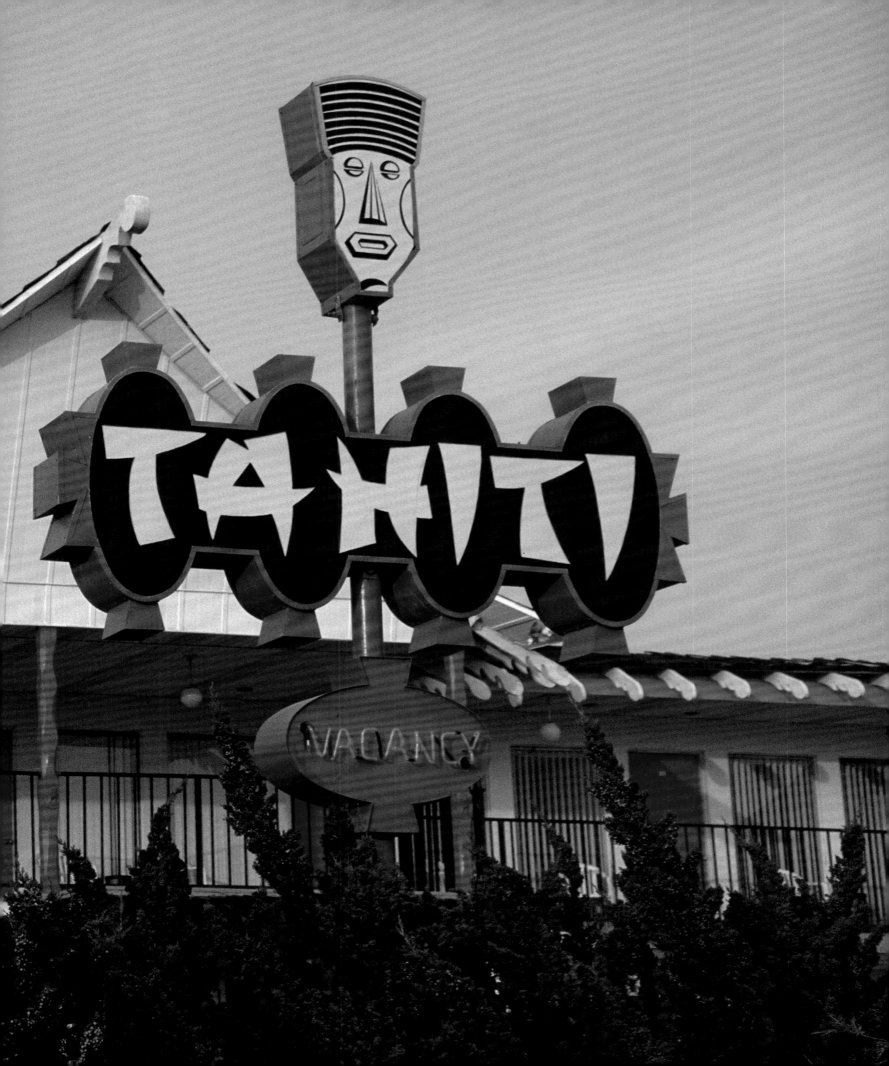

OUR FAVORITE COCKTAILS

and the hotels where they originated

ROB ROY
waldorf hotel, new york, 1894
2 oz. blended scotch, 1 oz. red vermouth,
2 dashes bitters, lemon twist

SINGAPORE SLING
raffles hotel, singapore, 1910–ish
1 ½ oz. gin, ½ oz. cherry heering,
¼ oz. cointreau liqueur, ¼ oz. benedictine,
4 oz. pineapple juice, ½ oz. lime juice,
½ oz. grenadine, 1 dash bitters

HANKY PANKY
savoy hotel, london, 1925
1 ½ oz. gin, 1 ½ oz. sweet vermouth,
2 dashes fernet branca, orange twist

TEQUILA SUNRISE
biltmore hotel, phoenix, late 1930s
1 ¼ oz. tequila, ¾ oz. creme de cassis,
¼ oz. lime juice, sparkling water

BLOODY MARY
st. regis hotel, new york city, 1934
1 oz. vodka, 2 oz. tomato juice,
1 dash lemon juice, 2 dashes salt,
2 dashes black pepper, 2 dashes cayenne pepper,
2 dashes worcestershire sauce, celery stalk

BLUE HAWAII
hilton hawaiian village, waikiki, 1957
¾ oz. light rum, ¾ oz. vodka,
½ oz. curacao, 3 oz. pineapple juice,
1 oz. sweet and sour mix,
a pineapple wedge, paper umbrella

NOW, HOW TO ORIGINATE YOUR OWN
if you've yet to make the honesty bar's acquaintance, allow us: this unattended beverage
oasis found in some boutique european hotels is where you can fix yourself a drink, much like you
would at home, but with professional accoutrements. a vodka tonic with a cherry, slice of lemon
and a swirly straw? no problem. just don't forget to tally your tipple(s) in the ledger.

SUITE 9
palazzo margherita
bernalda, italy

TIEPOLO SUITE
aman canal grande
venice, italy

ROOM 82
soho house berlin
berlin, germany

AQUA STRIPE AIRSTREAM
kate's lazy desert
landers, california

"room service? send up a larger room." — GROUCHO MARX

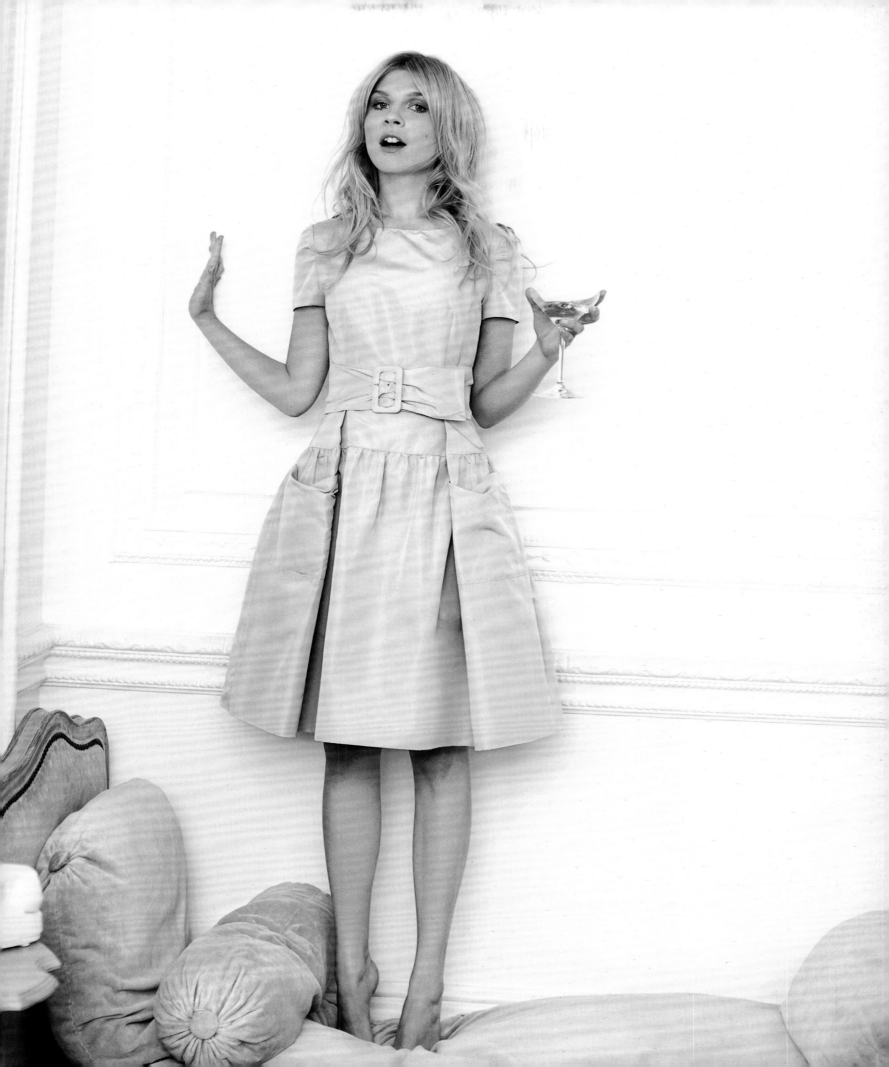

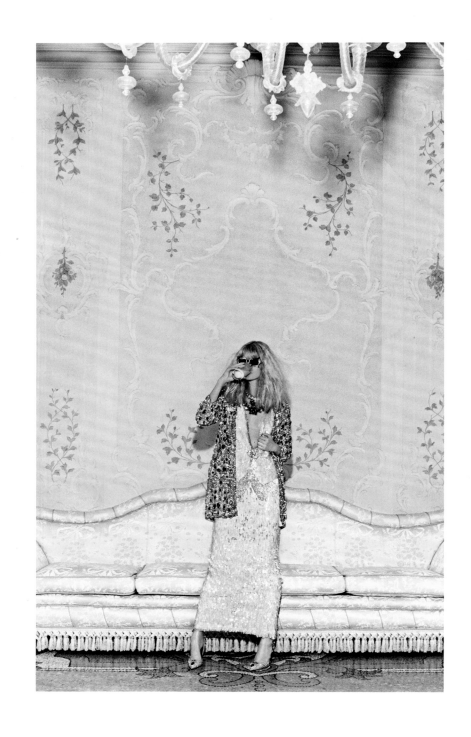

IF THESE WALLS COULD TALK
bauer il palazzo, venice (above). "pineapple" by studio printworks, sofitel sydney wentworth, sydney.
"zebras" by scalamandré, hotel montevideo, montevideo. "lotus" by farrow & ball, hôtel thoumieux, paris.
"brazillance" by carlton carney, the greenbrier, west virginia (opposite).

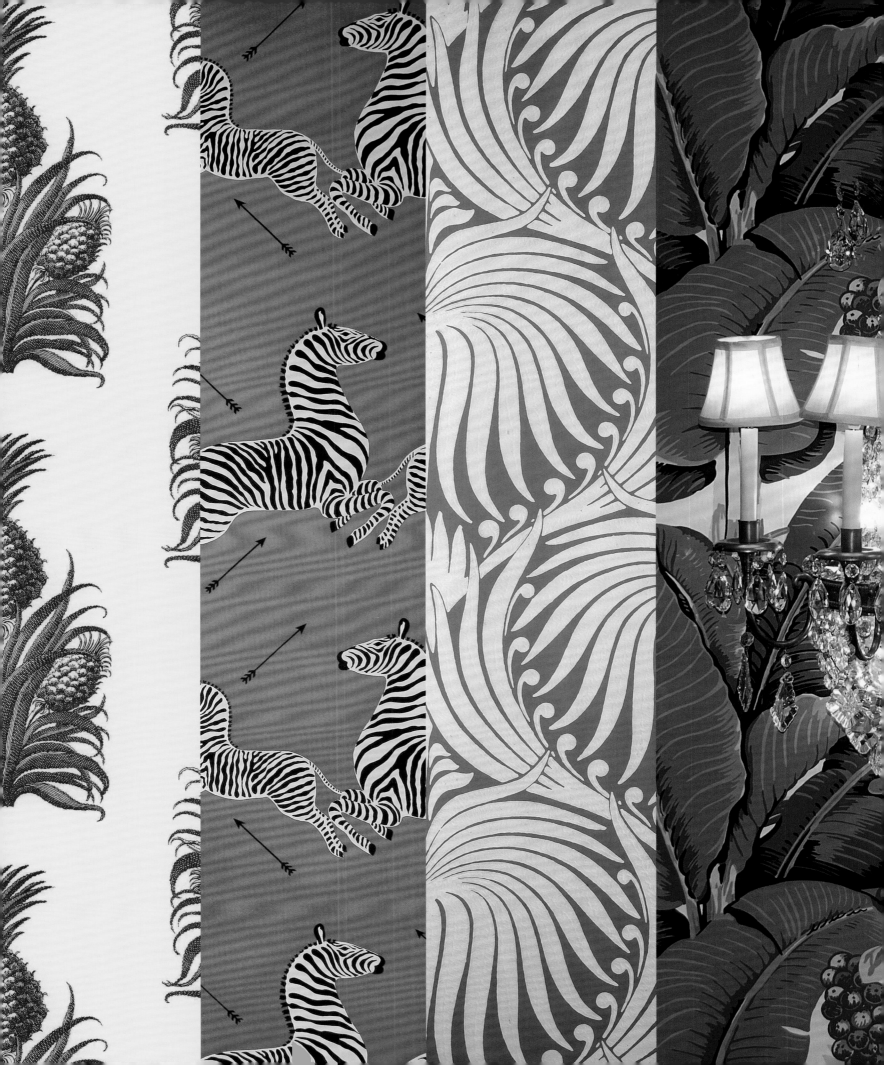

take a leaf from artist michael mcconnell's book.

draw on the stationery found in hotel drawers.

why don't you...stay in a hotel in the middle of the ocean...
watch the northern lights through the ceiling of your igloo...wake up in a treehouse...
kick up your boots in a vintage airstream...escape the desert heat by sleeping in a (restored) cave...
get cozy in an ice hotel...take in the views from henry VIII's royal palace...
become a resident in art and check into an art gallery...keep watch in a historic lookout tower...

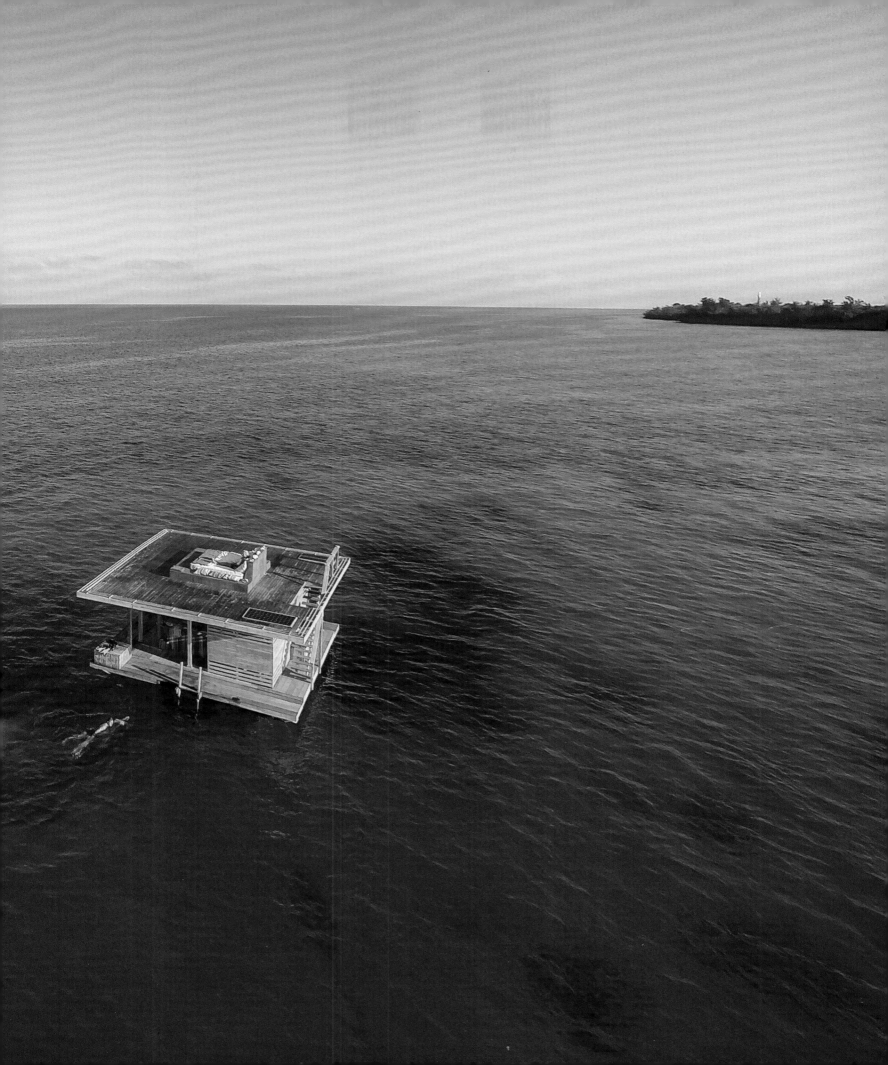

GETTING LOST IS ALWAYS A GOOD IDEA

in greek the word planet means wanderer, or, more poetically,
wandering star. with that in mind, we treat travel itineraries as friendly
suggestions: less like to-do's and more like to-see-if-we-are-in-the-mood's.
who's to predict what might catch our eye, or know where a little side street
might take us? knowing our options and then doing whatever we fancy
when we fancy it. we call it inspired wandering. give it a go.

ridges and furrows; the croquet balls were live hedgehogs, and the mallets live flamingos, and the soldiers had to double themselves up and stand on their hands and feet, to make the arches.

The chief difficulty Alice found at first was in managing her flamingo; she succeeded in getting its body tucked away, comfortably enough, under her arm, with its legs hanging down, but generally, just as she had got its neck nicely straightened out, and was going to give the hedgehog a blow with its head, it *would* twist itself round and look up into her face with such a puzzled expression that she could not help bursting out laughing; and when she had got its head down, and was going to begin again, it was very provoking to find that the hedgehog had unrolled itself, and was in the act of crawling away; besides all this, there was generally a ridge or furrow in the way wherever she wanted to send the hedgehog to, and, as the doubled-up soldiers were always getting up and walking off to other parts of the ground, Alice soon came to the conclusion that it was a very difficult game indeed.

The players all played at once, without waiting for turns, quarreling all the while, and fighting for the hedgehogs; and in a very short time the Queen was in a furious passion, and went stamping about, and shouting, "Off with his head!" or "Off with her head!" about once in a minute.

Alice began to feel very uneasy; to be sure, she had not as yet had any dispute with the Queen, but she knew that it might happen any minute, "and then," thought she, "what would become of me? They're dreadfully fond of beheading people here; the great wonder is, that there's anyone left alive!"

She was looking about for some way of escape and wondering whether she could get away without being seen, when she noticed a curious appearance in the air; it puzzled her very much at first, but after watching it a minute or two she made it out to be a grin, and she said to herself, "It's the Cheshire Cat; now I shall have somebody to talk to."

"How are you getting on?" said the Cat, as soon as there was mouth enough for it to speak with.

Alice waited till the eyes appeared, and then nodded. "It's no use speaking to it," she thought, "till its ears have come, or at least one of them." In another minute the whole head appeared, and then Alice put down her flamingo, and began an account of the game, feeling very glad she had someone to listen to her. The Cat seemed to think that there was enough of it now in sight, and no more of it appeared.

"I don't think they play at all fairly," Alice began, in rather a complaining tone, "and they all quarrel so dreadfully one can't hear one's self speak—and they don't seem to have any rules in particular; at least, if there are, nobody attends to them—and you've no idea how confusing it is all the things being alive; for instance, there's the arch I've got to go through next, walking about at the other end of the ground—and I should have croqueted the Queen's hedgehog just now, only it ran away when it saw mine coming!"

"How do you like the Queen?" said the Cat in a low voice.

"Not at all," said Alice; "she's so extremely—" Just then she noticed that the Queen

54

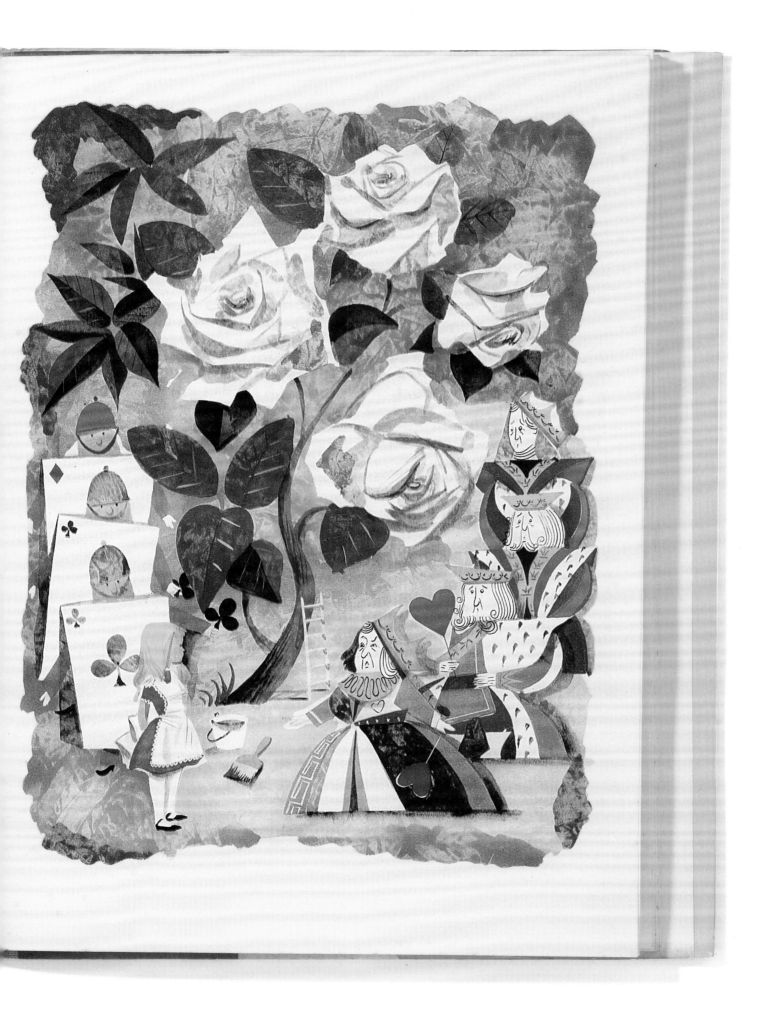

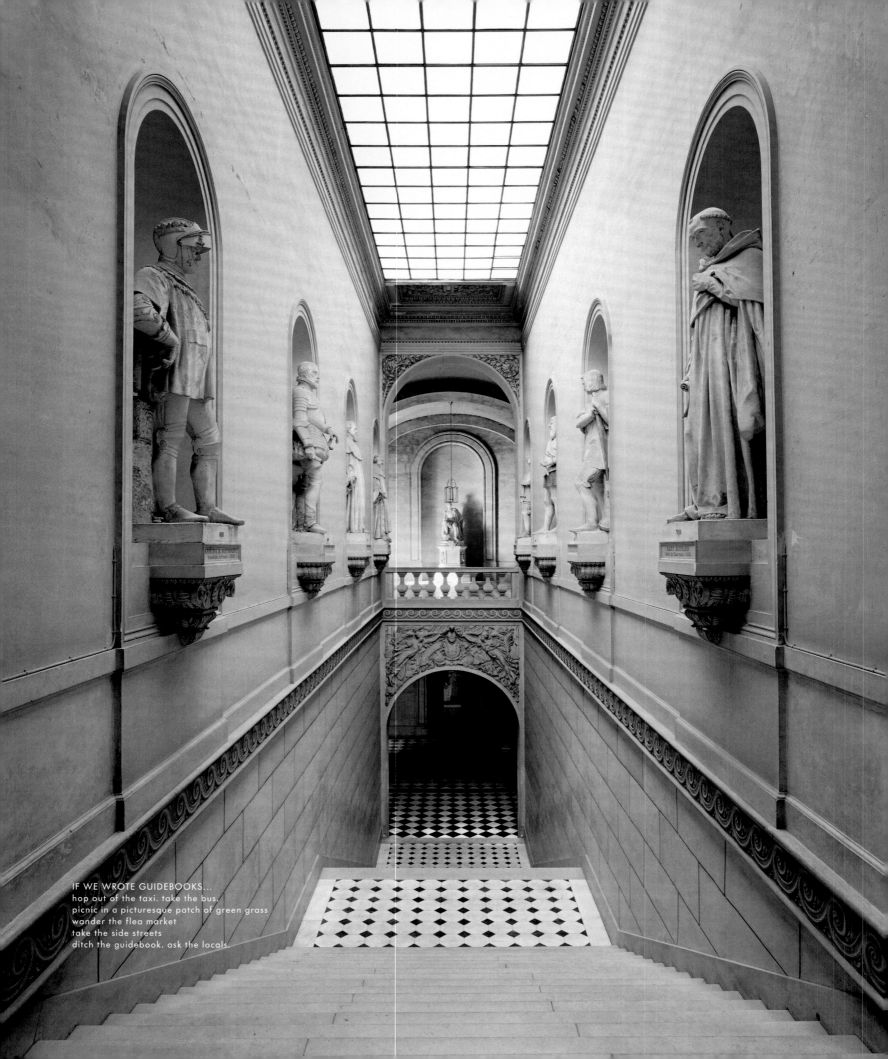

IF WE WROTE GUIDEBOOKS...
hop out of the taxi. take the bus.
picnic in a picturesque patch of green grass
wander the flea market
take the side streets
ditch the guidebook. ask the locals.

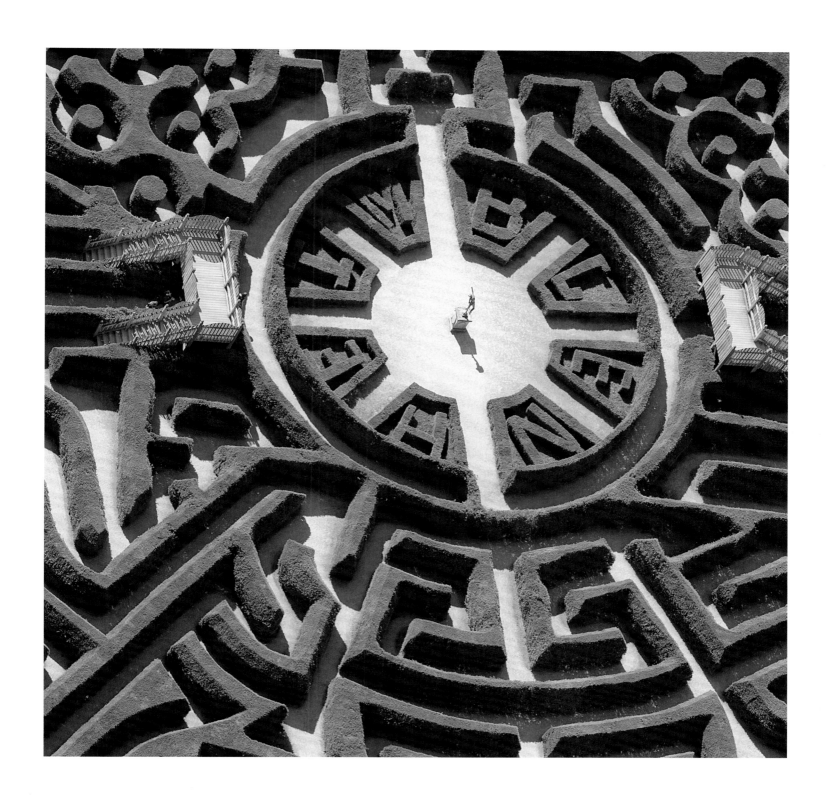

"the greatest secrets are always hidden in the most unlikely places." — ROALD DAHL

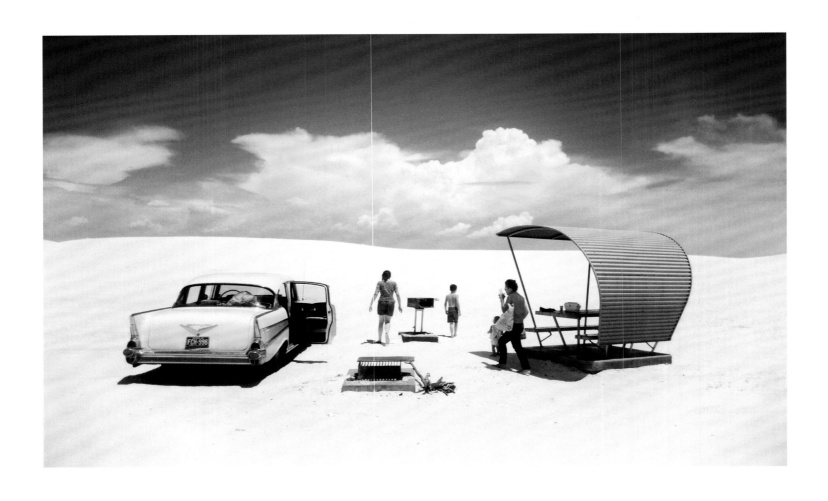

"nothing behind me, everything ahead of me, as is ever so on the road." — JACK KEROUAC

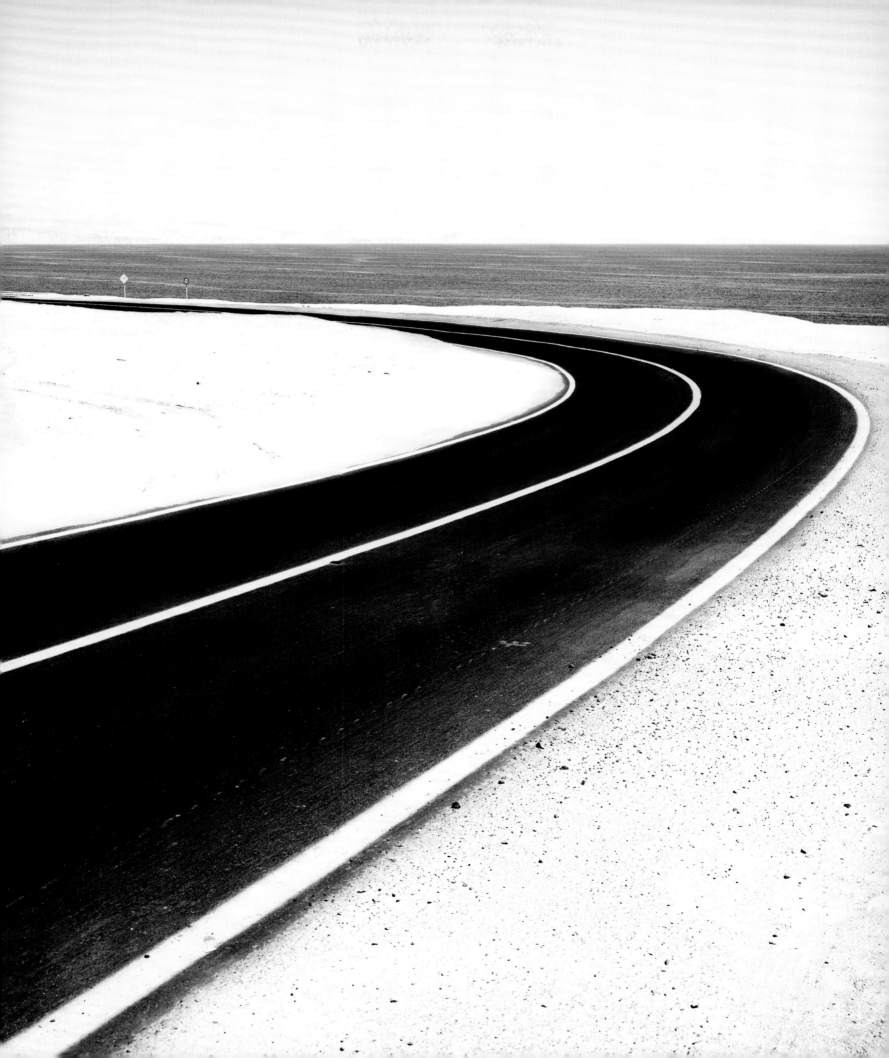

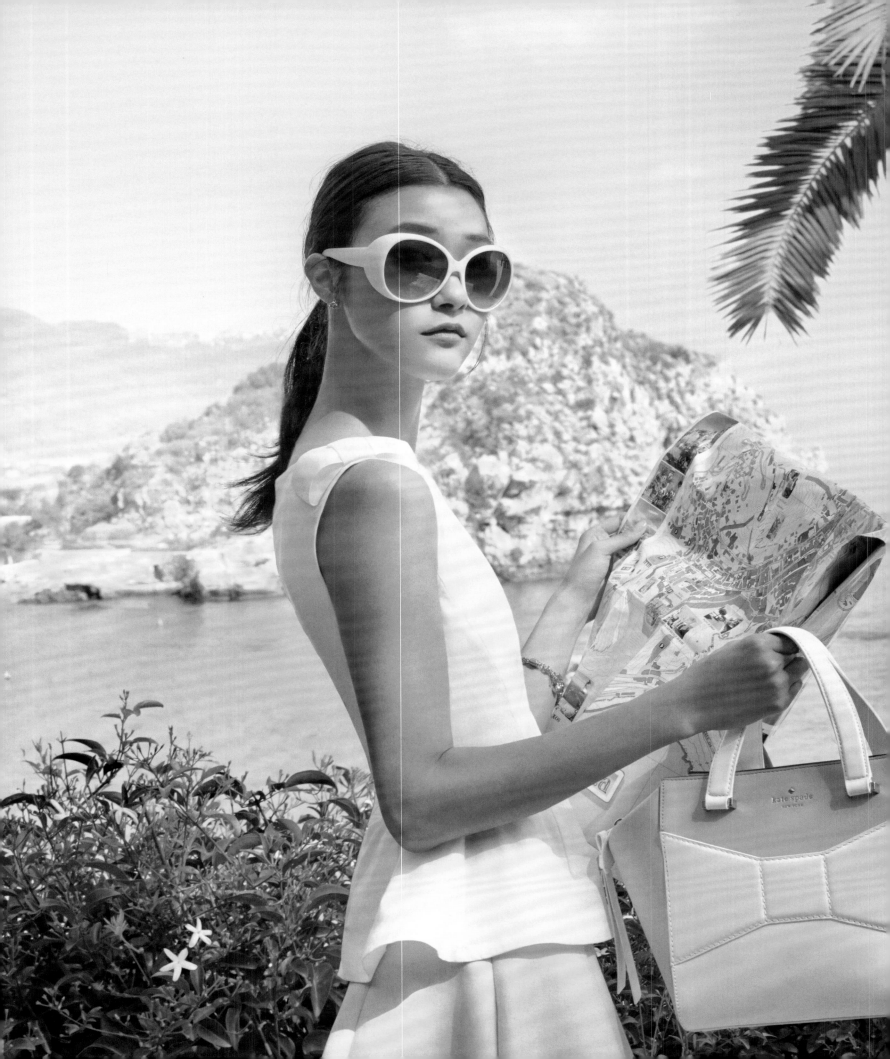

"WHICH WAY TO THE MARKET?"

"go straight."

"go left."

"no, take the second right."

"so far! you will walk?"

"see that lemon tree? four roads after."

"it's closed today."

— october 22, 2013, while shooting our spring 2014 campaign in italy. (we eventually found it, and it was open.)

she keep
on the grou
head in t

s her feet
nd and her
ne clouds.

cover a lot of ground.

"IF YOU DO
NOTHING
UNEXPECTED,
NOTHING
UNEXPECTED
HAPPENS."

— *fay weldon*

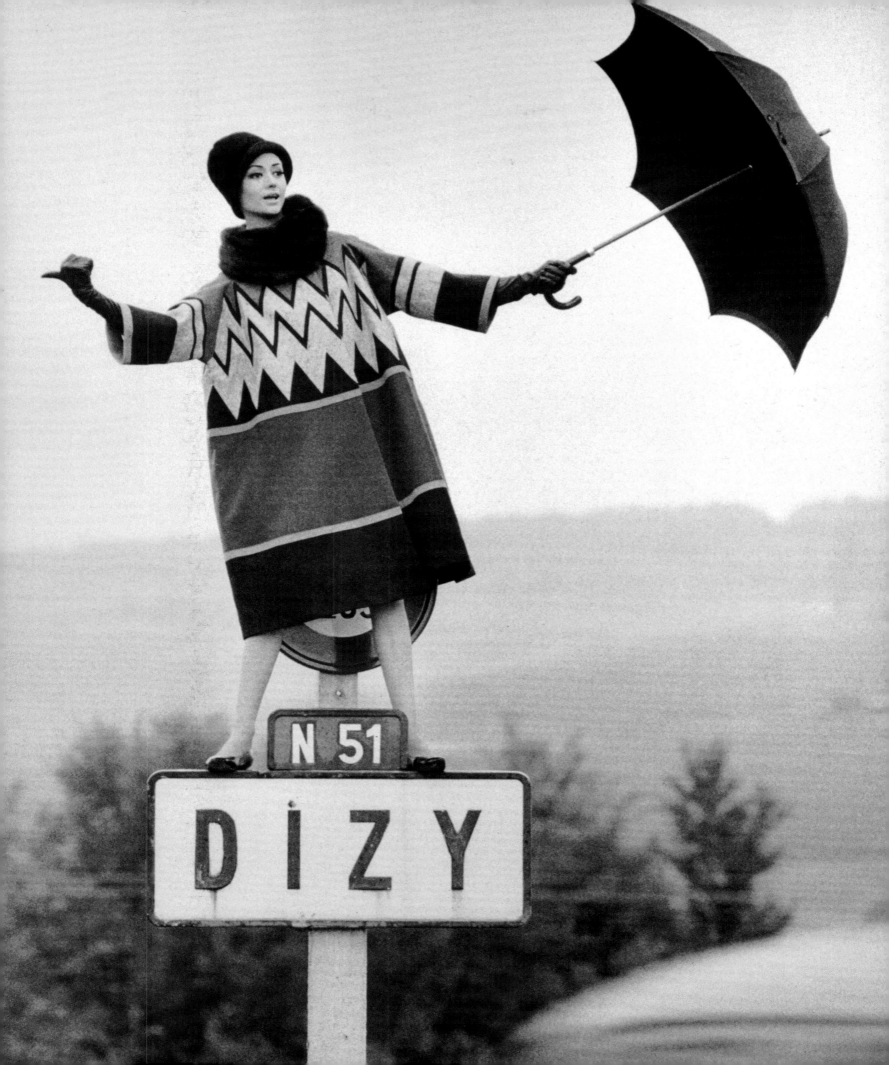

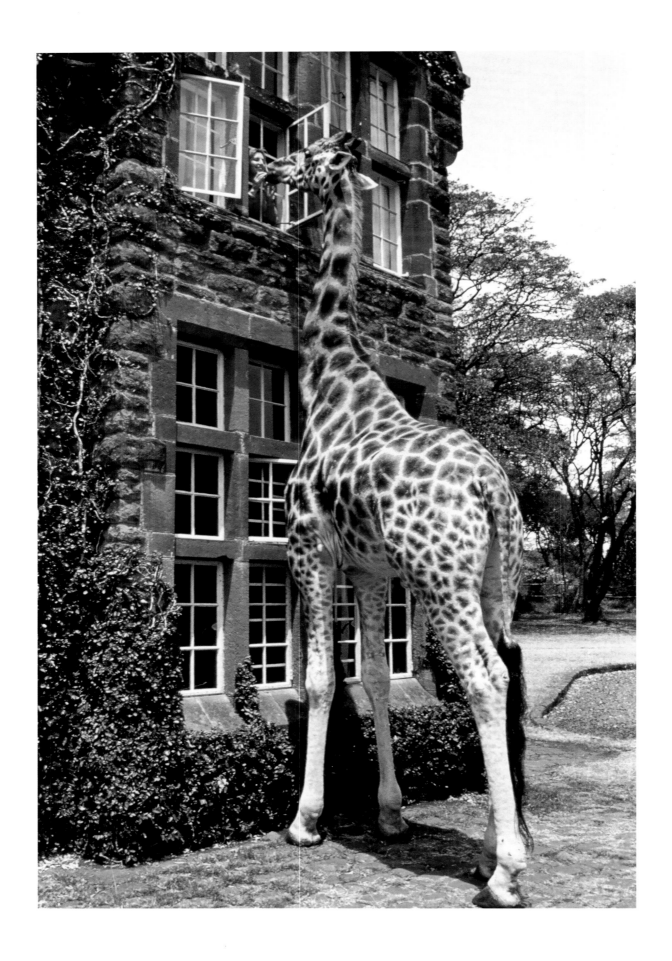

FANTASY WORLD TOUR

renting the pink convertible, las vegas
adding to the hotel robe collection, positano
refreshing lemon aid, capri
borrowing the neighbors' roses, nantucket
awaiting the return of the serve, silver lake
going for the art, staying for the gift shop, bilbao
impulse pottery buy, istanbul
the restorative powers of spaghetti, milan
sneaking into the opera and sneaking back out, sydney
lost in venice, *again*
napping between the wolseley and le voltaire, the eurostar
fancy dinner in flip flops, venice beach
hot chocolate and handbags, zurich
stocking up on winter woolies, oslo
a sudden interest in gardening, ritsurin koen
piazza-hopping, rome
backseat driver, the autobahn
feeding the giraffes, nairobi

"*instead of bringing back 1600 plants, we might return from our journeys with a collection of small unfêted but life-enhancing thoughts.*"
although, ALAIN DE BOTTON, we might also return with a sprig of wisteria from hermannshof weinheim in germany, too.

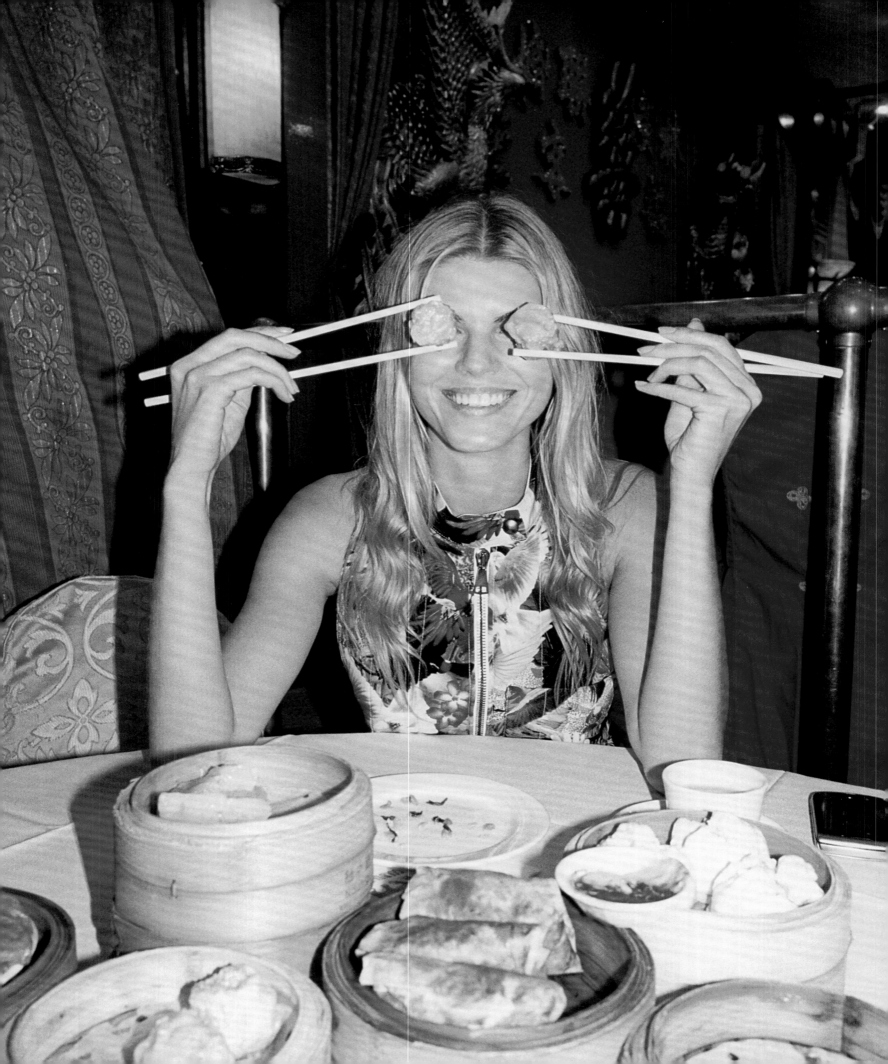

NǏ HǍO! ¡HOLA! CIAO! HELLO!

*you won't find us looking for a cobb salad in macchu pichu—or anywhere
else but at home. not when there are fish and chips to savor in brighton and
we can start the day with a piping hot chai in jaipur. we order another
round because where there is food and drink there are interesting people, rambling
conversations, and impromptu dancing to kick up our heels to. it all clicks
the moment that we let go of the why and embrace the why not.*

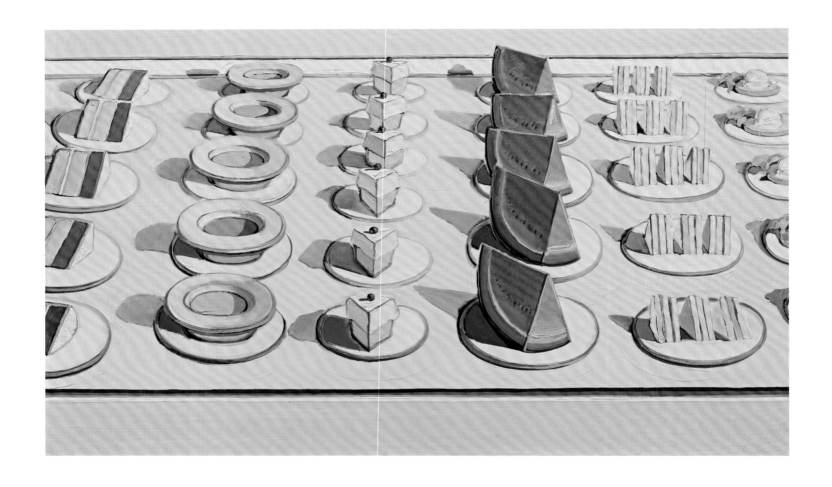

WHEN IN ROME, EAT PIZZA. WHEN EVERYWHERE ELSE...
in *mexico*, order *tacos al pastor* from a street vendor. in *sweden*, sample the *glasmastarsill* (otherwise known
as pickled herring). in *china*, make some *jiāozi* (dumplings). in *spain*, pop a *croquette*. while in morocco,
bite into a *spicy sardine*. the *philippines* is where to get *sorbetero* (it's ice cream. try cheddar cheese. trust us on that.).
don't leave *england* without sampling a *scotch egg*. in *belgium*, don't let a day go by without a *waffle*.

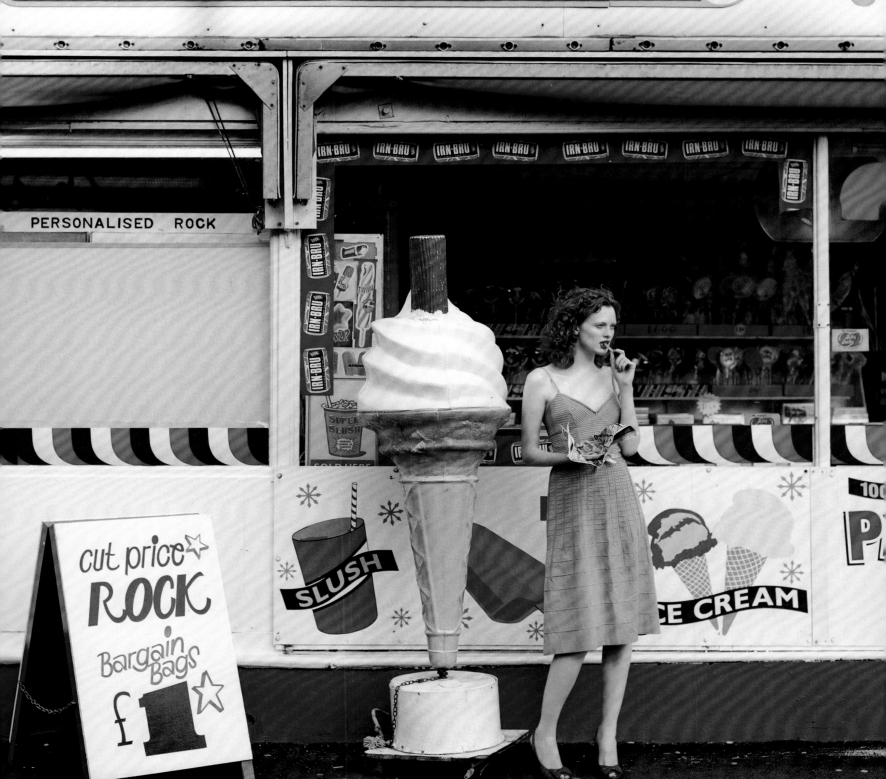

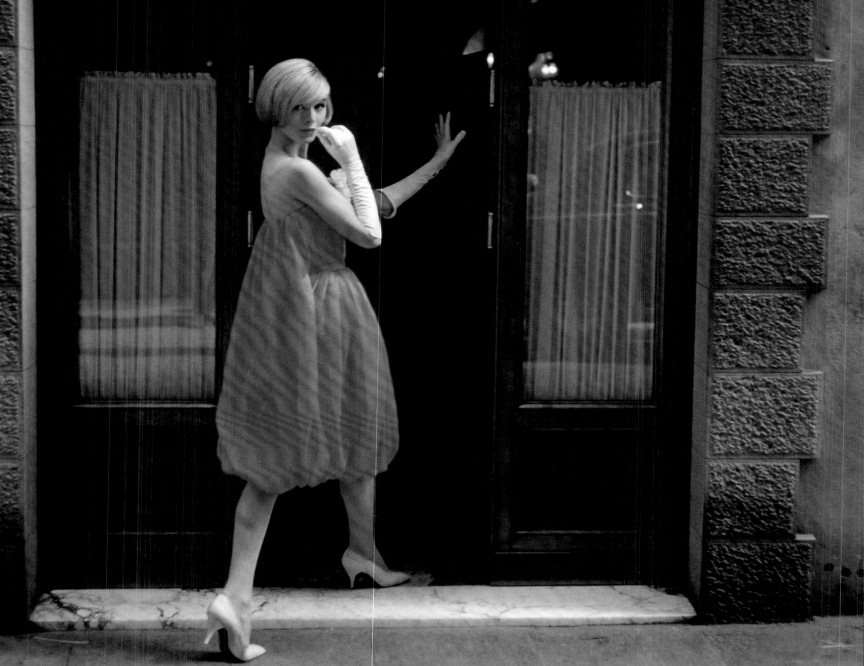

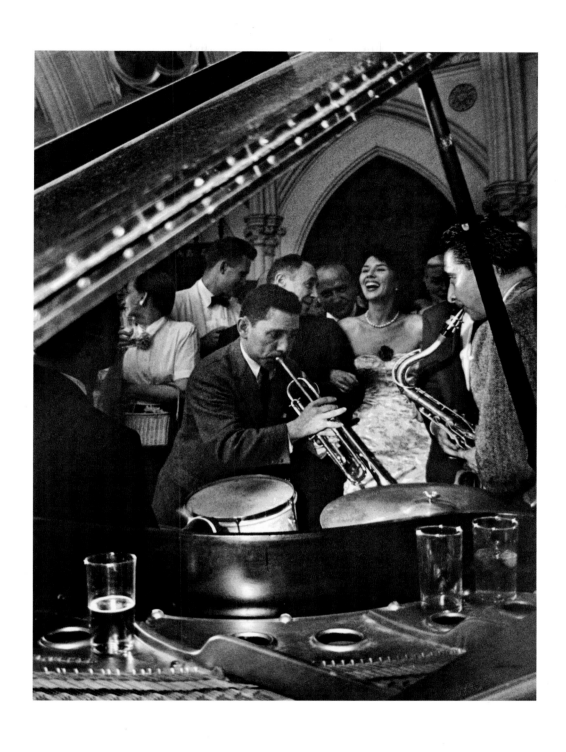

"*i never lose sight of the fact that just being is fun.*" — KATHARINE HEPBURN

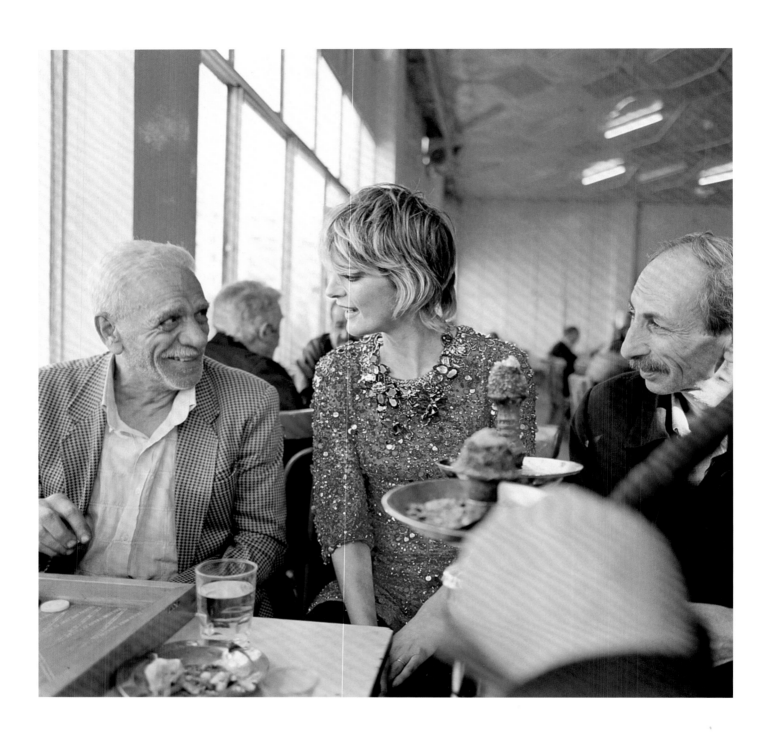

"but i always say, one's company, two's a crowd, and three's a party." —ANDY WARHOL

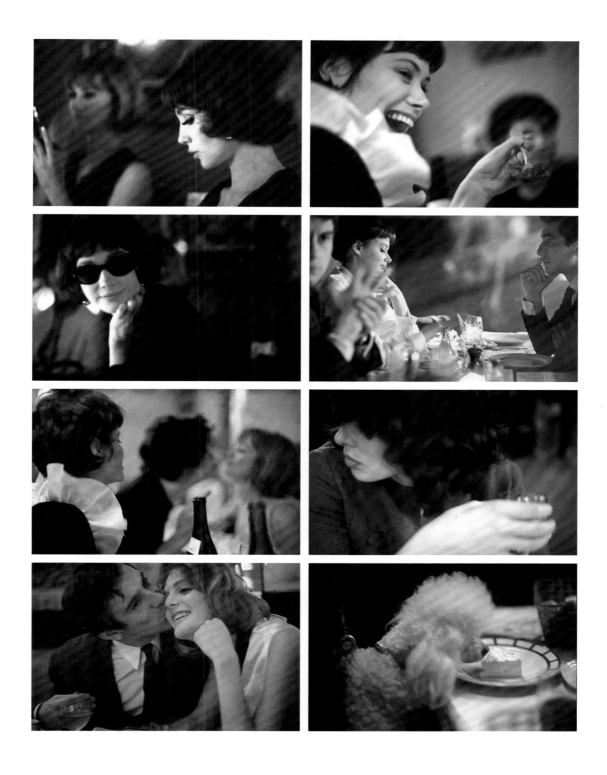

CAFE SOCIETY
the parisian neighborhood, les halles, may no longer exist exactly as it did the week fashion
photographer TOM PALUMBO took these candid snapshots in 1962, but the feeling of *joie de vivre* still does.

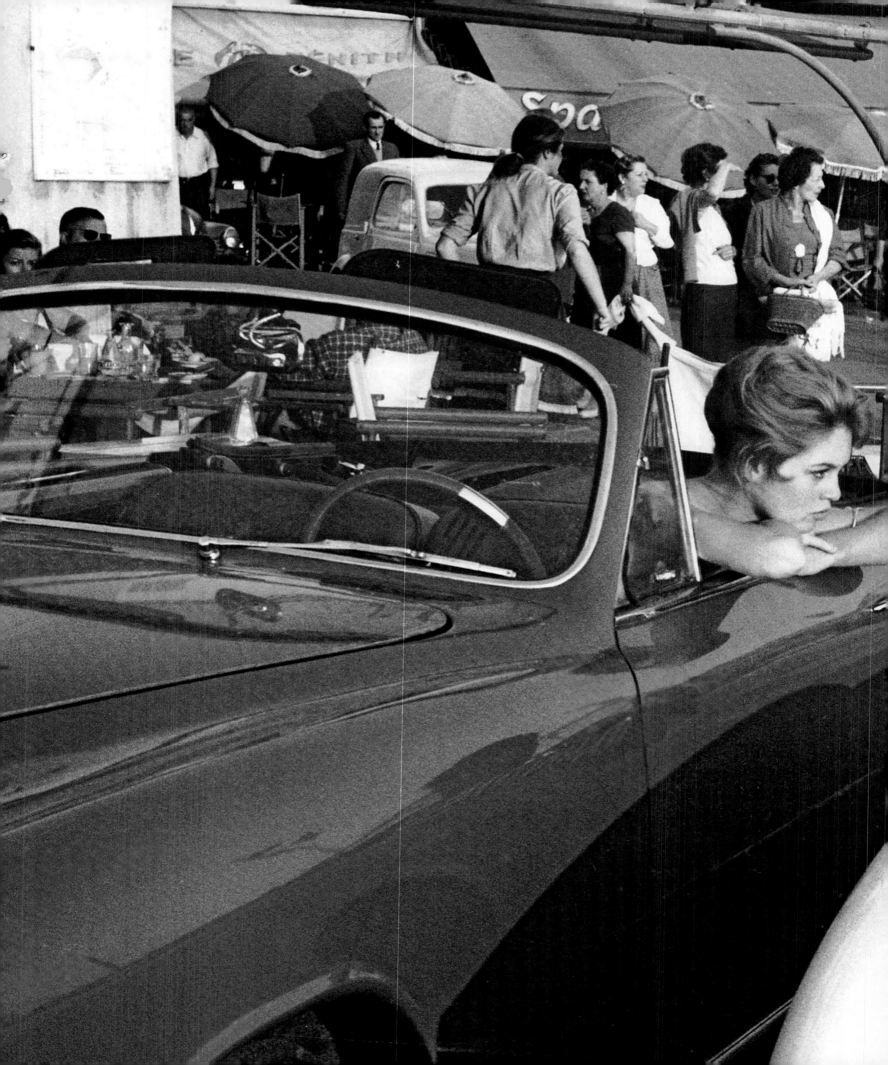

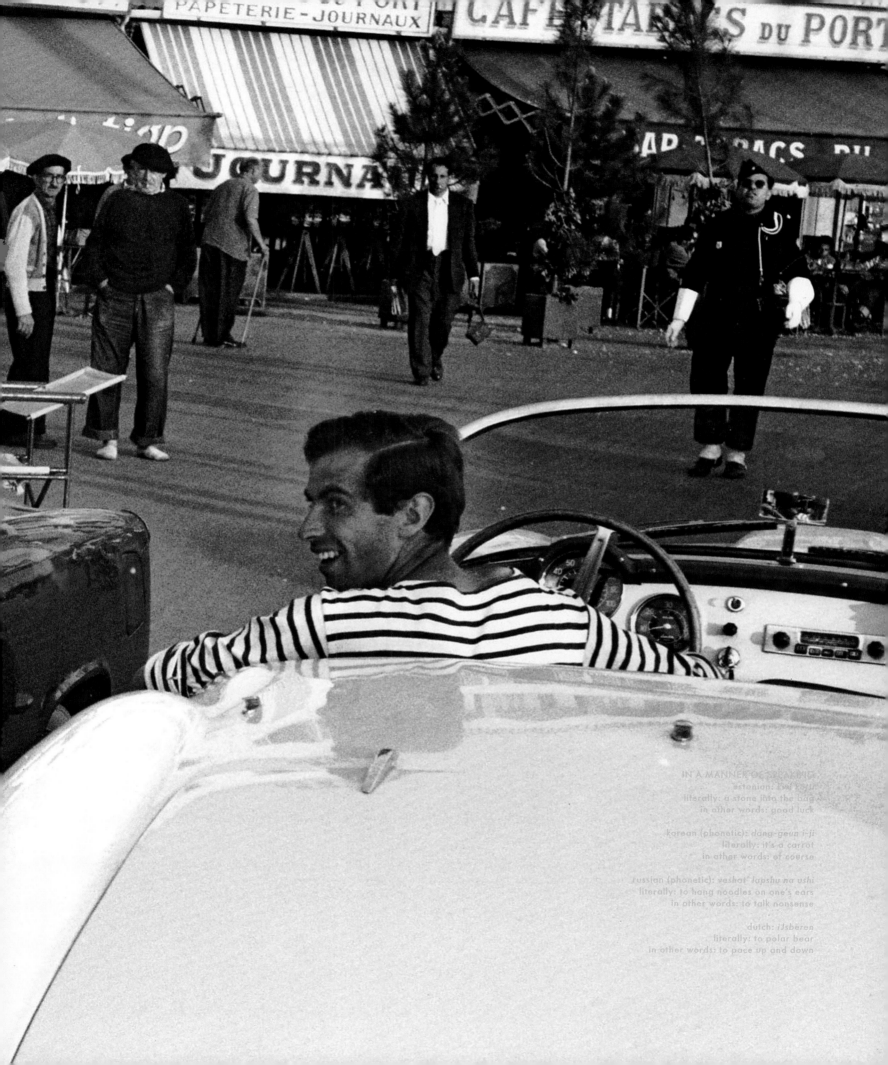

IN A MANNER OF SPEAKING
estonian: kivi kotti
literally: a stone into the bag
in other words: good luck

korean (phonetic): dang-geun i-ji
literally: it's a carrot
in other words: of course

russian (phonetic): veshat' lapshu na ushi
literally: to hang noodles on one's ears
in other words: to talk nonsense

dutch: ijsberen
literally: to polar bear
in other words: to pace up and down

"ever notice how "what the hell" is always the right answer?" — MARILYN MONROE

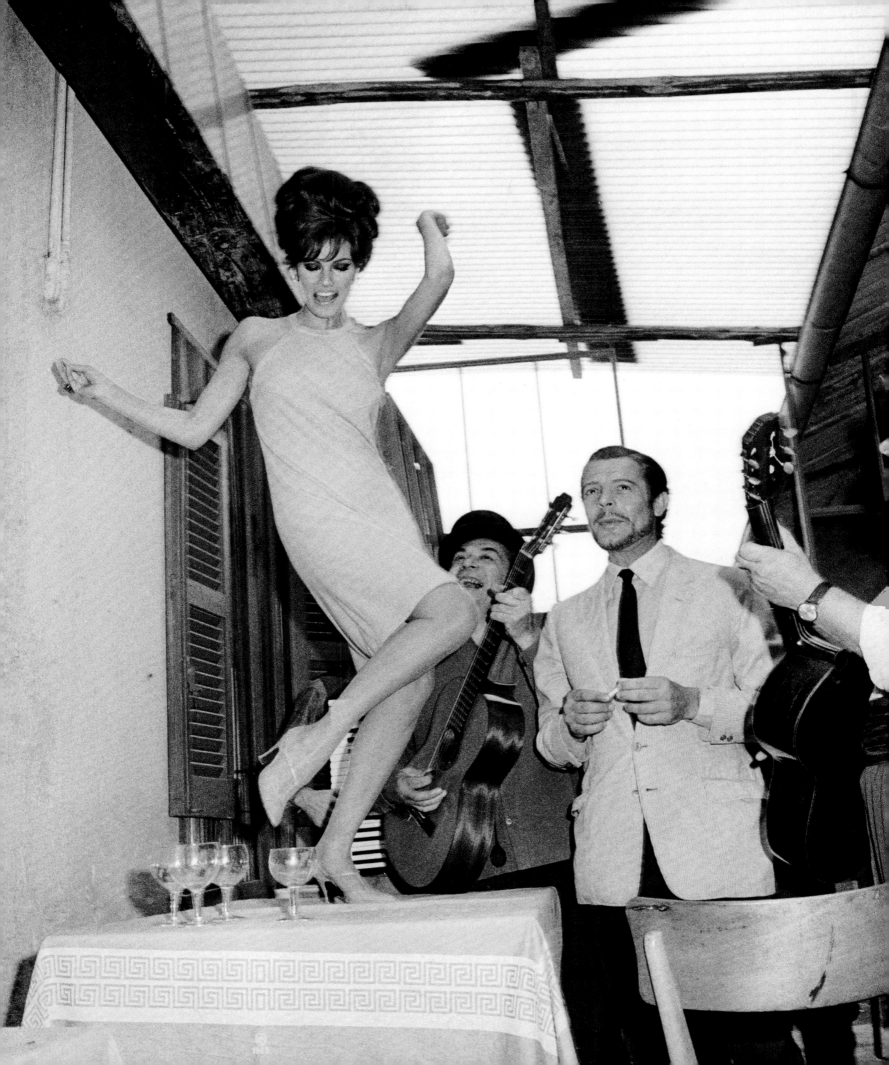

ams of
nters and
f lime.

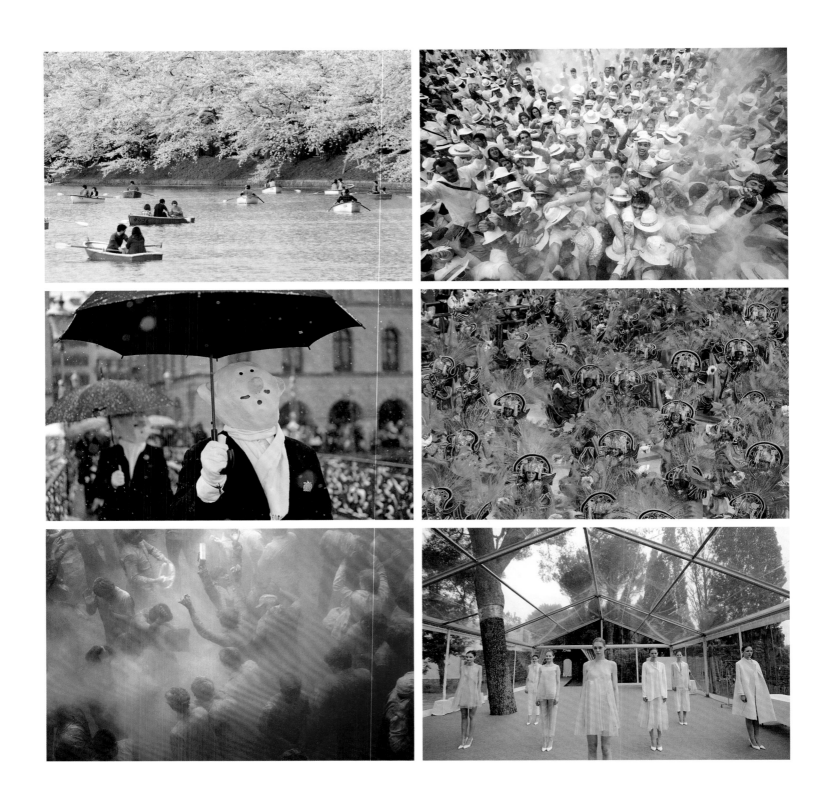

NO MATTER WHERE WE GO, ONE THING IS FOR CERTAIN...
clockwise from top left: cherry blossom festival, japan. los indianos carnival, las palma, spain. carnival, rio de janeiro, brazil.
hyeres festival, hyeres, france. holi festival, india. basler fasnacht, lucerne, switzerland.

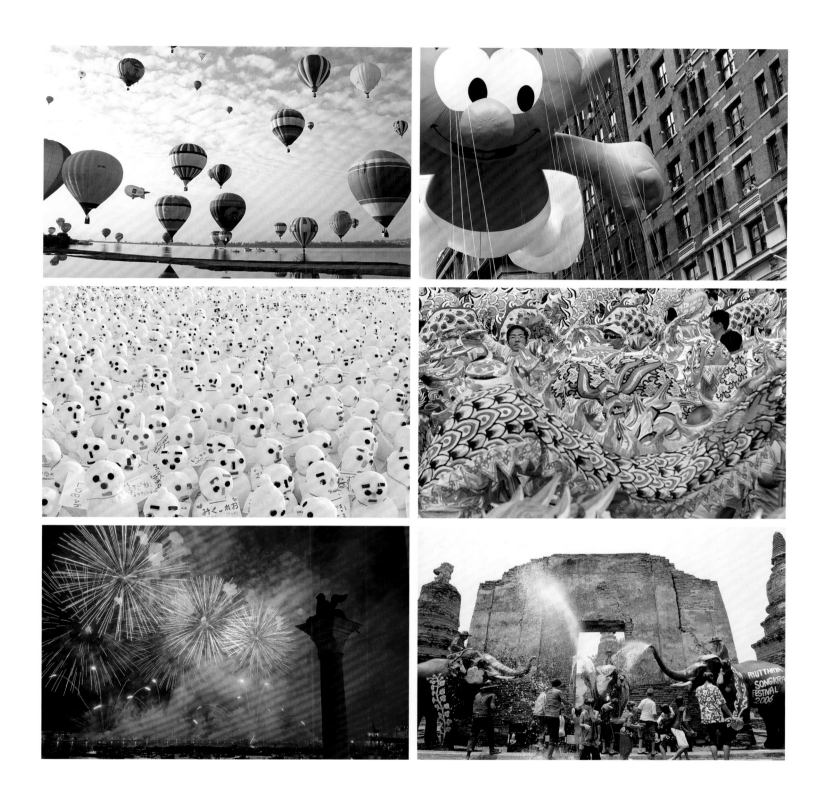

...EVERYONE LOVES A GOOD PARTY
clockwise from top left: international balloon festival, leon guanajuato, mexico. thanksgiving day parade, new york city, united states. chinese new year, china. songkran water festival, thailand. redentore festival, venice, italy. sapporo snow festival, japan.

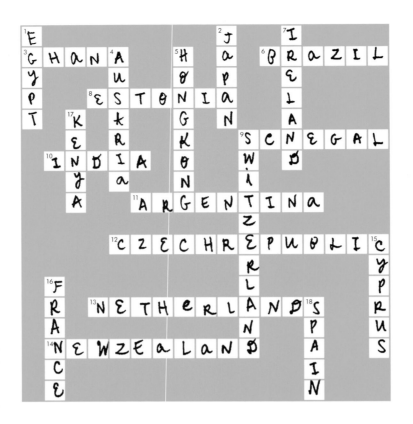

READING BETWEEN THE LINES
we're so glad not everything is global. but sometimes the
differences in local etiquette can have us at sixes and sevens. (letitia baldrige,
the white house social secretary during the kennedy administration,
once recalled nearly sending the kennedys on a trip to india with
leather-framed photos to give as gifts, not realizing that cows are sacred there.)
here's how others do things differently.

ACROSS
3. ask before you take a photo.
6. all the single ladies: greet people with a triple cheek kiss.
8. stand up when saying hello to someone.
9. indirectness is polite.
10. only sit down for a meal when told by the host where to sit.
11. showing up on time is considered rude: 30 to 60 minutes late is great.
12. say "*dobrý den*" ("good day") to everyone. really, everyone.
13. here, "going dutch" is called "going american."
14. it's "how do you do?" instead of "hello."

DOWN
1. present gifts with your right hand, not your left.
2. lightly slurp your soup if it's delicious.
4. to compliment the chef, cut your food with the side of your fork instead of your knife.
5. whole fish are served to symbolize abundance—but turn the fish over to reach for another
bite and your friends may think you're out to capsize the boat.
7. don't depart for the evening before buying a "round" of drinks for those in your group.
9. think twice about pointing your index finger to your head. (it's considered an insult.)
15. a gift of pastries will make your hostess swoon.
16. the only acceptable thing to eat with your fingers is a piece of bread.
17. it's impolite to eat and drink at the same time.
18. tipping isn't common, but for good service leave 5-10%.

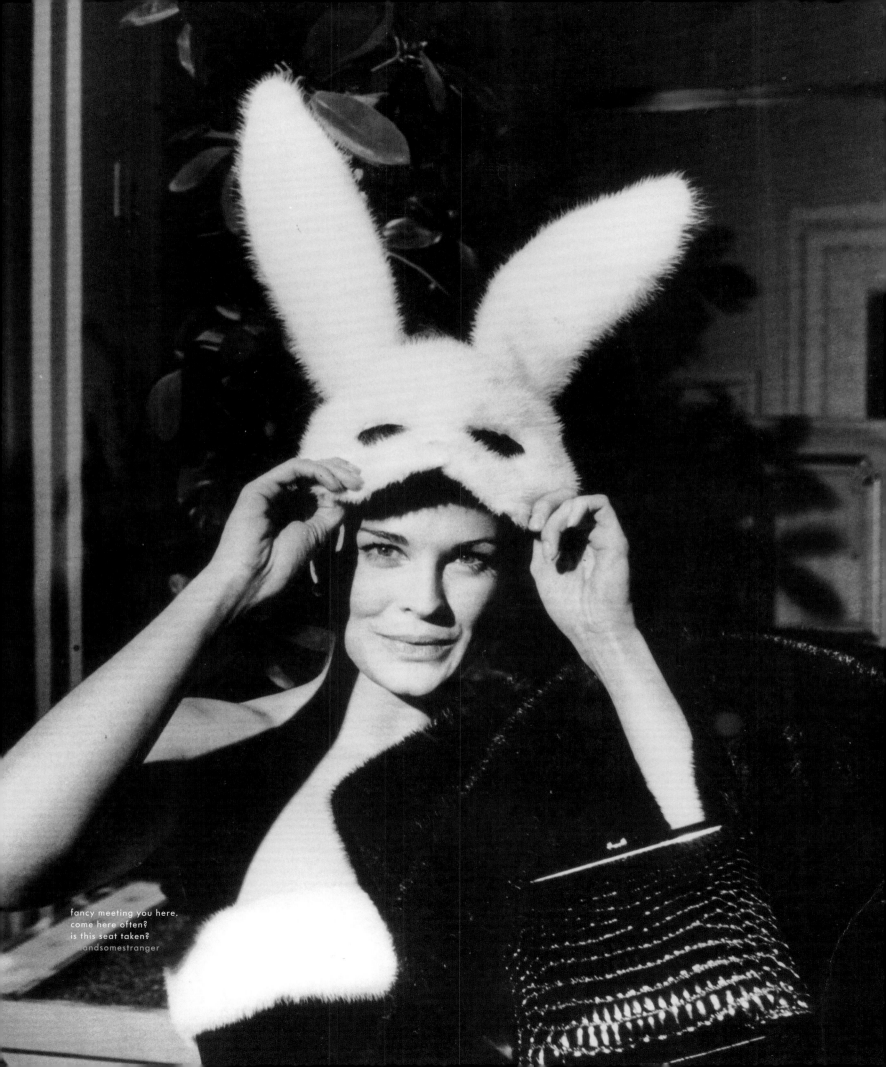

fancy meeting you here.
come here often?
is this seat taken?
andsomestranger

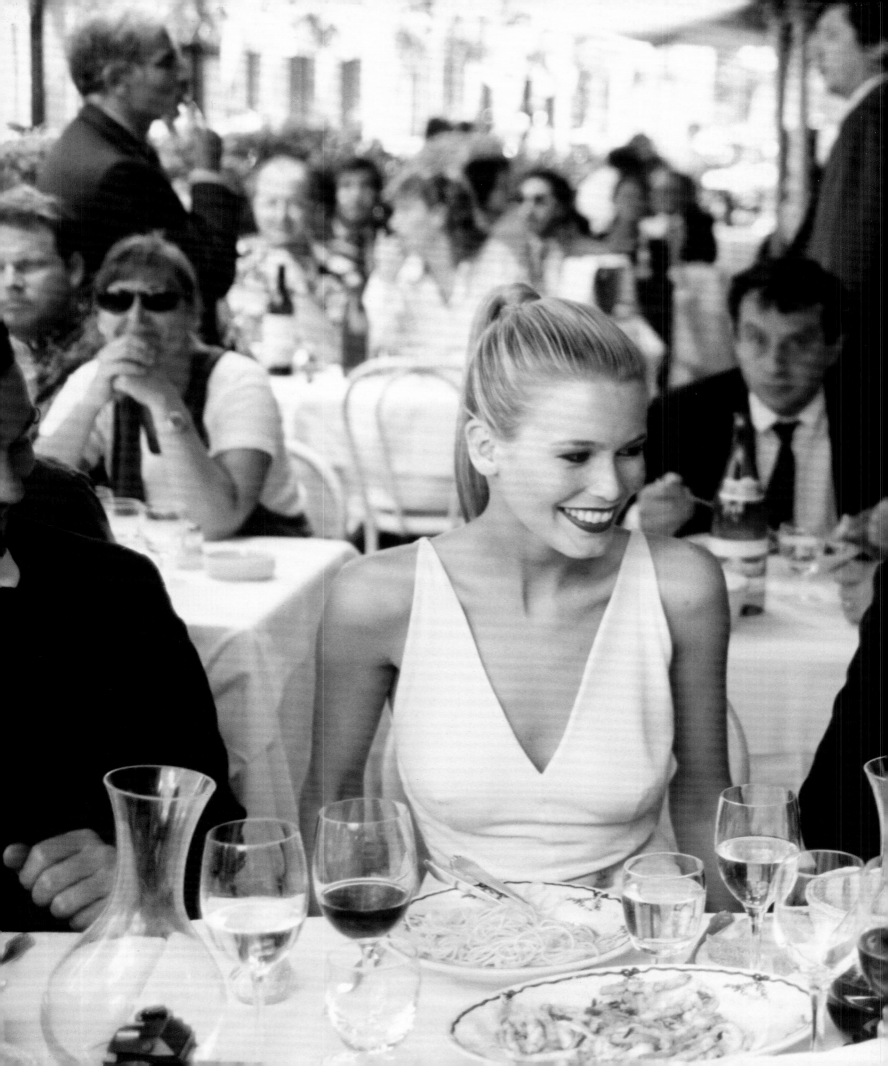

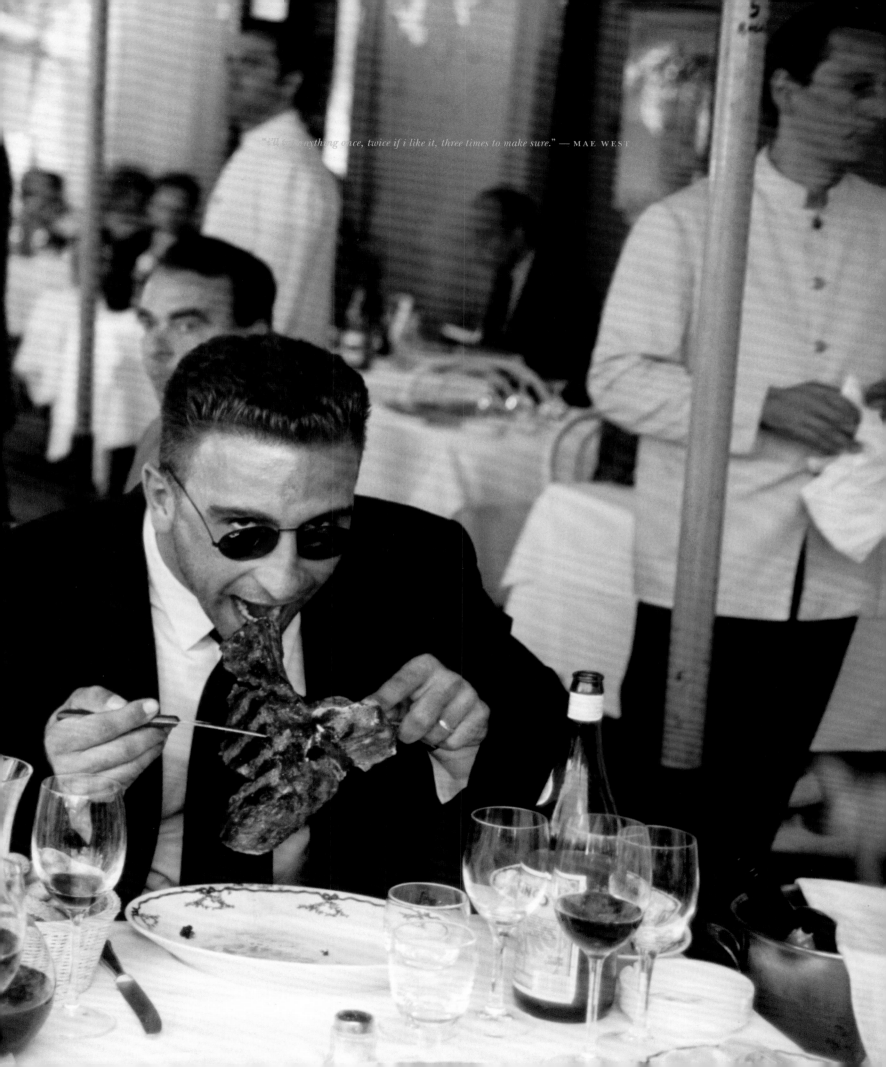

"I'll try anything once, twice if i like it, three times to make sure." — MAE WEST

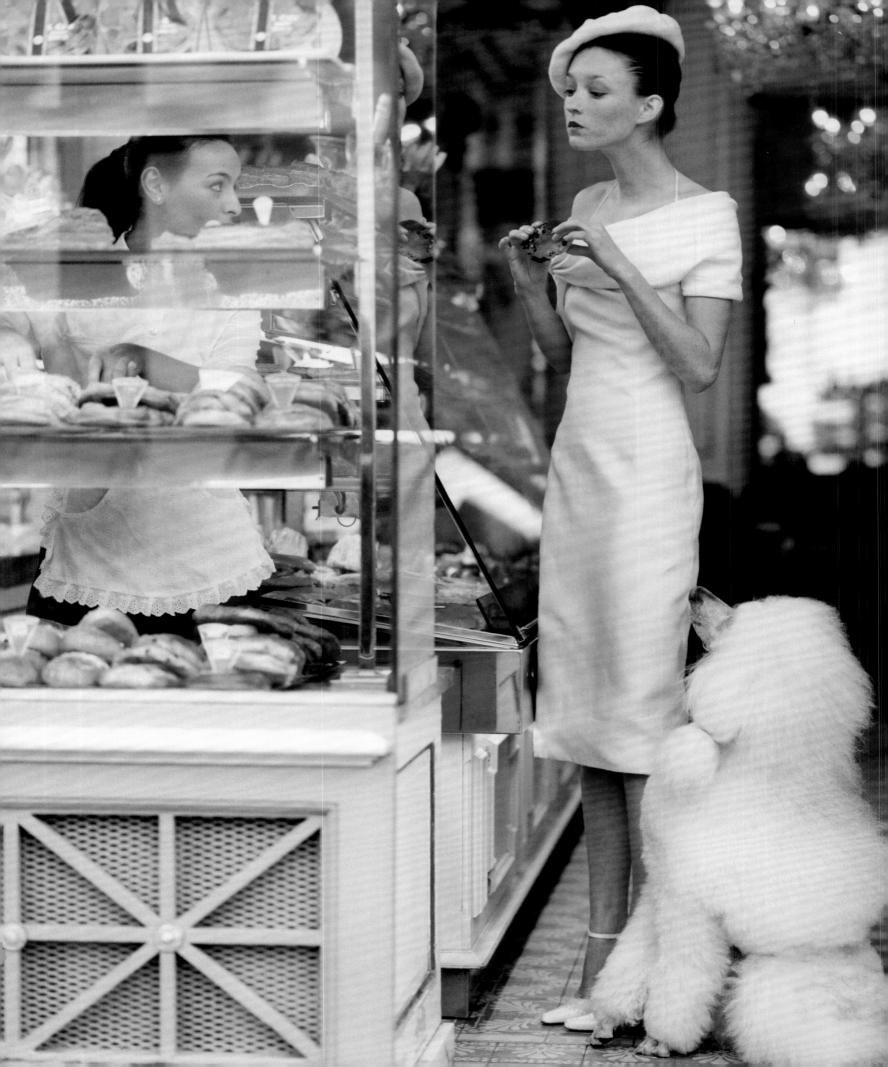

SIX OF ONE, HALF DOZEN OF ANOTHER
how to eat cake for breakfast almost anywhere

WAGASHI
(wha-gah-she)
japan

LAMINGTON
(lam-ing-ton)
australia

RUNEBERGINTORTTU
(ru-ne-br-gen-tor-tu)
finland

PIONONO
(pee-o-no-no)
peru

SKALICKÝ TRDELNÍK
(ska-lis-key trdel-neek)
slovakia

SCHWARZWÄLDER KIRSCHTORTE
(shh-wartz-vahlder kirsch-torte)
germany

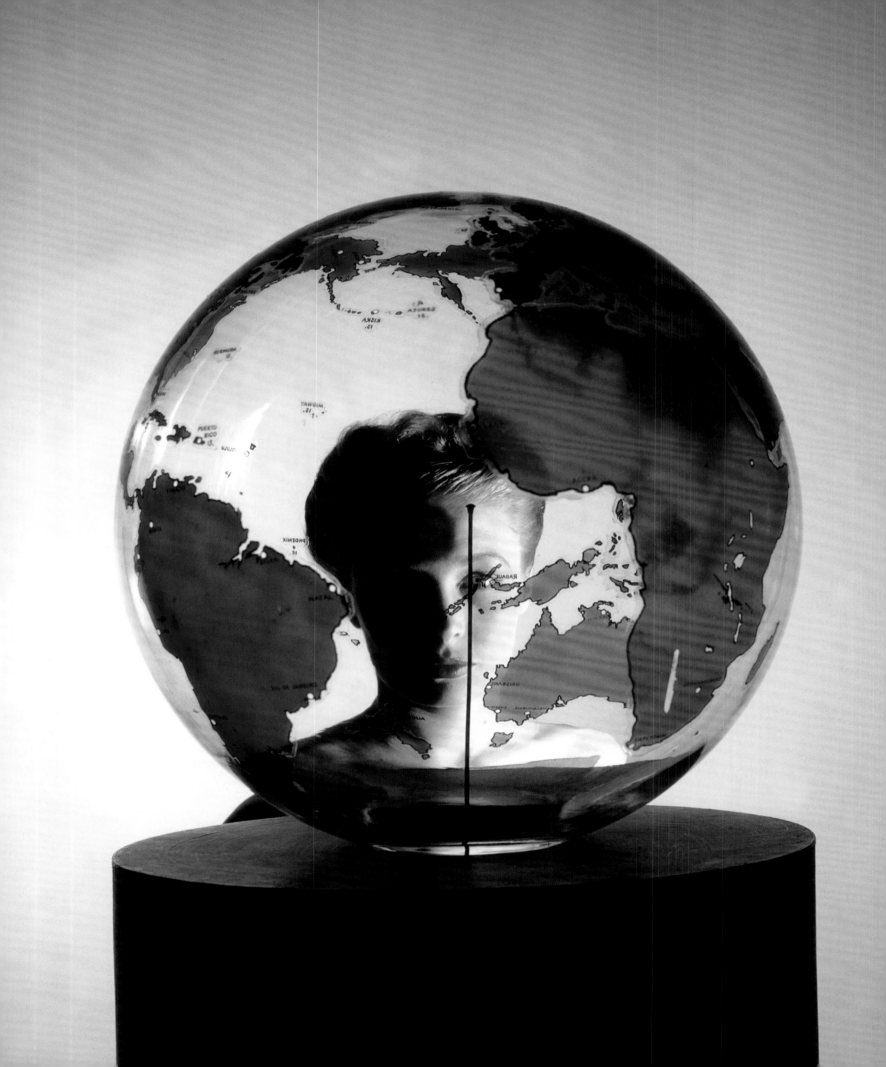

THE AWFULLY BIG ADVENTURE

these are the destinations that capture our attention and spark our imagination. are they the only places to visit? most certainly not. but they are places that have their own strong sense of style, and we like that. a lot.

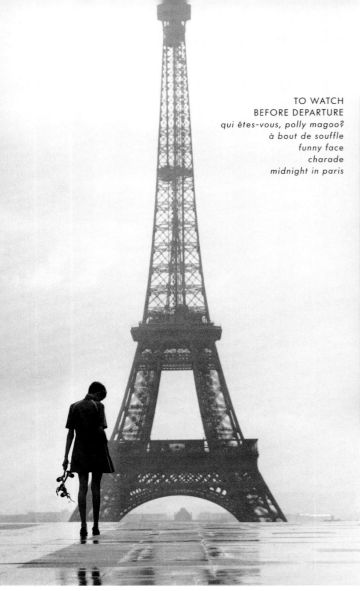

TO WATCH
BEFORE DEPARTURE
qui êtes-vous, polly magoo?
à bout de souffle
funny face
charade
midnight in paris

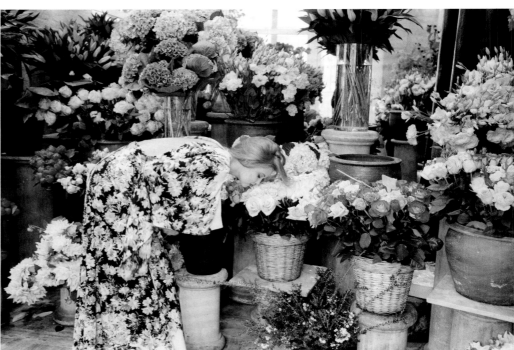

10 THINGS TO BUY
1. lingerie fit for *un petit coquette*
2. picardie wine tumblers for your home bistro
3. fragrance papers and soaps from the pharmacy
4. a set of lawn chairs like those in the jardin de luxembourg
5. a beautiful coffee table book. (it's even more chic in french.)
6. social stationery on verge paper. (classique!)
7. a cup and saucer from café de flore
8. a major mustard
9. macarons. so many macarons.
10. street art for your wall

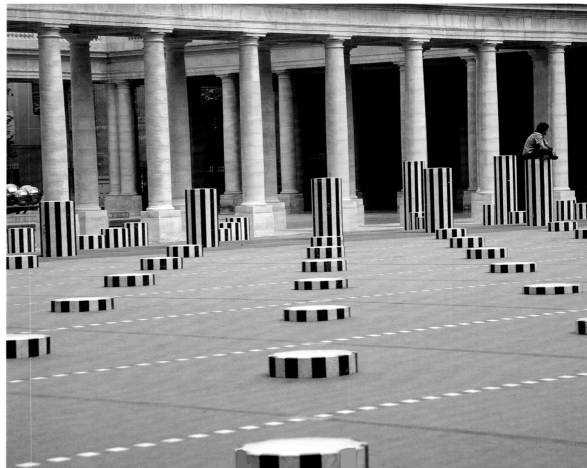

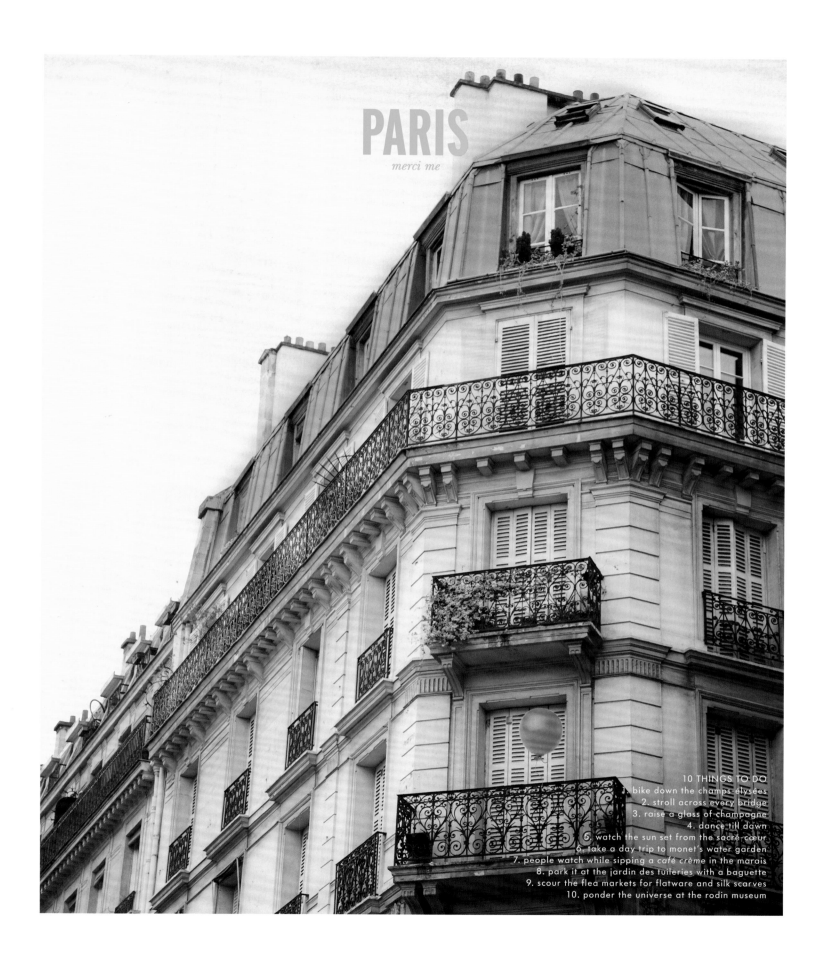

PARIS
merci me

10 THINGS TO DO
1. bike down the champs-élysées
2. stroll across every bridge
3. raise a glass of champagne
4. dance till dawn
5. watch the sun set from the sacré-cœur
6. take a day trip to monet's water garden
7. people watch while sipping a café crème in the marais
8. park it at the jardin des tuileries with a baguette
9. scour the flea markets for flatware and silk scarves
10. ponder the universe at the rodin museum

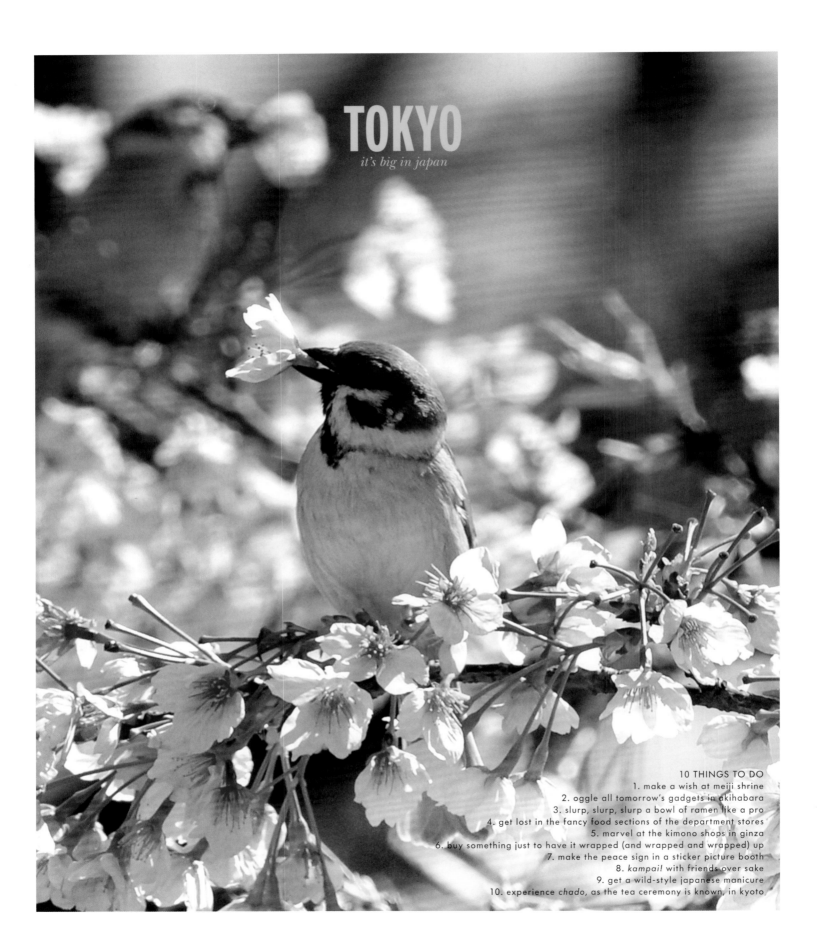

TOKYO

it's big in japan

10 THINGS TO DO
1. make a wish at meiji shrine
2. oggle all tomorrow's gadgets in akihabara
3. slurp, slurp, slurp a bowl of ramen like a pro
4. get lost in the fancy food sections of the department stores
5. marvel at the kimono shops in ginza
6. buy something just to have it wrapped (and wrapped and wrapped) up
7. make the peace sign in a sticker picture booth
8. *kampai!* with friends over sake
9. get a wild-style japanese manicure
10. experience *chado*, as the tea ceremony is known, in kyoto

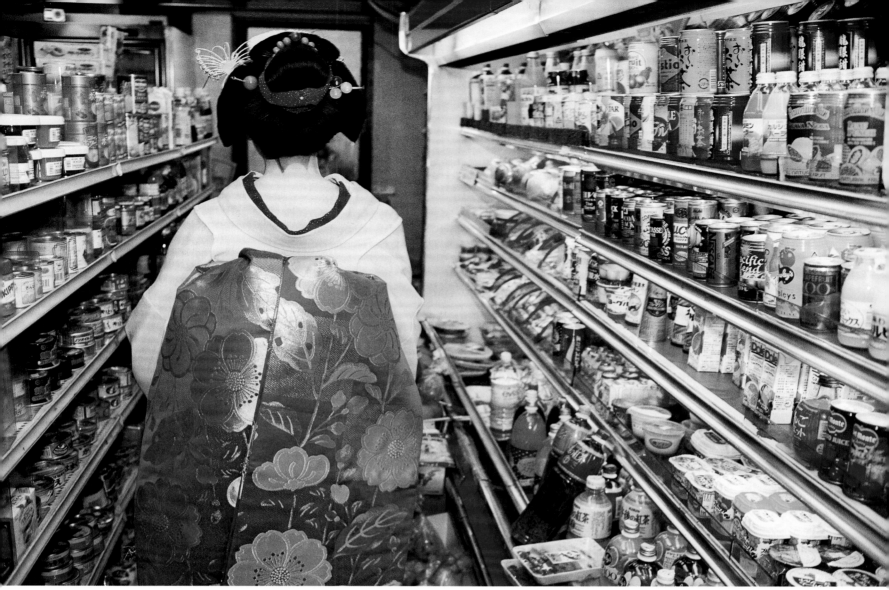

6 THINGS TO BUY
1. pens, stationery, stickers and washi tape of all shapes, colors and sizes
2. ceremonial matcha green tea
3. pretty paper packages of *omiyage* (traditional giftable candies, rice crackers and red bean sweets)
4. an instant or digital novelty camera
5. a pewter *katakuchi* sake set (a wide, pretty bowl for serving the good stuff)
6. socks

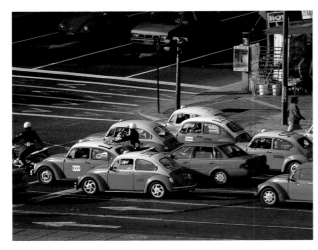

7 THINGS TO BUY
1. a bottle of small-batch mezcal
2. jars of chilis and guava-jamaica preserves
3. handmade baskets, bracelets and serapes from the market
4. colorful papel picado, tissue paper banners and flags
5. a clay pot, cazuelas and steel comal for the kitchen
6. a traditional skirt
7. plastic market totes in bright patterns

DON'T FORGET TO PACK
a copy of robert bolano's *the savage detectives*,
set in the city's artsy scene in the 70s

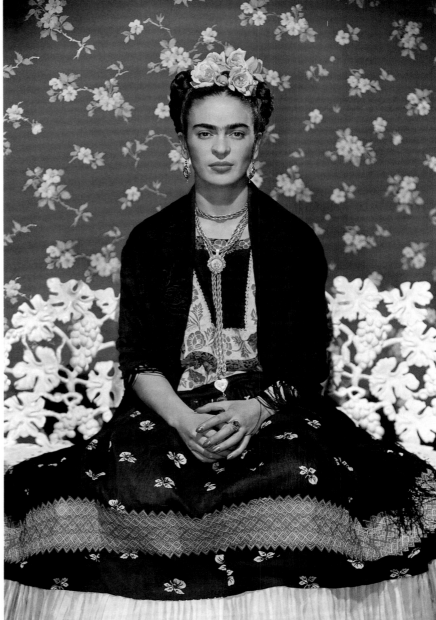

MEXICO CITY
a good ole time

12 THINGS TO DO
1. say *"hola!"* to frida khalo's blue-hued childhood home-turned-museum
2. take a siesta so you'll be fresh for your 10 pm dinner reservation
3. wander the galleries and shops of roma
4. take a trip through history via the expansive museo nacional de antropologia
5. explore templo mayor, a mesoamerican pyramid in the heart of the city
6. take a photo on the steps of the artful museo soumaya
7. tip your hat to the *mariachis* at plaza garibaldi
8. chase your *tequila* with *sangrita*
9. sip milky *pulque* like the aztecans did 2,000 years ago
10. dip your *churro* into your hot chocolate
11. try fried grasshopper
12. sample the sauteed *maguey* worms

SANTORINI

it's all greek to me

BE MUSED:
THE NINE VERY CREATIVE WOMEN
OF GREEK MYTHOLOGY
calliope epic poetry
clio history
erato love poetry
euterpe music
melpomene tragedy
polyhymnia sacred poetry
terpsichore dance
thalia comedy
urania astronomy

11 THINGS TO DO
1. gaze at the aegean sea
2. daydream in a hammock
3. say "eviva" when you clink glasses of *assyrtiko* (greek white wine)
4. tiptoe around a sleeping volcano
5. catch a showstopping sunset
6. take a donkey ride through the hills
7. scooter from beach to beach
8. make yogurt and honey a daily meal
9. sunbathe on a sailboat
10. take the cable car from town to the old port
11. order the catch of the day at a taverna

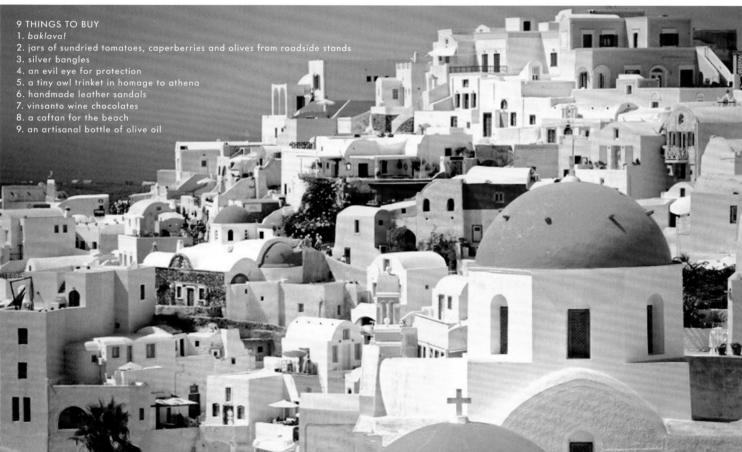

9 THINGS TO BUY
1. *baklava!*
2. jars of sundried tomatoes, caperberries and olives from roadside stands
3. silver bangles
4. an evil eye for protection
5. a tiny owl trinket in homage to athena
6. handmade leather sandals
7. vinsanto wine chocolates
8. a caftan for the beach
9. an artisanal bottle of olive oil

"there was a jeweled city on the horizon, spires rising in the night, but the jewels were diadems of electric and the spires were the neon of signs ten stories high."
— NORMAN MAILER

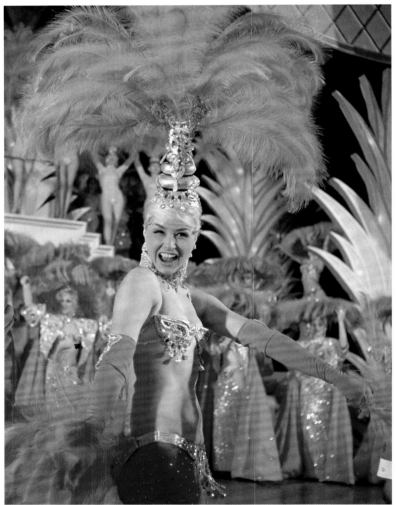

9 THINGS TO DO
1. roll the dice
2. take in a show
3. dance the night away
4. put it all on red
5. wink at the dealer
6. have a martini before your steak, rat pack style
7. pay your respects to the signage of yesteryear at the neon museum
8. sample the foods of the world without leaving the strip
9. go spa-ing at a 5-star hotel

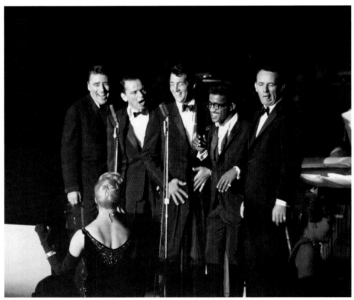

LAS VEGAS

7 THINGS TO BRING HOME
1. retro casino memorabilia
2. vintage tees from legendary shows
3. a deck of cards
4. fuzzy dice
5. a novelty pen
6. some extra change in your purse
7. a good story

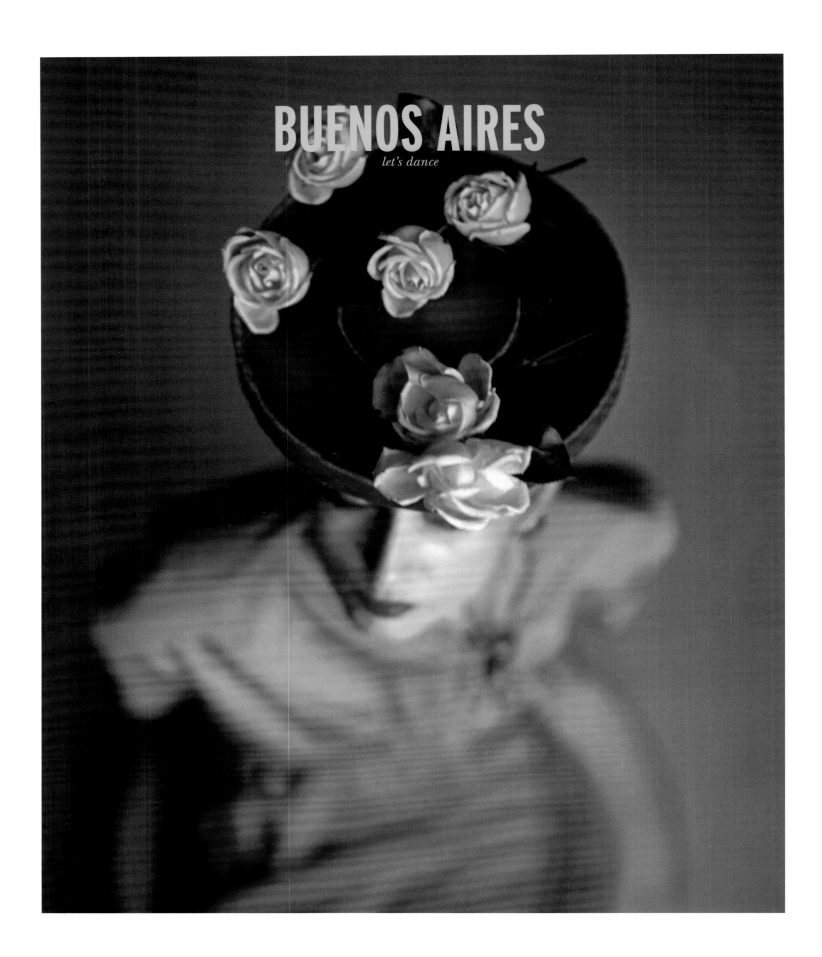

BUENOS AIRES
let's dance

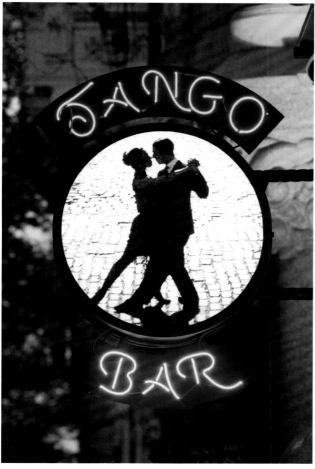

BAJA UN CAMBIO (RELAX!)
in argentina it's perfectly alright—even expected—
to be fashionably late.

10 THINGS TO DO
1. take tea at the alvear palace hotel
2. bike along the rio de la plata through the lush inner city nature preserve
3. pay homage to evita at the city's cementerio de la recoleta
4. feast like a *gaucho* on steak
5. art gallery hop
6. take in a late dinner at a turn-of-the-century mansion-turned-restaurant
7. stop for a scoop of *dulce de leche* ice cream
8. soak in the literary air at the city's largest bookstore, a heavenly frescoed old theater
9. hit the dance floor at the tango hall or *milonga al fresco* (outdoor party)
10. cheer on the ponies from the grandstand at the hipodromo de palmero

7 THINGS TO BUY
1. a jar of artisanal *dulce de leche*
2. vintage silver from the antiques markets
3. a pair of custom riding boots
4. a leather-bound notebook
5. a cowhide rug
6. slip-on espadrilles
7. a bottle of argentine sparkling wine

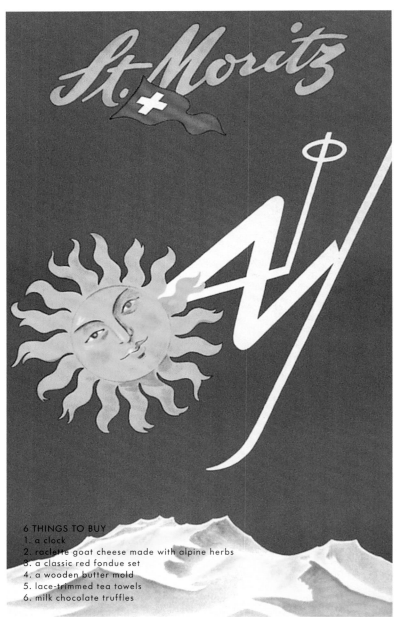

St. Moritz

6 THINGS TO BUY
1. a clock
2. raclette goat cheese made with alpine herbs
3. a classic red fondue set
4. a wooden butter mold
5. lace-trimmed tea towels
6. milk chocolate truffles

10 THINGS TO DO
1. hit the slopes
2. soak in a hot tub
3. have a cup of cocoa by the fire
4. snowshoe by the light of the moon
5. feast on fondue in a cozy cellar restaurant
6. break at a mountain hut to take in a panoramic view of the valleys
7. tip the zither player
8. play fetch with a st. bernard
9. eat *birchermuesli* with a silver spoon
10. watch the world zip by from the dining car of the rhätische bahn

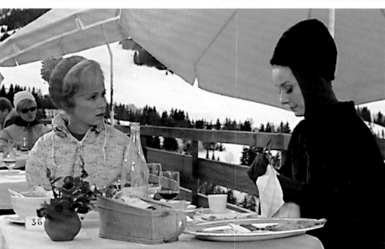

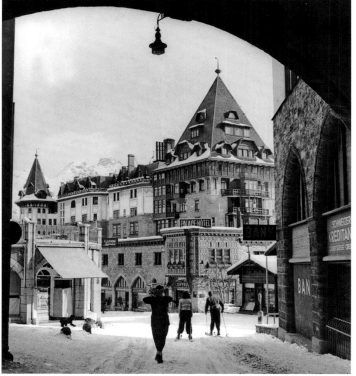

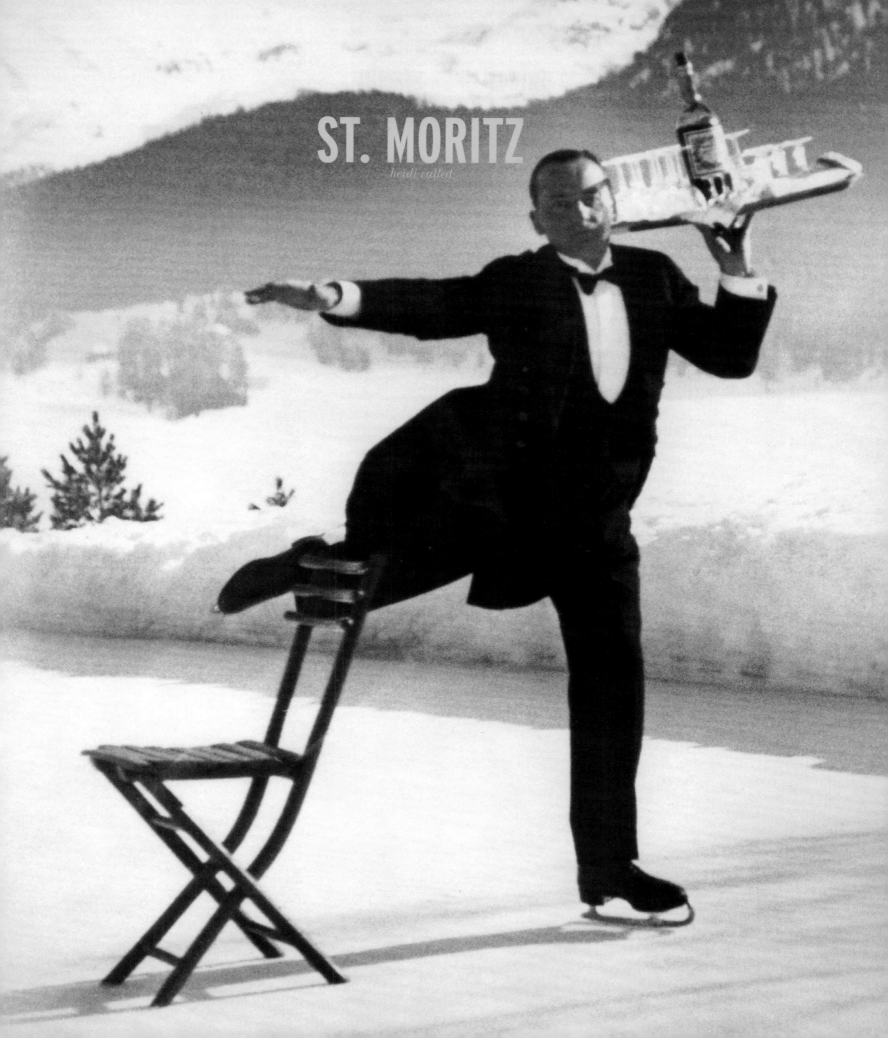

ST. MORITZ

heidi called

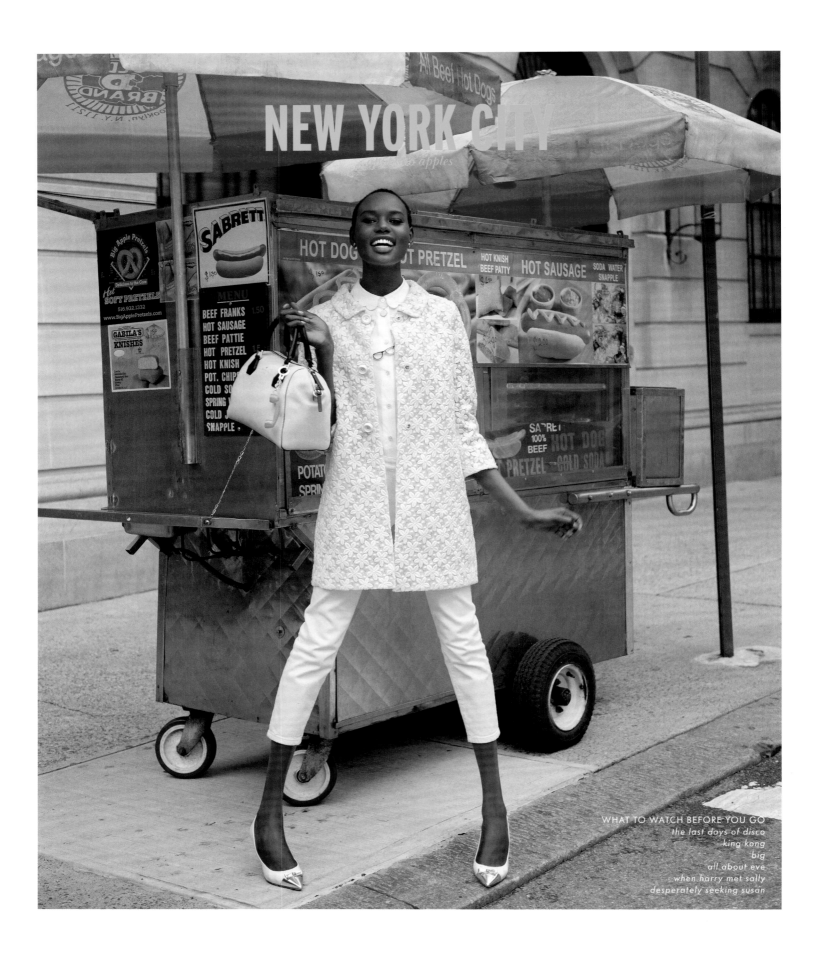

NEW YORK CITY
big apples

WHAT TO WATCH BEFORE YOU GO
the last days of disco
king kong
big
all about eve
when harry met sally
desperately seeking susan

11 THINGS TO DO

1. sip street cart coffee in a "we are happy to serve you" paper cup
2. listen to jazz at washington square park
3. traverse the brooklyn bridge on foot or by citi bike
4. take the train all the way to "the end" (aka: montauk)
5. lose yourself in the new york public library
6. wind your way through the guggenheim
7. stroll the highline
8. put the "deli" in "delicious" with a pastrami on rye
9. rollerskate in central park
10. feed the birds
11. catch a matinee of the new york city ballet

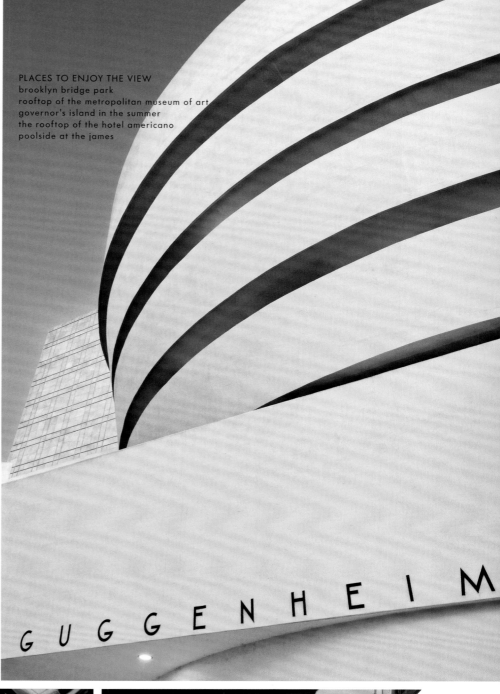

PLACES TO ENJOY THE VIEW
brooklyn bridge park
rooftop of the metropolitan museum of art
governor's island in the summer
the rooftop of the hotel americano
poolside at the james

GUGGENHEIM

POST
NO
BILLS

SOHO-CAST IRON HISTORIC DISTRICT
BROADWAY

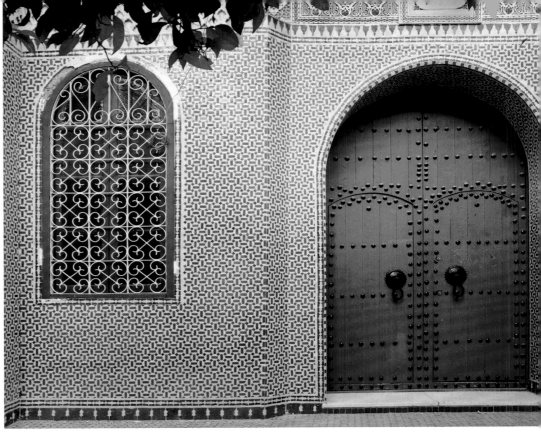

LIVE LIKE A LOCAL
ready, set, haggle: to the shopkeepers in the medina,
it's part of the fun. name a ridiculously low price;
hope to meet somewhere in the middle. act disinterested,
even walk away—they're sure to follow. seal the deal with
a friendly handshake on the agreed upon *dirham*.

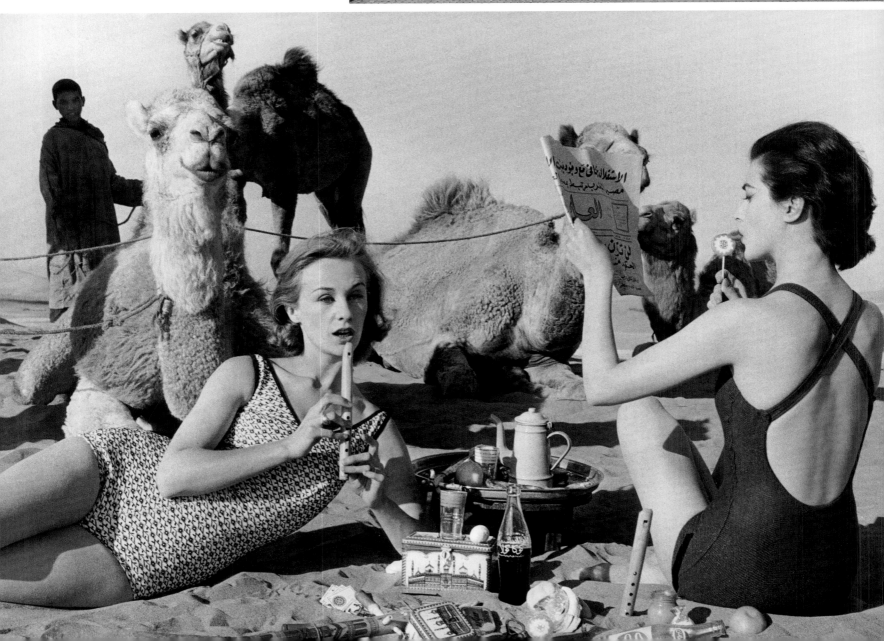

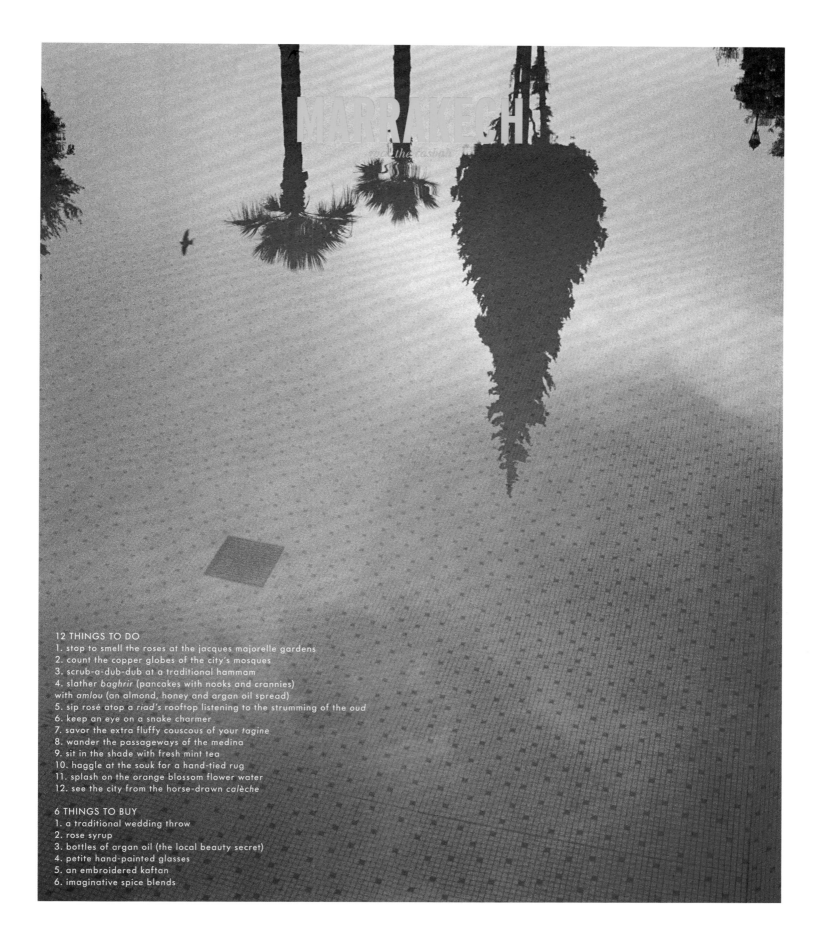

MARRAKECH
and the Casbah

12 THINGS TO DO
1. stop to smell the roses at the jacques majorelle gardens
2. count the copper globes of the city's mosques
3. scrub-a-dub-dub at a traditional hammam
4. slather *baghrir* (pancakes with nooks and crannies)
with *amlou* (an almond, honey and argan oil spread)
5. sip rosé atop a *riad's* rooftop listening to the strumming of the *oud*
6. keep an eye on a snake charmer
7. savor the extra fluffy couscous of your *tagine*
8. wander the passageways of the medina
9. sit in the shade with fresh mint tea
10. haggle at the souk for a hand-tied rug
11. splash on the orange blossom flower water
12. see the city from the horse-drawn *calèche*

6 THINGS TO BUY
1. a traditional wedding throw
2. rose syrup
3. bottles of argan oil (the local beauty secret)
4. petite hand-painted glasses
5. an embroidered kaftan
6. imaginative spice blends

BERLIN
stolen moments

12 THINGS TO DO
1. pedal through grunewald forest
2. finish a whole plate of *schnitzel*
3. leaf through international indie magazines at the newsstand
4. use a tiny wooden fork to eat *currywurst*
5. check out the gallery scene around checkpoint charlie
6. shop for records
7. grab a table at the *biergarten* that has the most twinkling lights
8. walk the berlin wall
9. spend an afternoon reading and drinking espresso
10. leave a discotheque at dawn
11. ride the escalator through europe's largest department store
12. soak up the history in the streets

WEEKEND ITINERARY
nearly everything is closed on sundays
so stay up fantastically late on saturday, sleep till noon,
and arrive at the flea market by 1 pm.

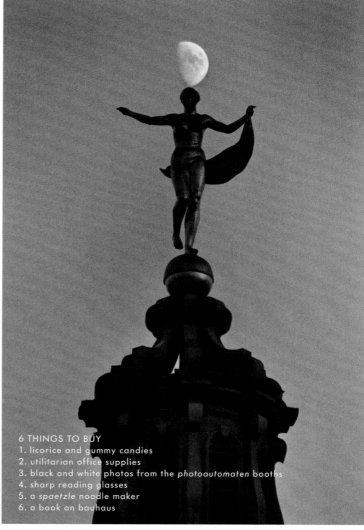

6 THINGS TO BUY
1. licorice and gummy candies
2. utilitarian office supplies
3. black and white photos from the *photoautomaten* booths
4. sharp reading glasses
5. a *spaetzle* noodle maker
6. a book on bauhaus

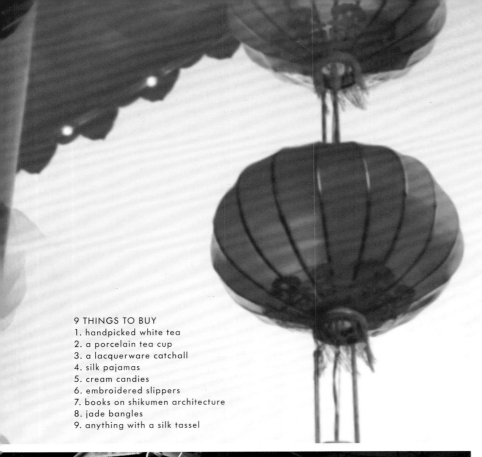

9 THINGS TO BUY
1. handpicked white tea
2. a porcelain tea cup
3. a lacquerware catchall
4. silk pajamas
5. cream candies
6. embroidered slippers
7. books on shikumen architecture
8. jade bangles
9. anything with a silk tassel

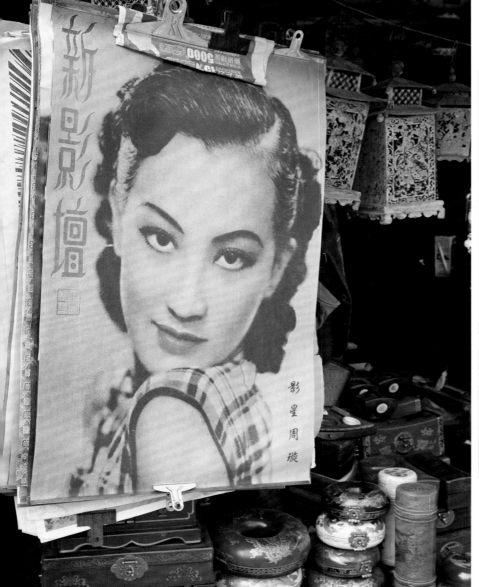

WATCH YOUR STEP!
cars and cyclists rule the road—and sometimes
the sidewalks, it's up to pedestrians to mind
their p's and q's.

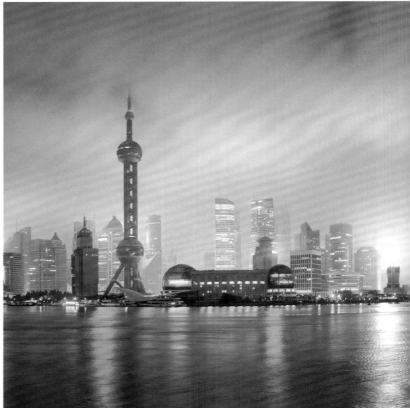

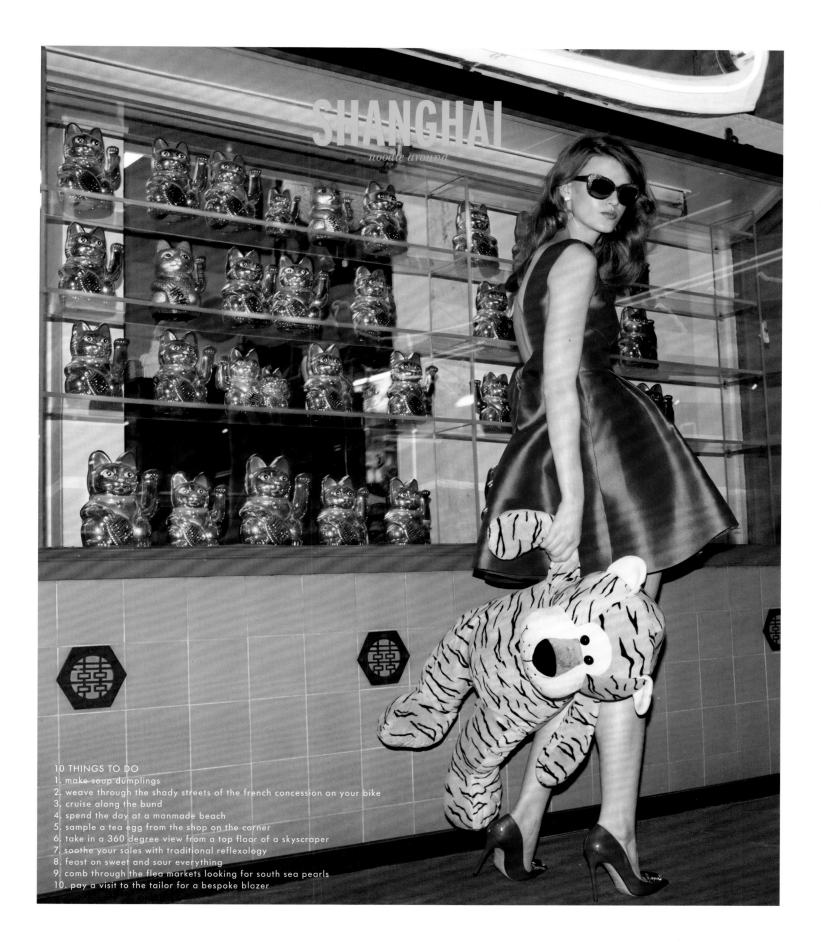

SHANGHAI

noodle around

10 THINGS TO DO
1. make soup dumplings
2. weave through the shady streets of the french concession on your bike
3. cruise along the bund
4. spend the day at a manmade beach
5. sample a tea egg from the shop on the corner
6. take in a 360 degree view from a top floor of a skyscraper
7. soothe your soles with traditional reflexology
8. feast on sweet and sour everything
9. comb through the flea markets looking for south sea pearls
10. pay a visit to the tailor for a bespoke blazer

AMALFI COAST

tutto bene

6 THINGS TO BUY
1. leather sandals
2. a red coral figurine
3. candied orange peel
4. olive oil
5. dried pasta in all shapes and sizes
6. a woven straw tote

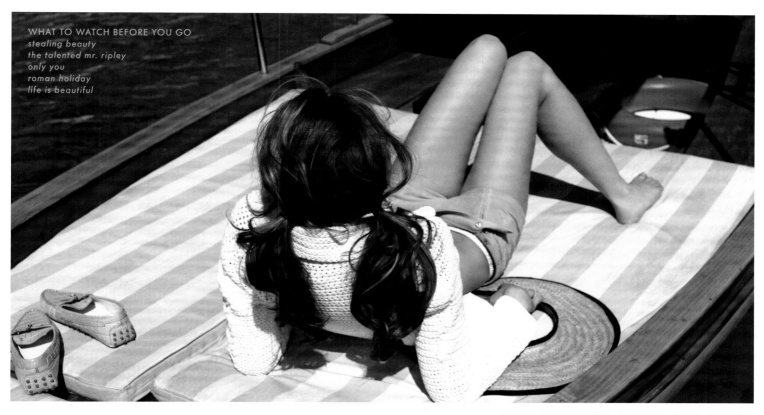

WHAT TO WATCH BEFORE YOU GO
stealing beauty
the talented mr. ripley
only you
roman holiday
life is beautiful

12 THINGS TO DO
1. order a campari and soda in the garden of a villa overlooking the water
2. take the stairs two by two. catch your breath while you take in the view from the top.
3. order a crisp glass of *falanghina* with your *zuppa di pesce*
4. bike along the cobblestone streets to the beach
5. drop anchor off the coast and watch the sun go down
6. cannonball into the sea
7. cool off with a lemon granita or *limoncello*
8. take in big scenic drive in a tiny sports car
9. spend the day on a rocky shore in a chaise under a striped umbrella
10. eat pizza
11. sail to capri
12. zip around on a vespa

in italy, a perfect espresso
is called "god's drink"

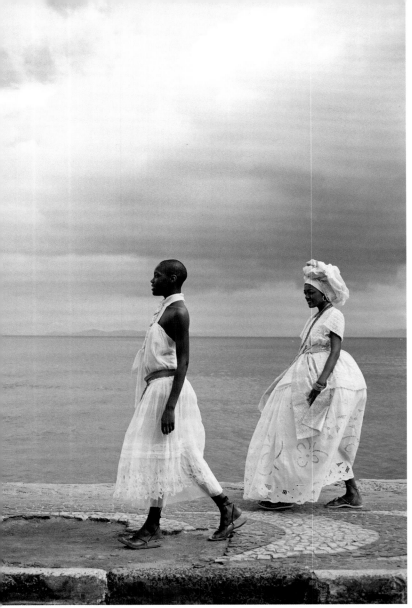

10 THINGS TO DO
1. swim with the sea turtles
2. awe at the house of wonders museum
3. snorkel around the reefs with the seahorses
4. hydrate with *zed* (pineapple juice) and *dafu* (freshly cracked coconuts)
5. meet the ginger-topped monkeys of jozani forest, the last red colobus monkey sanctuary
6. snack on seafood at sunset at the forodhani gardens
7. dance to the funky *taarab* beat
8. snooze on a white sand beach under a swaying palm tree
9. safari on the mainland to count the wildebeests along the serengeti
10. wave hi to freddie mercury's house

WHAT TO PACK
a wide-brimmed hat
long-sleeve cotton buttondown
a scarf
a one-piece swimsuit
binoculars

10 THINGS TO BUY
1. a raffia beach bag
2. an ostrich eggshell bead necklace
3. banana soap
4. *kitenge* fabric in pop patterns
5. a coconut shell mobile
6. a clove wreath
7. a *bantu* beach coverup
8. batik tablecloths
9. cinnamon bark
10. a carved teak keepsake box

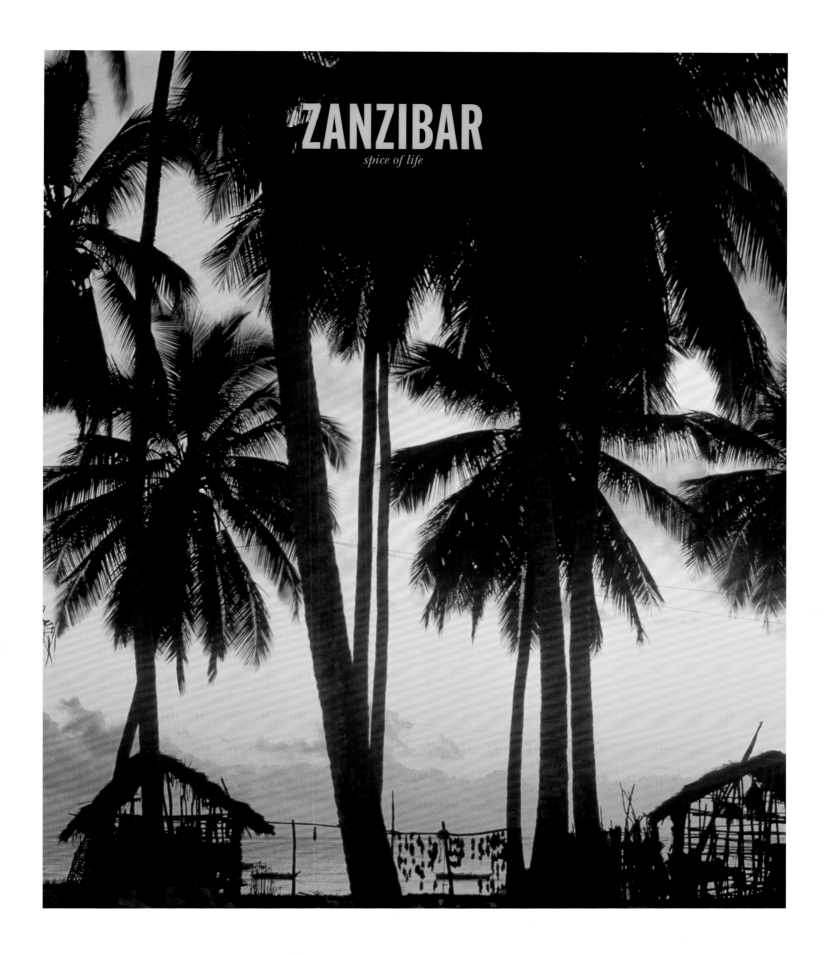

ZANZIBAR

spice of life

LONDON

cheers!

KEEP
LEFT

8 THINGS TO DO
1. take a spin on a red double decker bus
2. have a proper g&t at a proper hotel bar
3. sculpt the perfect bite of scone, jam and clotted cream
4. salute the guards at buckingham palace
5. walk from hyde park through green park
6. see what light doth yonder window break at shakespeare's globe theatre
7. museum hop through south kensington
8. spend sunday morning shopping and snacking through broadway market

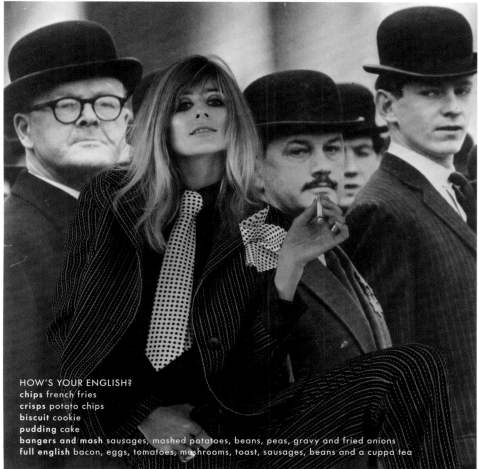

HOW'S YOUR ENGLISH?
chips french fries
crisps potato chips
biscuit cookie
pudding cake
bangers and mash sausages, mashed potatoes, beans, peas, gravy and fried onions
full english bacon, eggs, tomatoes, mushrooms, toast, sausages, beans and a cuppa tea

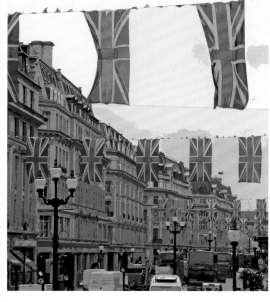

4 FOODSTUFFS TO SAMPLE
1. yorkshire gold tea
2. pink champagne truffles
3. battenburg cake
4. marmite

WHAT TO ORDER
BY THE POOL
a shandy
an avocado grande
chuy punch
a hot dog
shrimp cocktail

*"in the springtime, the swallows fly to capistrano,
the bees head for the flowers and kids here in southern
california take off for palm springs. it seems
to be some kind of primitive, instinctual urge."*
— PALM SPRINGS WEEKEND, 1963

6 THINGS TO BUY
1. bakelite from a thrift shop
2. a piece of mid-century design (big or small)
3. vintage barware
4. ceramics with (a little) kitsch
5. a cocktail ring
6. fresh dates

172

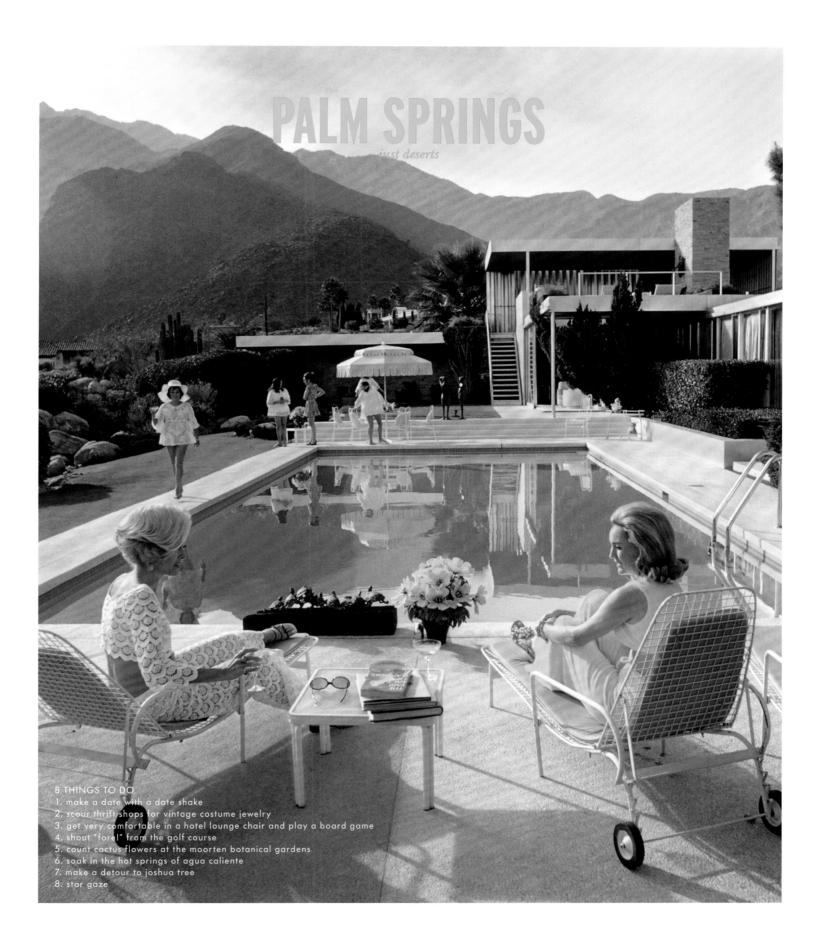

PALM SPRINGS
just deserts

8 THINGS TO DO
1. make a date with a date shake
2. scour thrift shops for vintage costume jewelry
3. get very comfortable in a hotel lounge chair and play a board game
4. shout "fore!" from the golf course
5. count cactus flowers at the moorten botanical gardens
6. soak in the hot springs of agua caliente
7. make a detour to joshua tree
8. star gaze

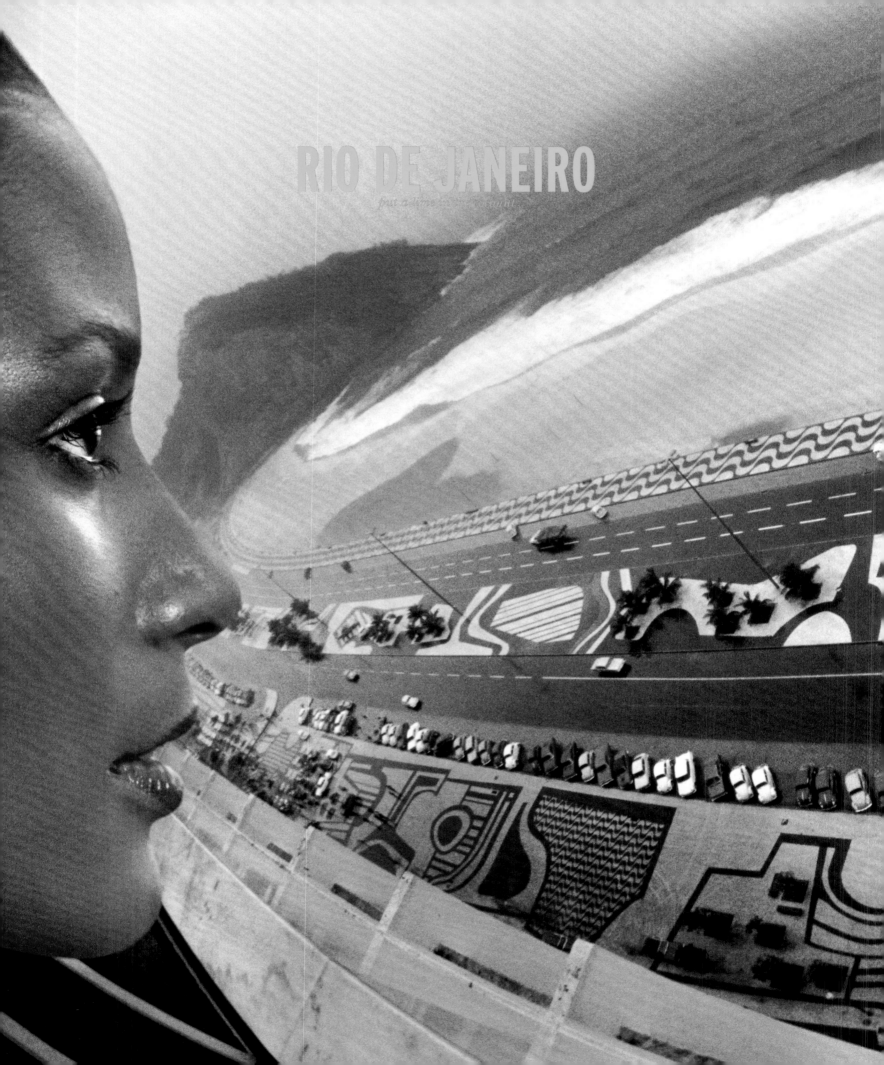

11 THINGS TO DO
1. drink something refreshing from a coconut
2. stroll the roberto burle marx–designed boardwalk along ipanema beach
3. pause for thought in the jardim botânico
4. seek out rare books on oscar niemeyer
5. spend the afternoon on the white sands of copacabana beach
6. get distracted by shiny things in the outdoor markets
7. enjoy the view from sugarloaf mountain
8. shop for vintage bossa nova albums
9. buy an itsy bitsy bikini
10. stock up on native *maracuja* (passionfruit) scented soaps
11. samba the night away

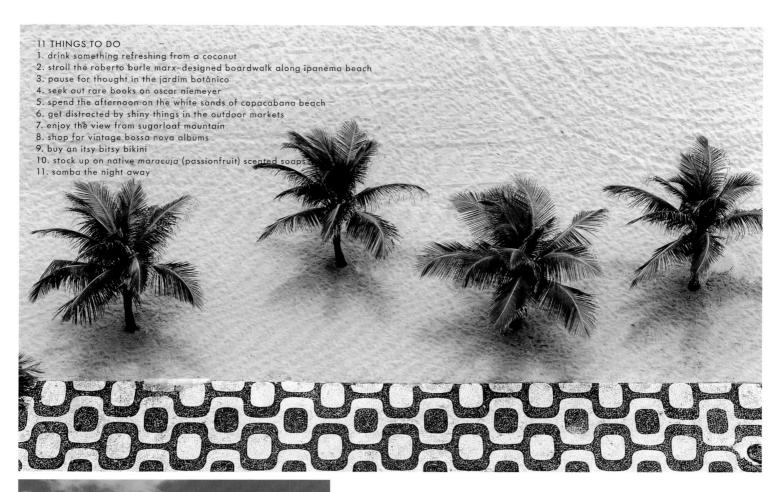

"her name is rio and she dances on the sand."
— "RIO" BY DURAN DURAN

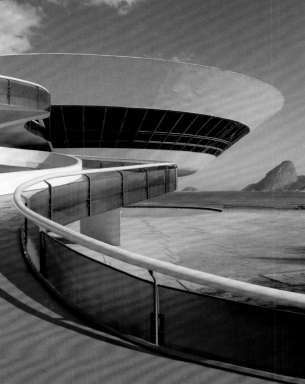

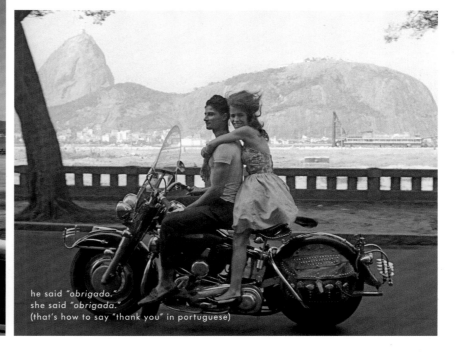

he said *"obrigado."*
she said *"obrigada."*
(that's how to say "thank you" in portuguese)

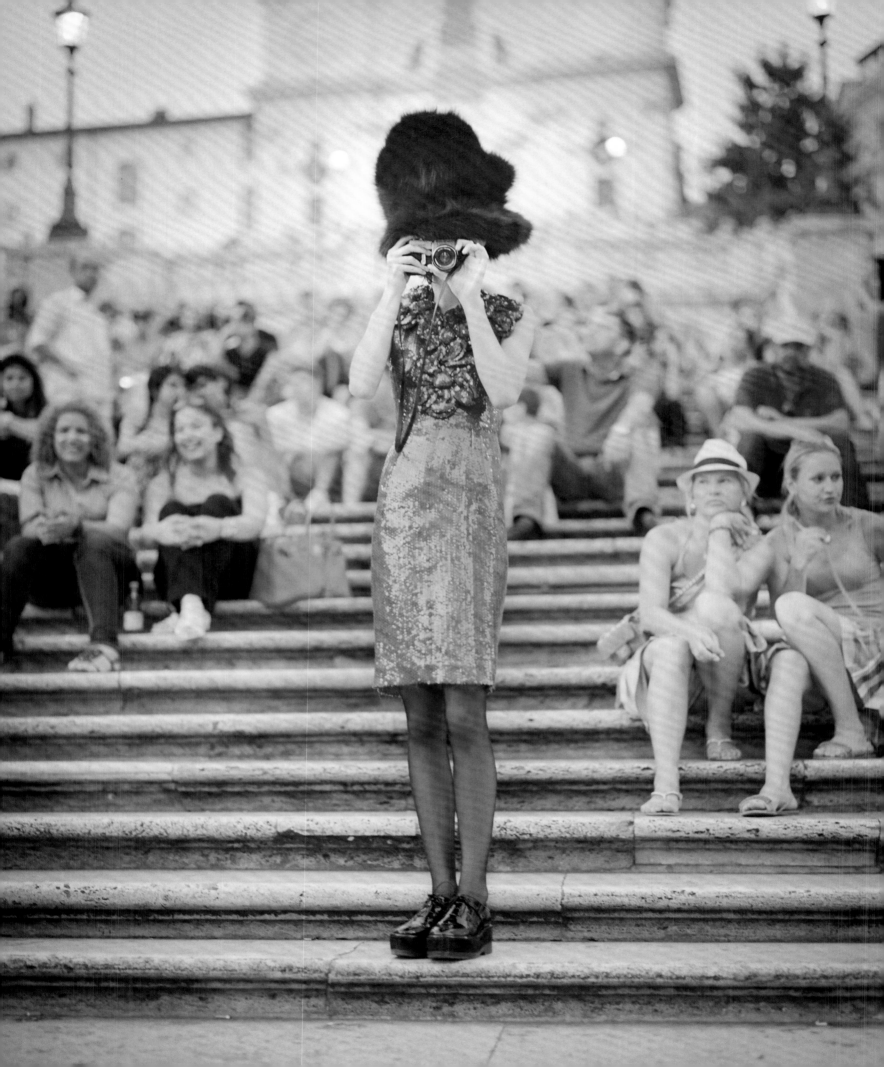

PHOTO FINISH

*every time we click the shutter, a camera doesn't just capture a
moment in time. it captures our moment in time. photography aficionados
that we are—take a peek at our art-filled salon walls and coffee tables
piled high with books—we've learned that amazing photos can happen
both under the most artfully planned circumstances and by pure
and crazy chance. they can express larger-than-life moments and shine
a spotlight on tiny details so we can remember them forever. whatever
our point of view is, we like to make it an inspired one.*

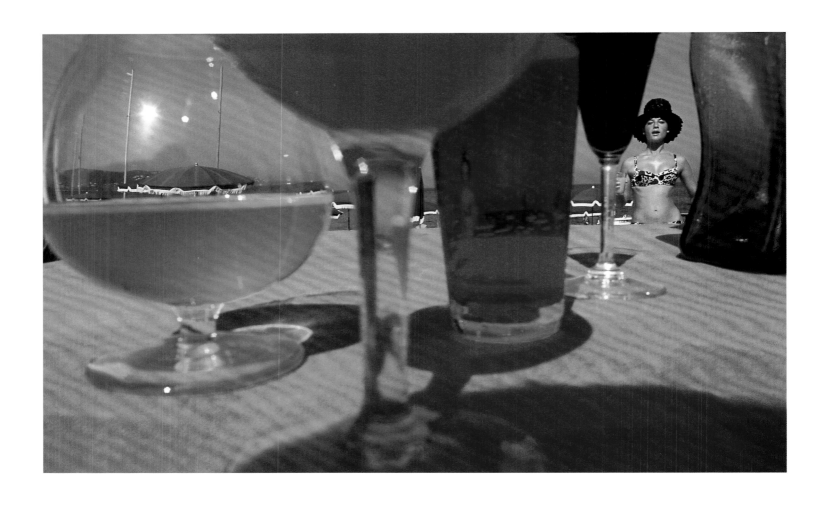

zoom in. way in. or, zoom out. way out.

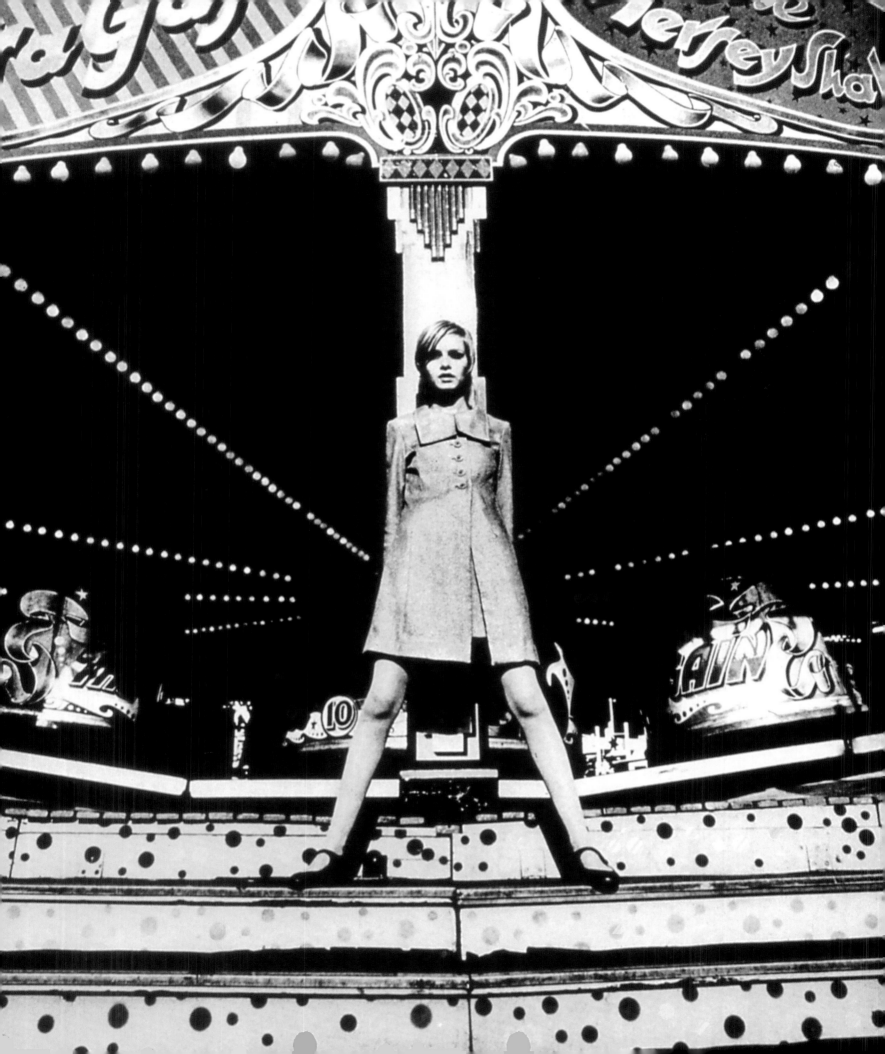

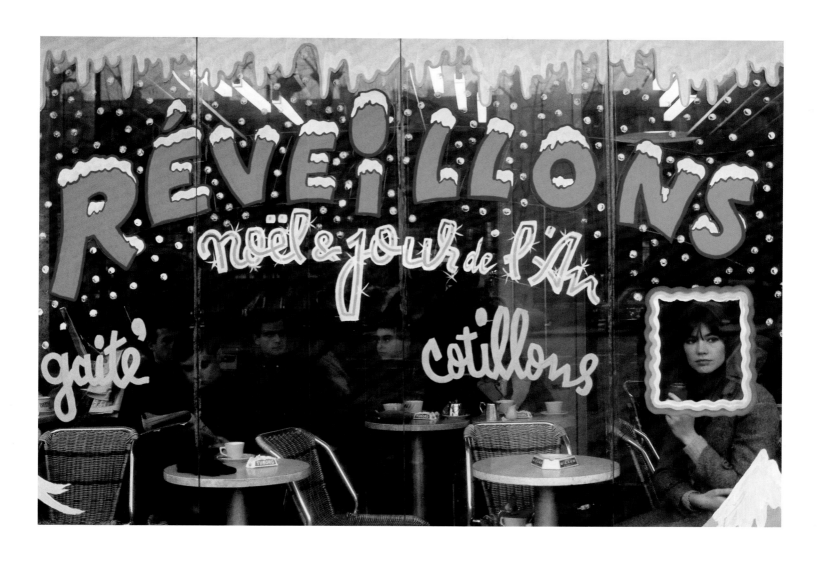

make your subject the center of attention—be it a person (opposite), or a location (above).

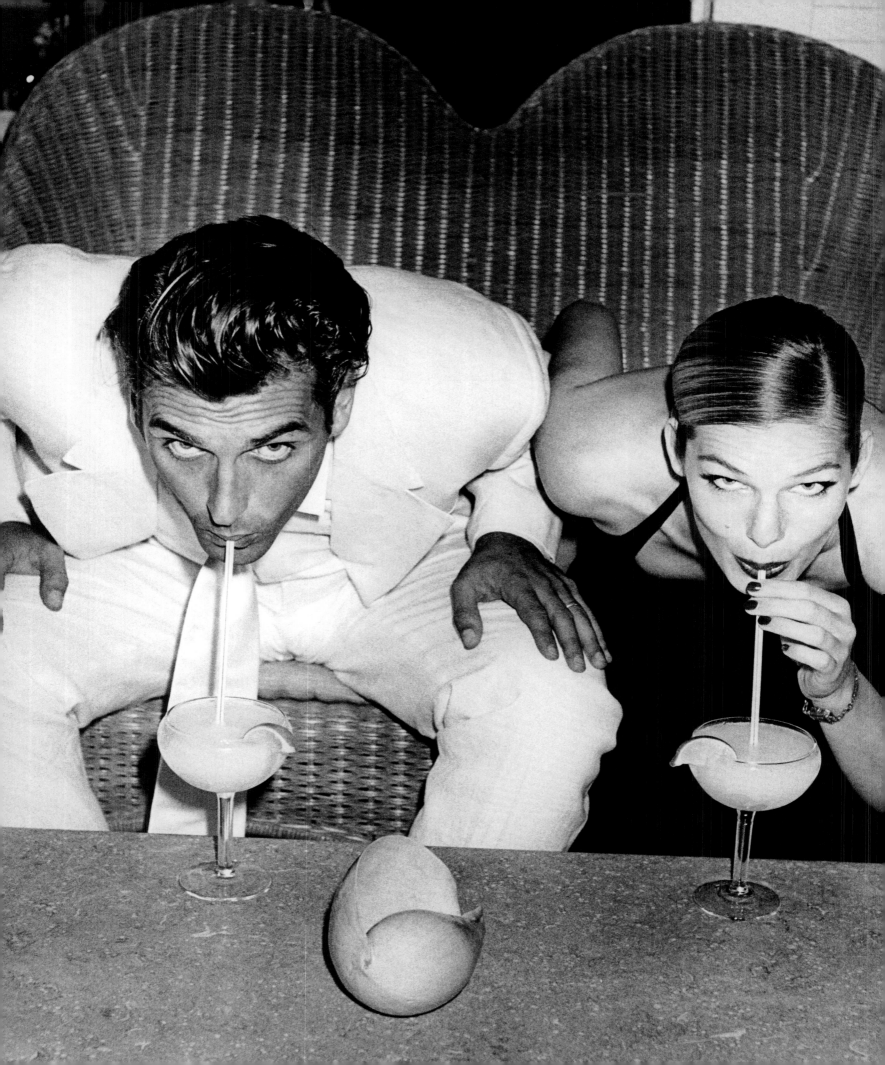

"IT'S MORE
IMPORTANT TO
CLICK WITH
PEOPLE THAN
TO CLICK
THE SHUTTER."

— *alfred eisenstaedt*

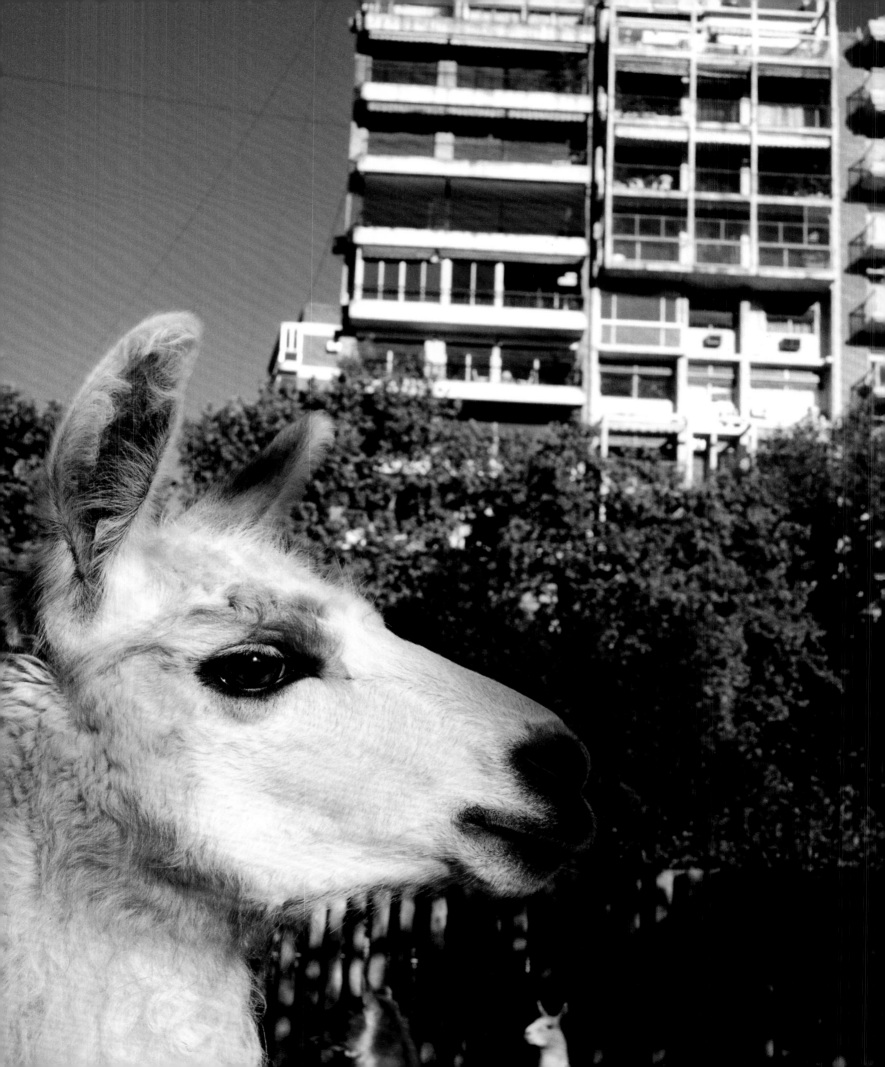

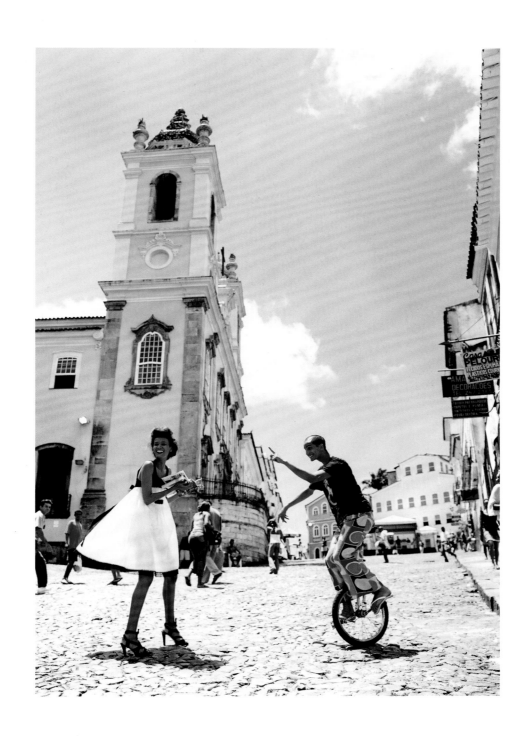

incorporate those you meet along the way, whether intentional (above)
or unplanned (like our photobomb-loving llama in buenos aires, opposite).

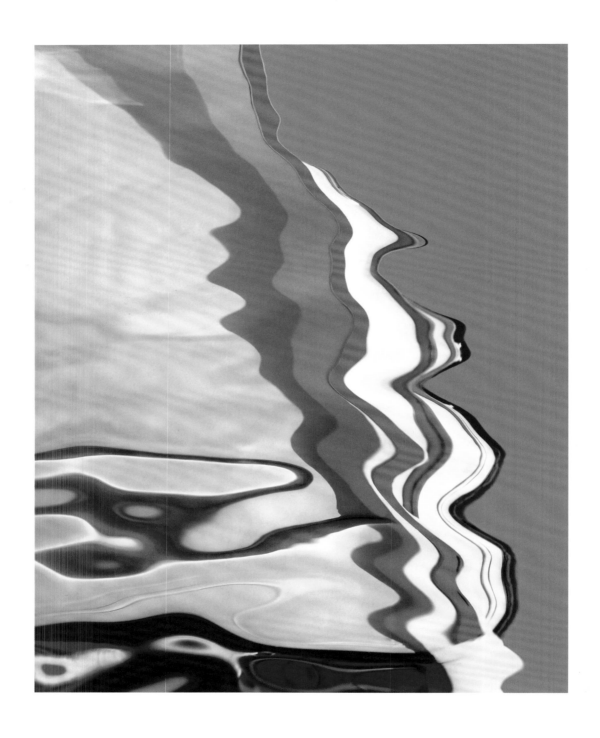

sharp photos are the traditional ideal. but we think
distorted ones (in the form of reflections) are quite beautiful too.

"A CAMERA
IS A TOOL
FOR LEARNING
HOW TO
SEE WITHOUT
A CAMERA."

— *dorothea lange*

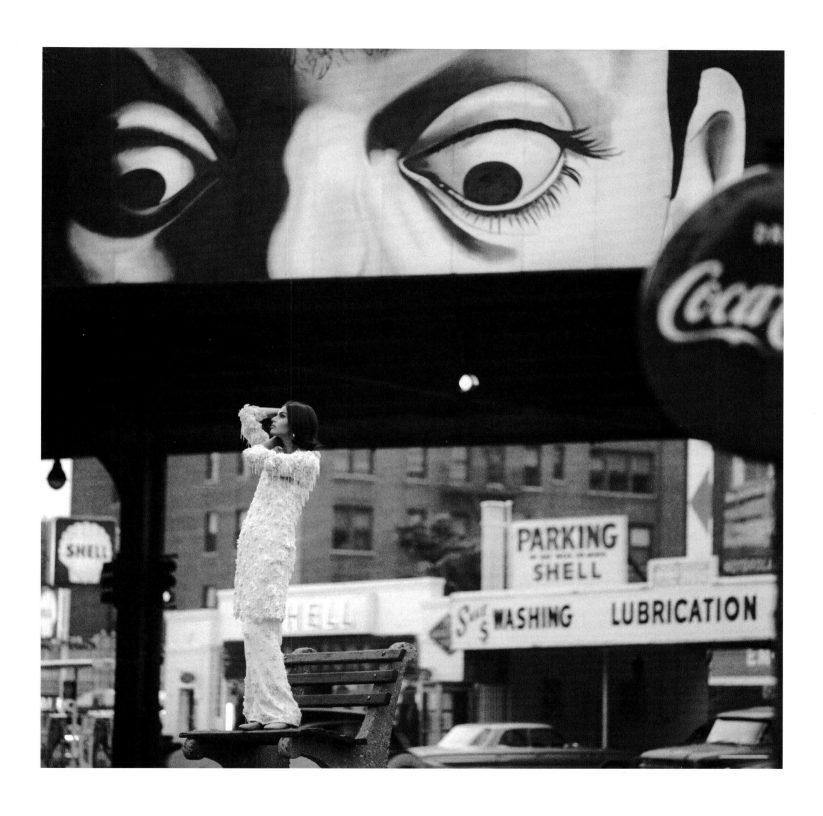

play with your surroundings.

view things from a different perspective (above). or try quickly clicking the shutter three or more
times and see what happens (opposite): when shooting a portrait, sometimes the truly great photo happens
the second after the first official one is taken, when the subject relaxes. better yet, you may
discover that the sum of all the photos, displayed together, tell a richer story than just one.

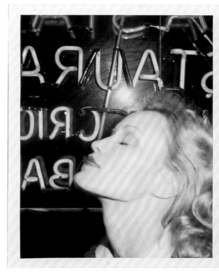
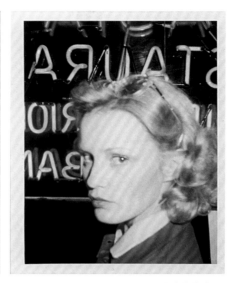
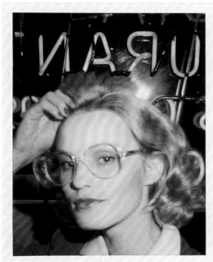
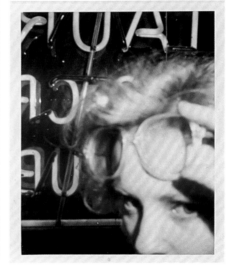
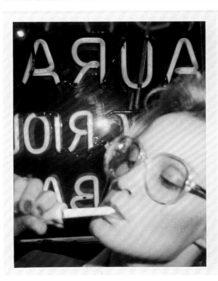
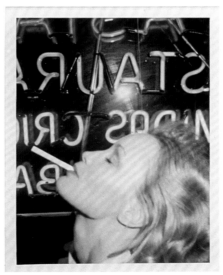

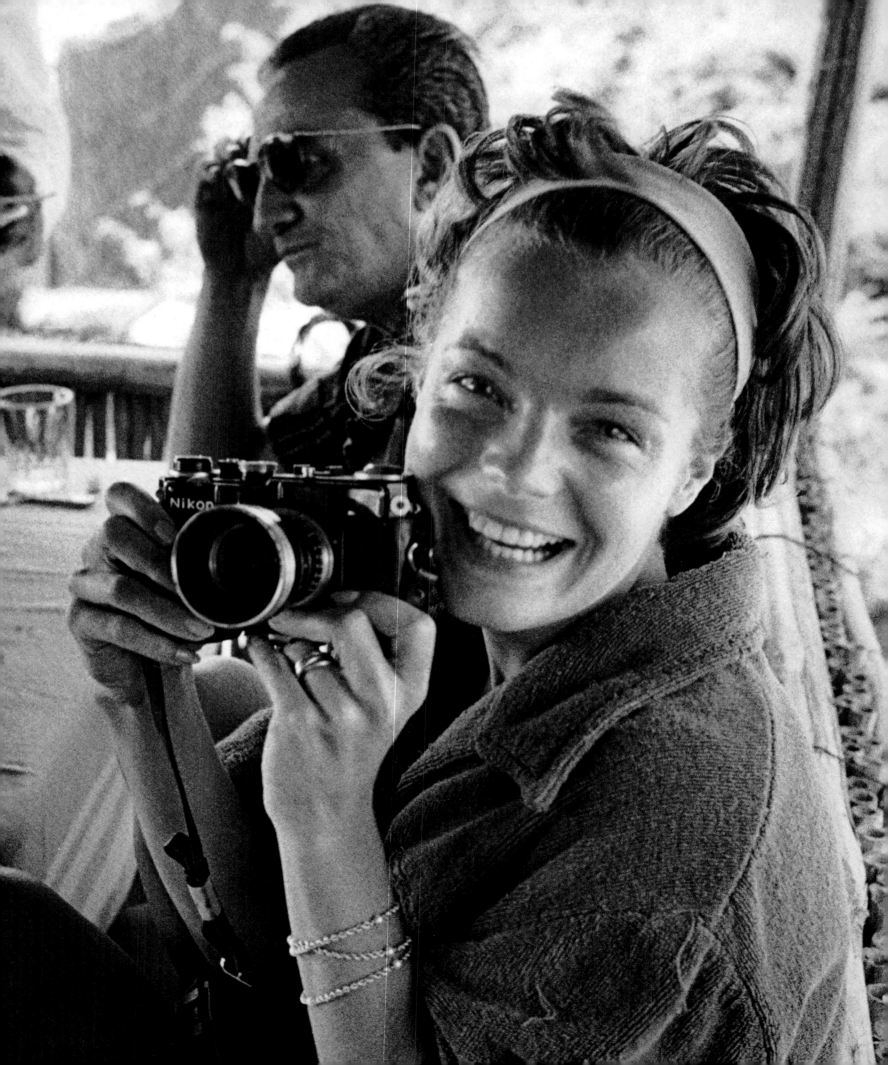

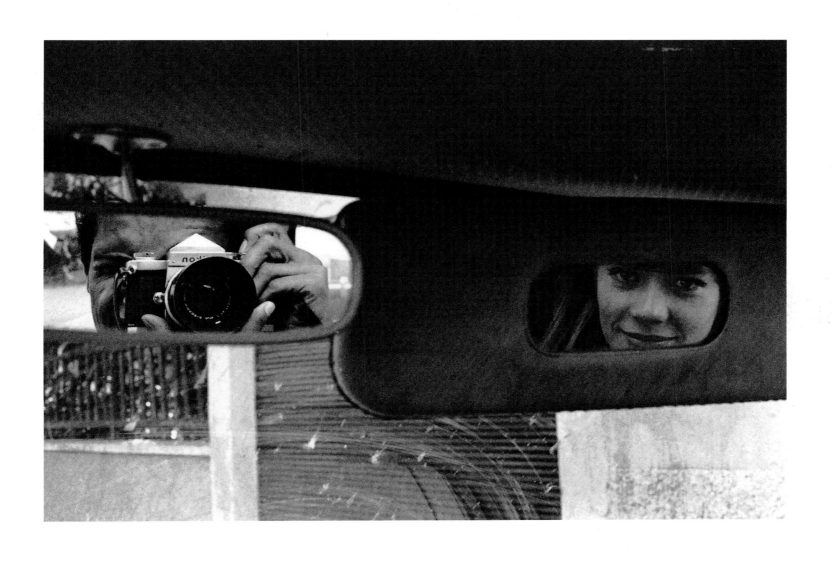

"what do you hang on the walls of your mind?" — EVE ARNOLD

21 THINGS TO DO
WITH YOUR PHOTOS
think outside the box

1.

trim a print down to locket-size

2.

turn them into magnets for the fridge

3.

turn a landscape or cityscape photo into wallpaper

4.

invite friends over for a slideshow

5.

have them printed as coasters

6.

make a series of postcards

7.

print them in black and white

8.

have one screenprinted on a pouch

9.

turn one into a puzzle

10.

display them on a clothesline made of ribbon or sparkly twine

11.

transform a few into old-school badges with a button-maker

12.

print them on transparent paper and display on a lightbox

13.

animate them into mini videos

14.

put one in a customizable snowglobe

15.

turn them into book covers

16.

process them in sepia tones for a vintage look

17.

collage multiple images into one single image

18.

send them to your aunt

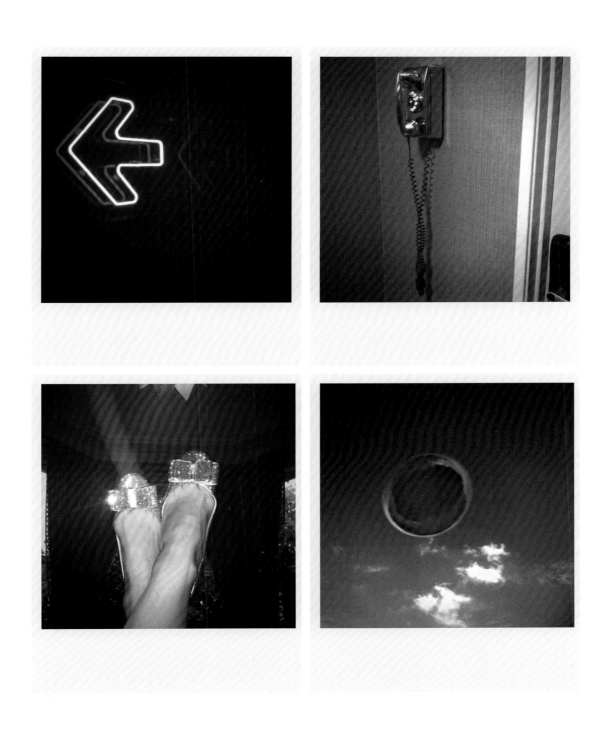

19. create a polaroid wall

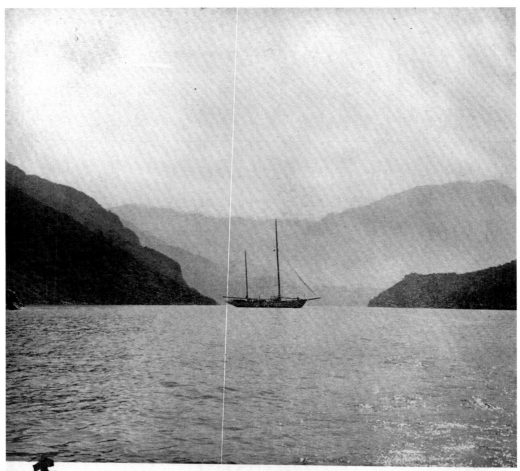

The "Sylvia", a white sailing yacht of grace and speed (seen here anchored in the bay at MYRA, TURKEY), manned by an all-Italian crew of courage and charm. Last summer, when the "Sylvia" spent a month sliding among the Greek islands and along the stark coast of Southern Turkey, most of the passengers were Italian as well, including the hosts of this Elysian adventure, Gianni and Marella Agnelli; and their young son, Edvardo; also Prince Adolfo CARACCIOLO, who was chaperoning his beautiful daughter, Allegra. The other guests were: a gentleman from Copenhagen, MR. Eric Nielsen; and Two Americans: this scribe, and a charming Tycoon from Washington, D.C.; MRS. Philip GRAHAM.

20. take a page from truman's journal. for the january 15, 1966, issue of *vogue*, TRUMAN CAPOTE turned a boat trip he took in turkey with his italian hosts and their guests into a work of art by creating an eight-page pictorial with his photos and handwritten notes. then he gave it an epic title.

THE SYLVIA ODYSSEY

Photographs with (handwritten) ∧ Comment

by

TRUMAN CAPOTE

Carlo, a crew-member, looking like a stone head among the stone ruins along lonely Turkish shores.

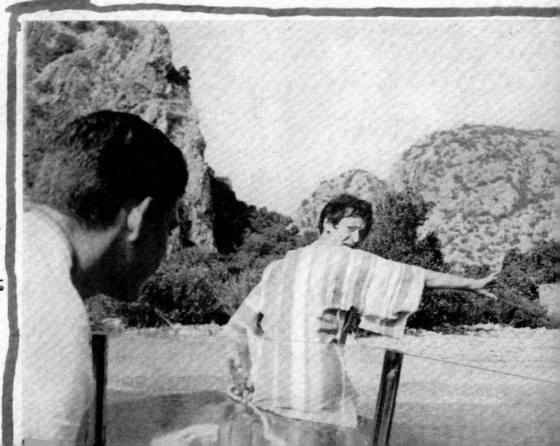

marella, directing a speed-boat into safe-harbor at a Turkish cove where we want to bathe. But, lovely as it was, it turned out not to be too damned safe — a flock of wild bees swarmed out to meet us.

21. ditch the camera altogether and, like artist BRUNO GRIZZO, bring your watercolors instead

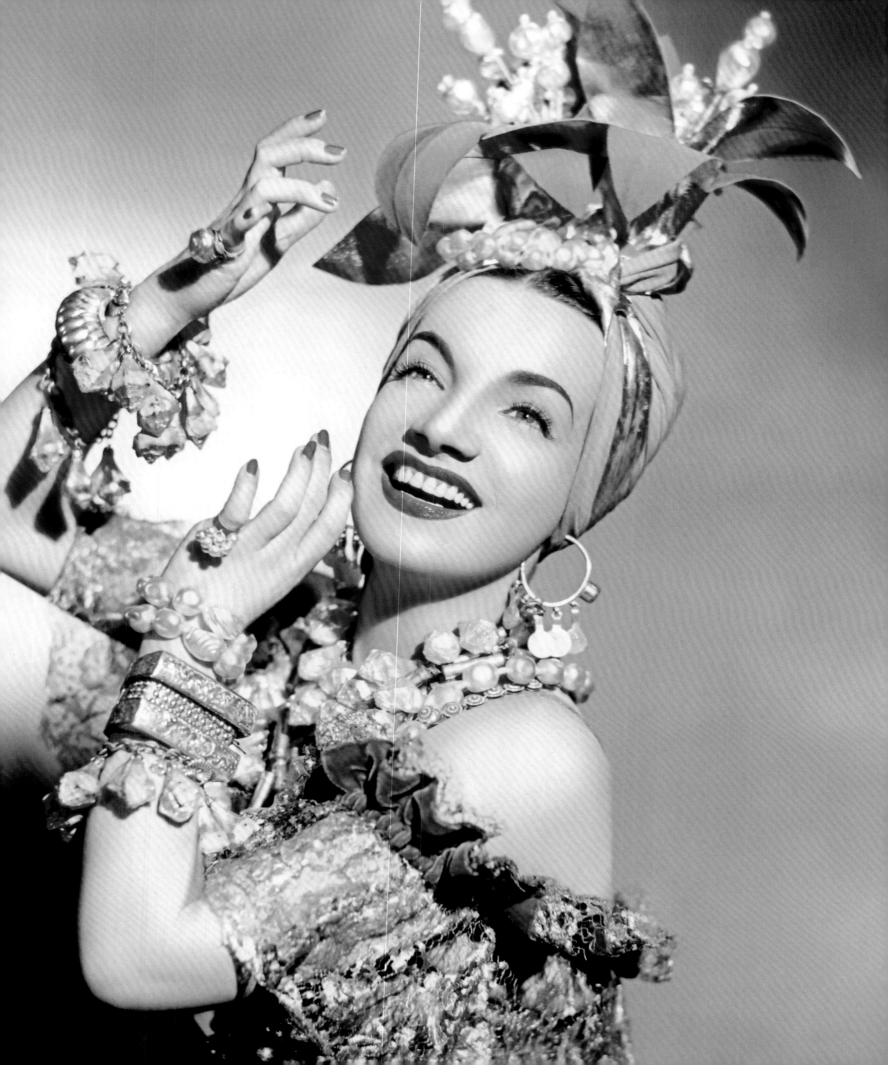

9

THINGS PICKED UP ALONG THE WAY

we love curating our homes and closets with indigenous treasures and vintage discoveries of all shapes, sizes and eras. some of our favorite souvenirs, though, have never seen the inside of our suitcases—like learning how to wrap a present as only the japanese can, or how to cook a curry that changes our (and our friends') taste buds forever. together, these are the things that keep our adventures alive long after the trip is officially over.

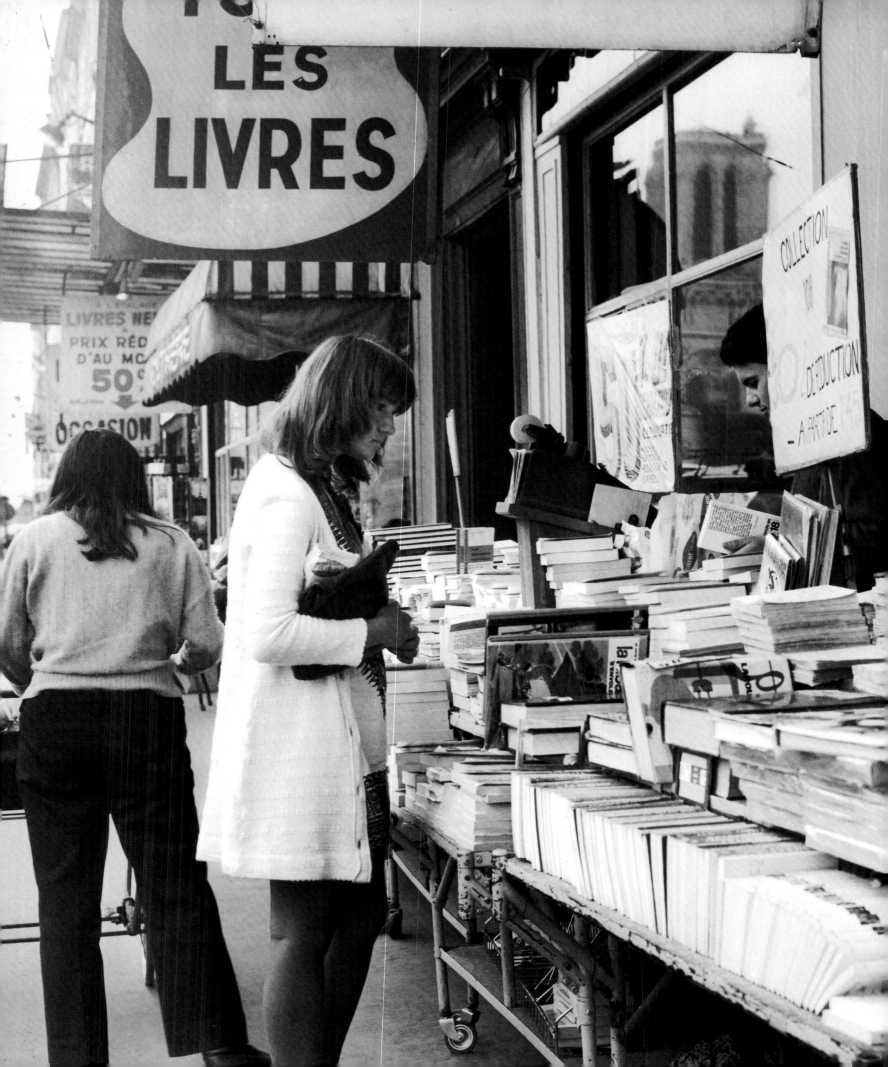

*make up your story
as you go along.*

SHOP LOCAL
berlin: vintage mid-century modern furniture; extra-bitter, extra-dark chocolate
morocco: wooden serving trays inlaid with intricate patterns, carpets, silk scarves
tokyo: *yukatas*—light kimono-style robes for springtime
buenos aires: handwoven *mantas* (wool blankets) in bold patterns
paris: vintage clothing, lingerie, macarons
marrakech: bright poufs, babouche slippers, glass lanterns
amalfi coast: ceramic antipasti dishes, handmade paper stationery, *limoncello*
london: marmalade, tea, teapots, hats, woolen blankets in graphic prints

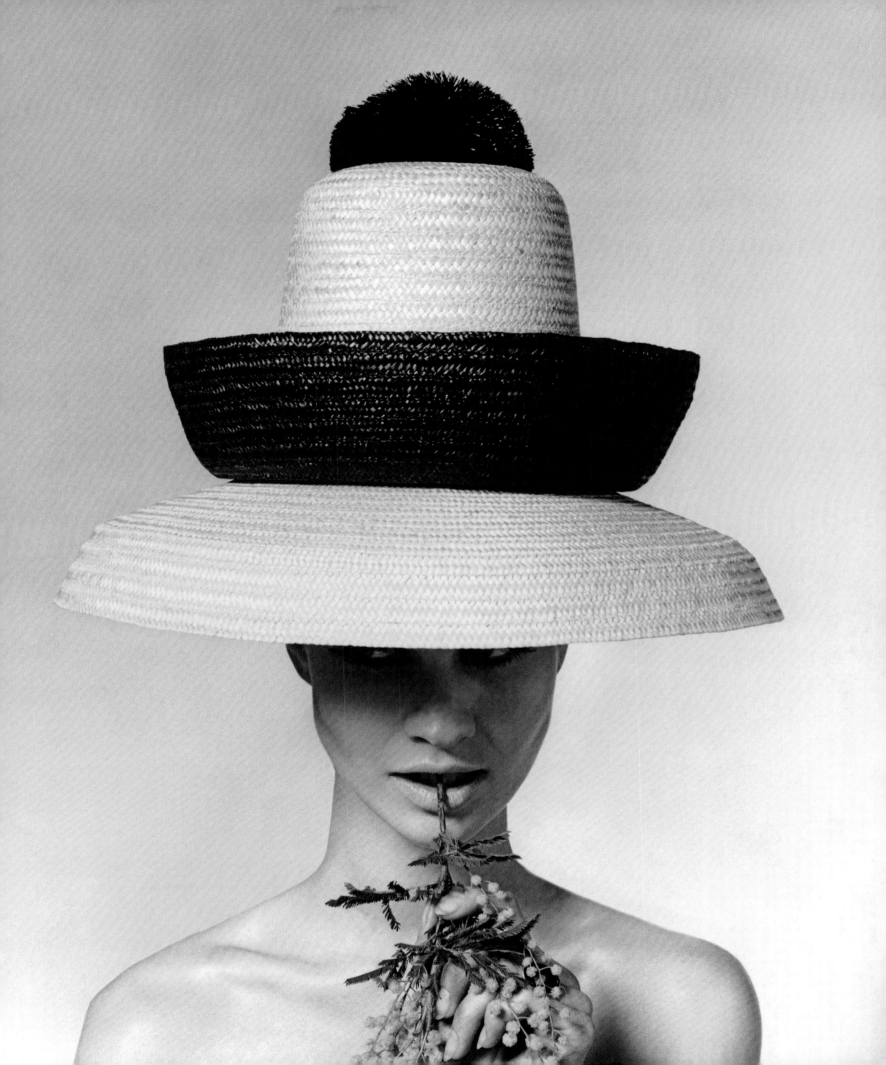

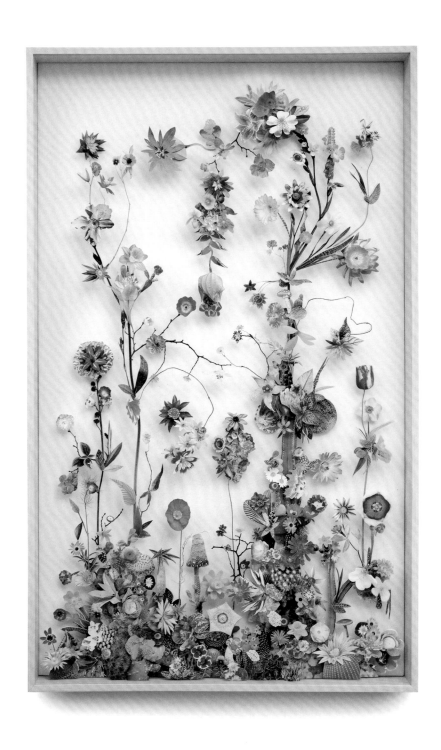

"the best things in life are free. the second best things are very, very expensive." — C O C O C H A N E L
we're quite partial to the simple act of pressing flowers that we find all over the world.
when it comes to displaying them, we love the work of anne ten donkelaar,
whom we stumbled upon in the netherlands: she transforms her field finds into art,
combining them with paper cutouts and setting them under glass.

WE CAME, WE SAW, WE COOKED

THE MOROCCAN CURE-ALL BREAKFAST
top plain yogurt with a poached egg smothered in a sauce of equal parts olive oil and harissa.
—learned from our hotel's chef in tangier during a particularly strong case of jet lag

THE JAPANESE LUNCH TO GO
stuff a rice ball with cooked salmon or *umeboshi* (pickled plums) and wrap with a piece of nori.
—self-taught

A PROPER ENGLISH SUPPER SIDE DISH
roast roughly chopped parsnips and potatoes in duck fat till perfectly crisp.
—gleaned from a friend's proper aunt over dinner in notting hill

THE SPICE BLEND TO SPANISH-IFY ANYTHING
mix in equal parts garlic powder, onion powder, hungarian paprika, sweet
smoked paprika, and salt; add half the amount of chili flakes or spicy red pepper.
—via a spice market vendor who taught us to mix our own blend

A SINGAPOREAN HANGOVER SECRET
spread coconut jam on toasted and buttered white bread. serve with a soft-boiled egg and dark soy sauce.
—the perfect suggestion from an understanding waiter

THE SECRET INGREDIENT OF AN "APPETITLICHSTE!" CHEESE FONDUE
while the fondue is simmering, throw a triangle of spreadable cheese into the pot. (the type that comes
wrapped in foil in a round cardboard box.)
—during the great fondue debate in our chalet kitchen, st. moritz

EVERYTHING IN GOOD TASTE
the local supermarket is our regular stop for all sorts of things, like potato chips in flavors we've
never heard of, things in pretty packages that make for delightful gifts and special sauces.
KETCHUP united states of america. PLUM SAUCE china. WASABI japan. CURRY SAUCE india. PESTO italy.

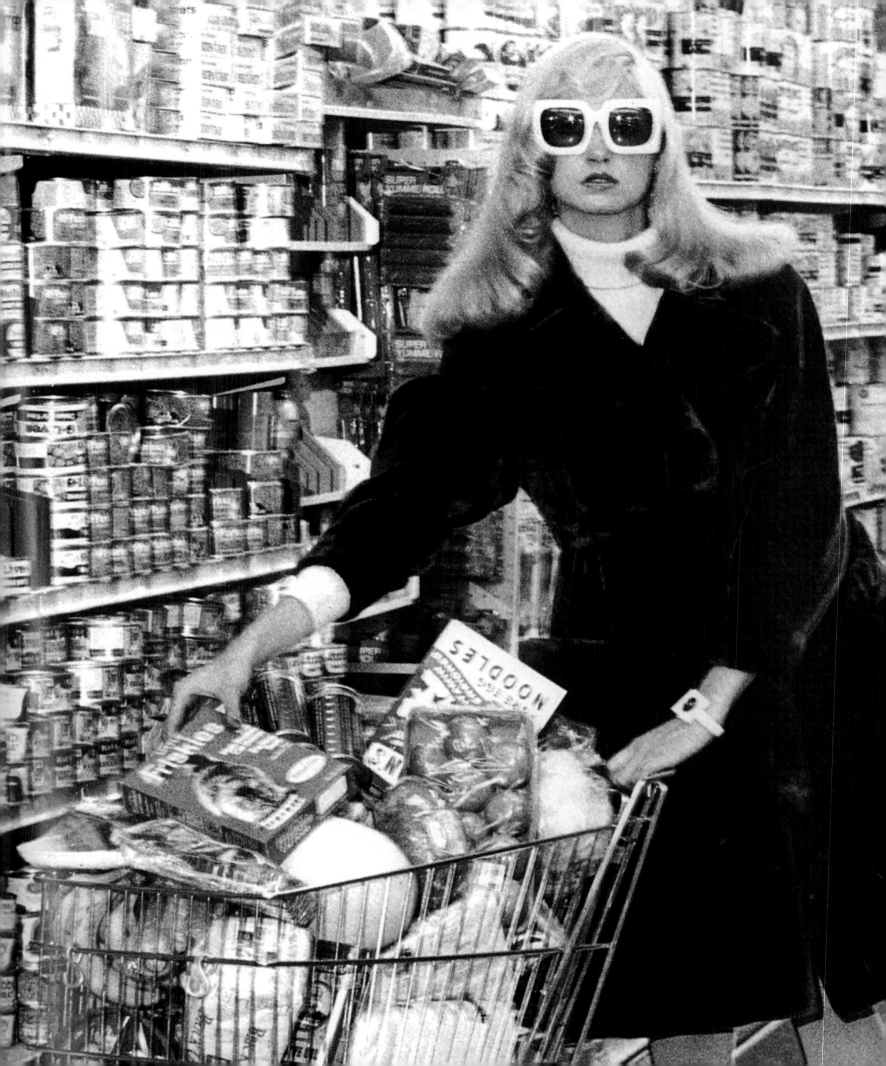

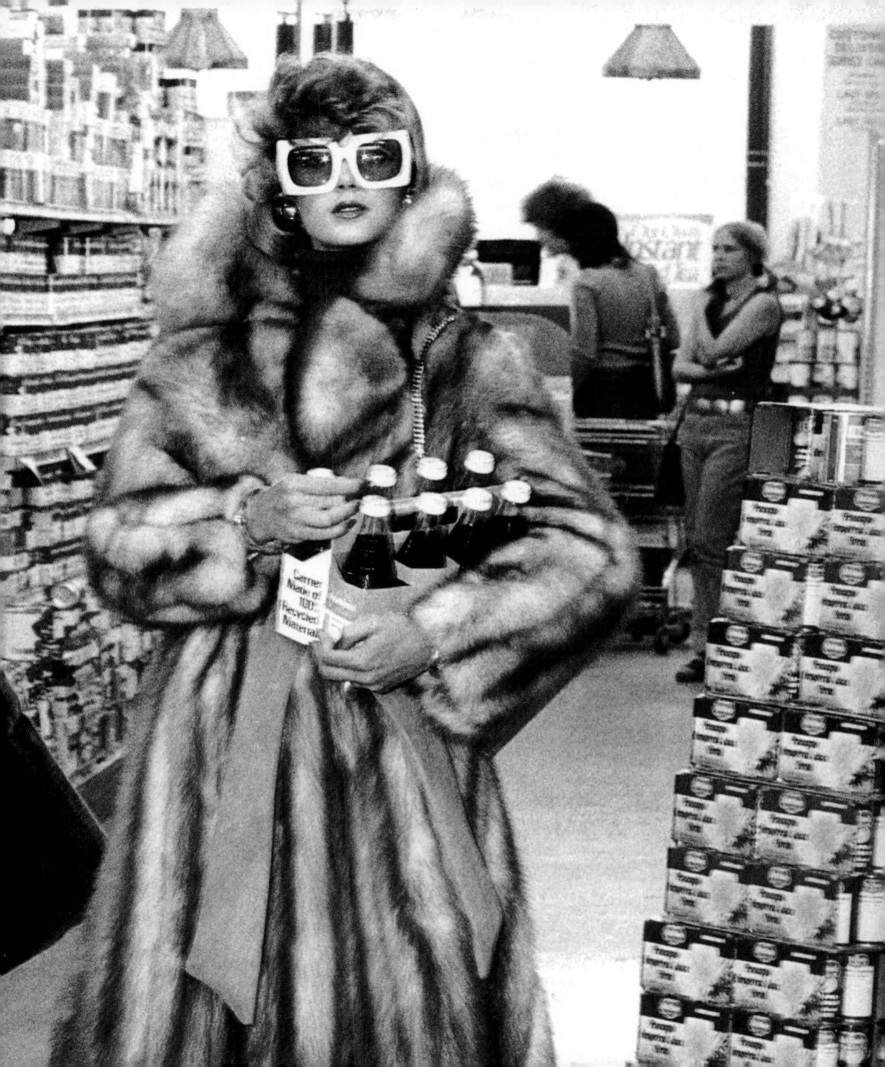

she lives
she always

the life
imagined.

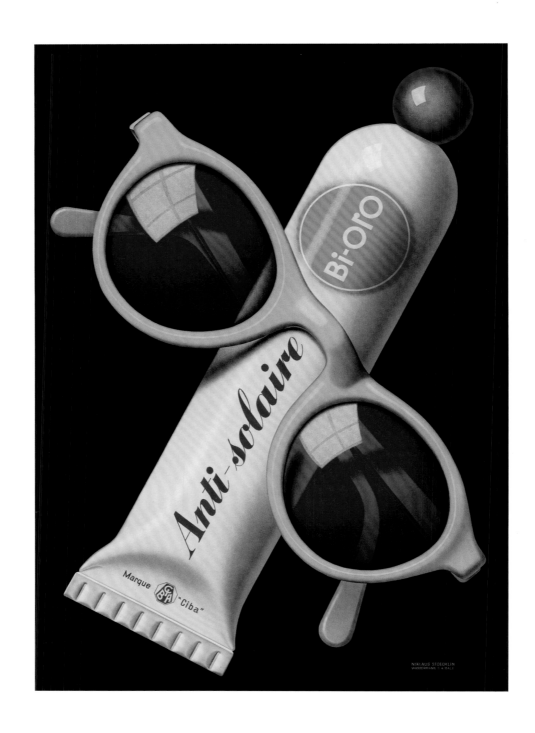

we don't always know what it is, but we love the packaging of our
drugstore finds. (this above, by the way, is suntan lotion.) while we're there,
we'll also buy a stack of postcards (opposite)—to send and to frame.

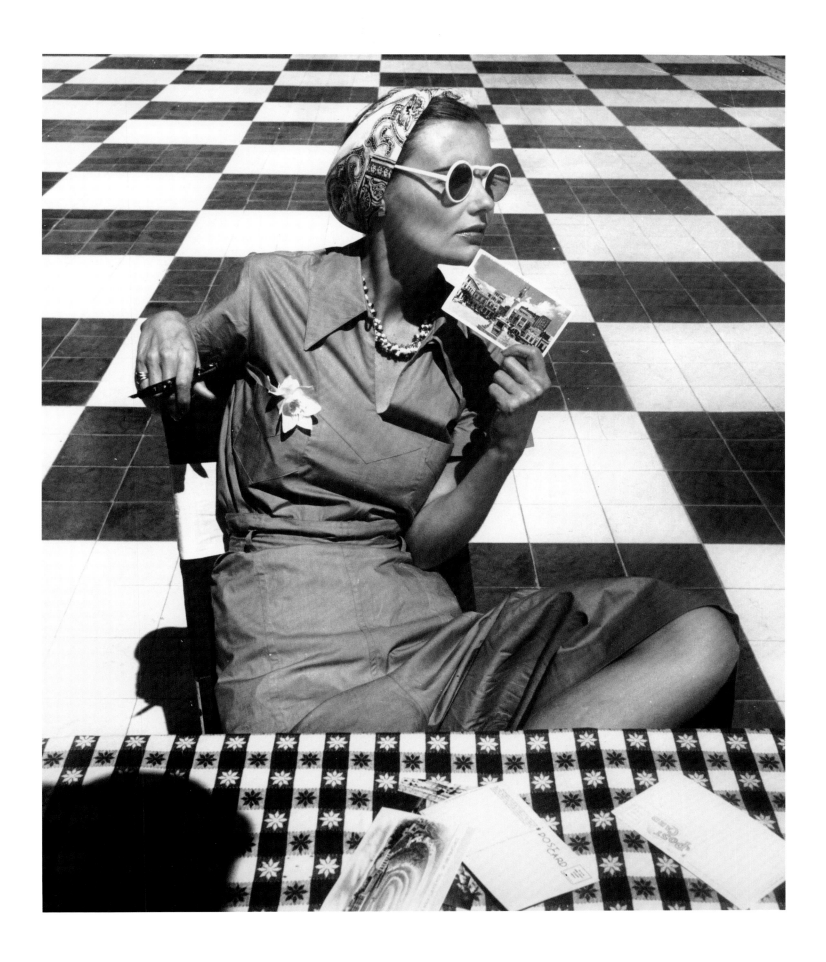

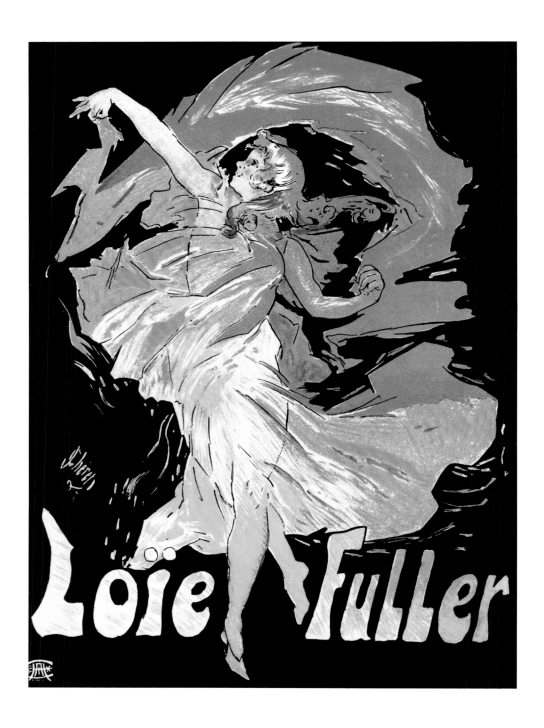

fine art poster (above) or found art (opposite, one of the many street flyers by colby printing company in los angeles)...

...what matters most to us is that it'll look good on our wall.

"be daring. be different. be impractical." CECIL BEATON probably wasn't
talking about shopping, but we think it applies quite well here. we once brought home
a ballgown from buenos aires and a chandelier from berlin.

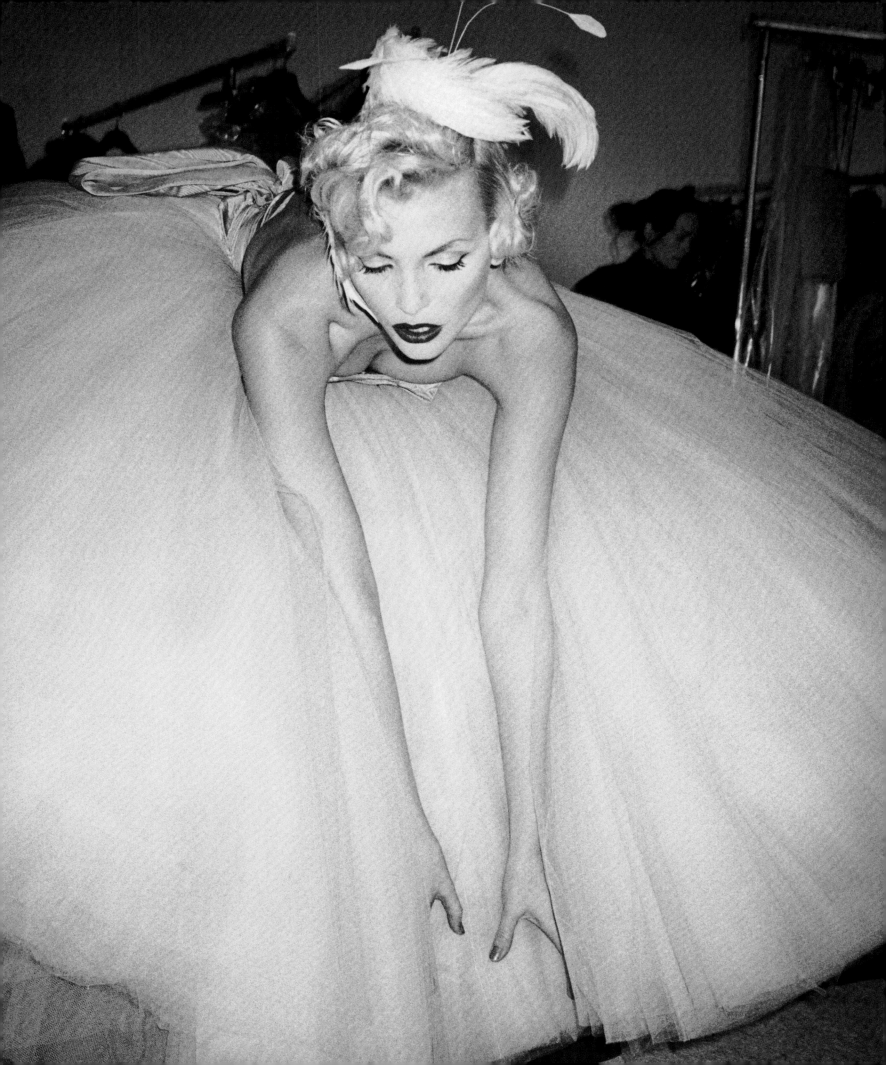

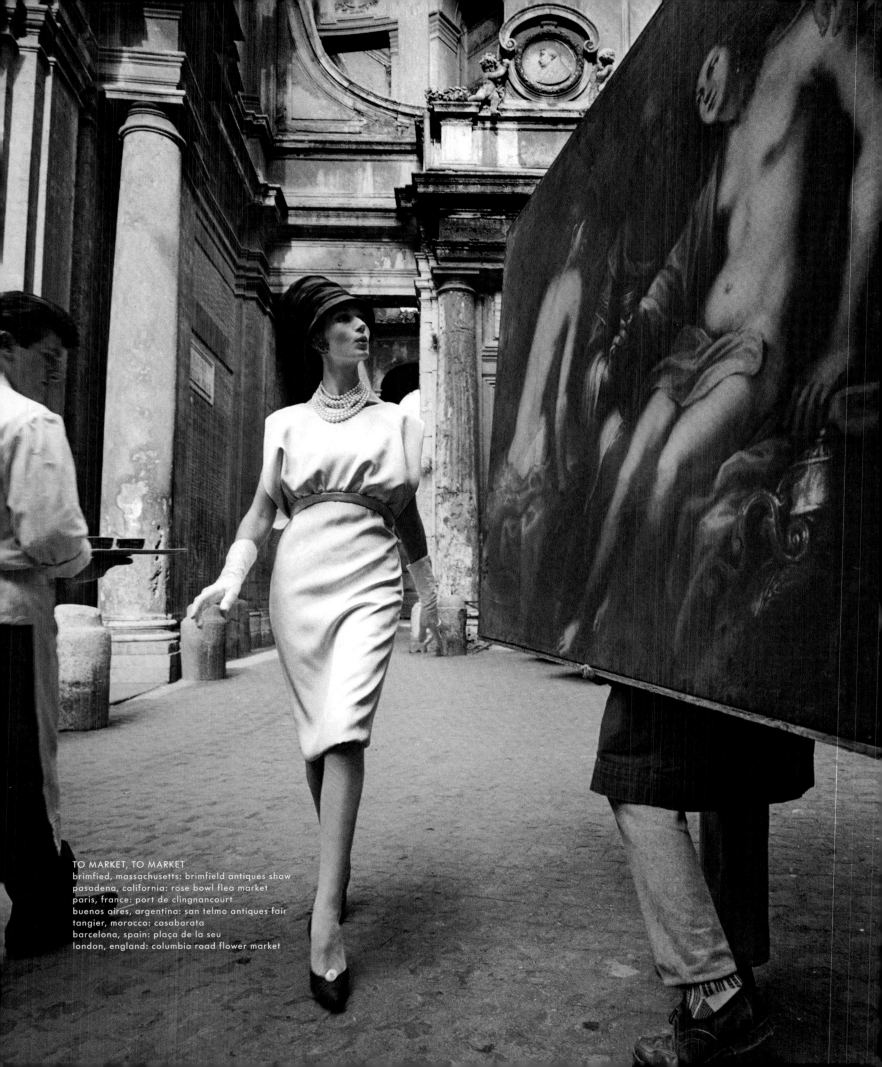

TO MARKET, TO MARKET
brimfied, massachusetts: brimfield antiques show
pasadena, california: rose bowl flea market
paris, france: port de clingnancourt
buenos aires, argentina: san telmo antiques fair
tangier, morocco: casabarata
barcelona, spain: plaça de la seu
london, england: columbia road flower market

15 THINGS WE WANTED TO BRING
HOME BUT COULDN'T GET THROUGH CUSTOMS

1.

the scotch eggs

2.

a flamingo we named fred

3.

argentine roses

4.

the sydney symphony orchestra (we settled for a cd)

5.

the vintage black sports car we borrowed for the drive to rome

6.

our poodle-shaped carnation bouquet from tokyo

7.

david

8.

stinky cheese

9.

sharp cheese

10.

a love bird from shanghai's gubei flower and bird market

11.

monet's water garden

12.

a few carnival props from brighton pier

13.

two cases of champagne from epernay

14.

a cone of *dulce de leche* ice cream

15.

the eiffel tower

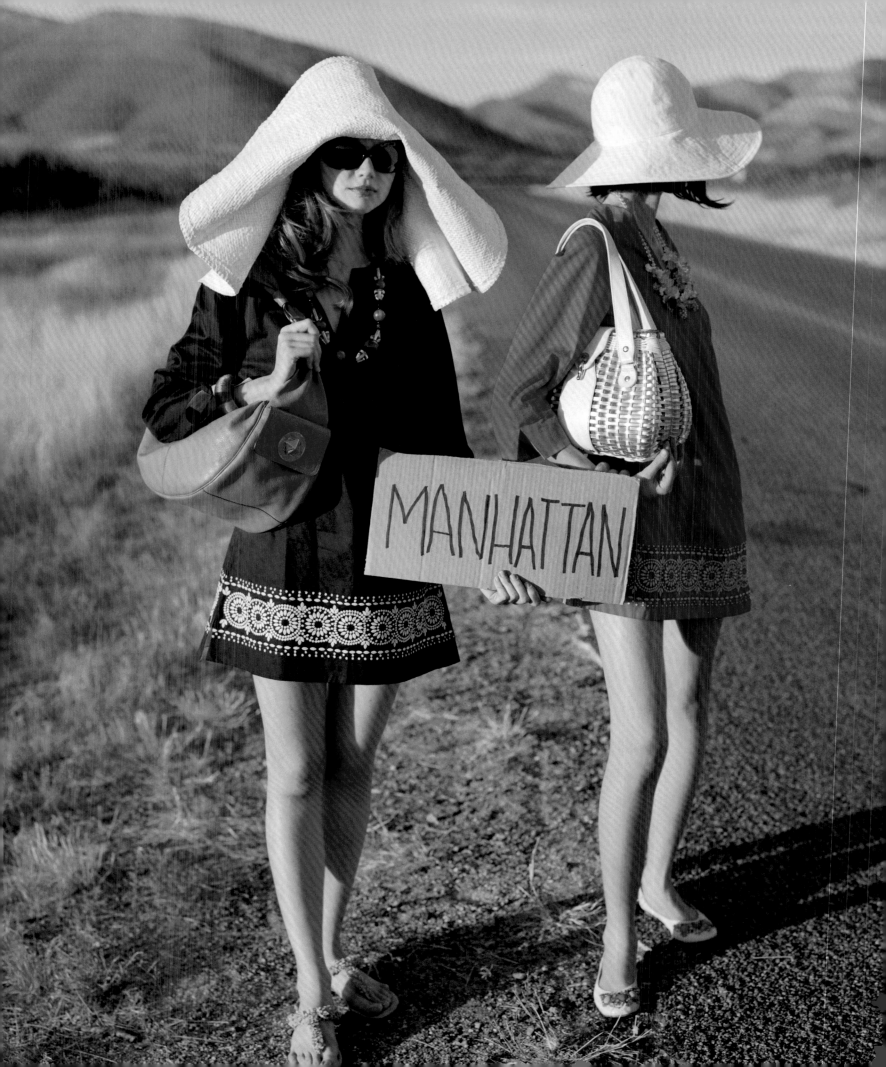

HOME SWEET HOME

there's a quickening heartbeat and an overwhelming rush that happens when we see home on the horizon. we catch our breath, as if simultaneously sealing in all the experiences of the journey now over and seeing the place started from with fresh and inspired eyes. sometimes a break from our routine is the very thing we need to remind us that our everyday is pretty extraordinary, too. that's why we're so excited to arrive home. we know it's the beginning of a new adventure.

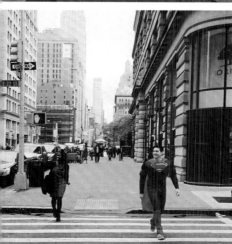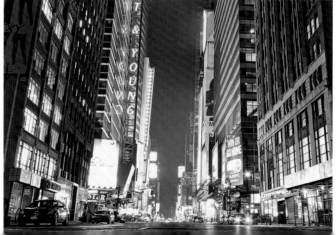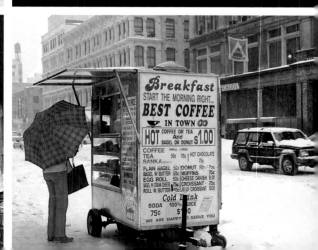

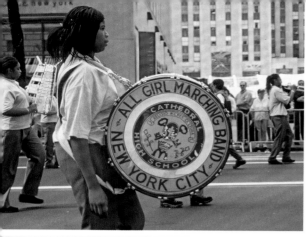

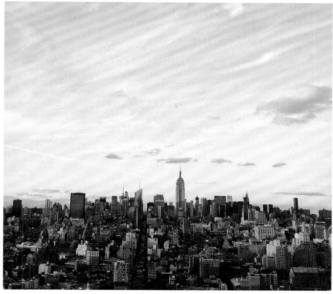

*"the city seen from the queensboro bridge is always
the city seen for the first time, in its first wild promise
of all the mystery and the beauty in the world."*
—F. SCOTT FITZGERALD

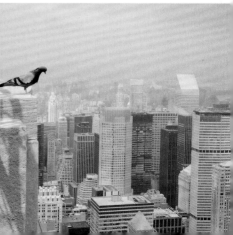

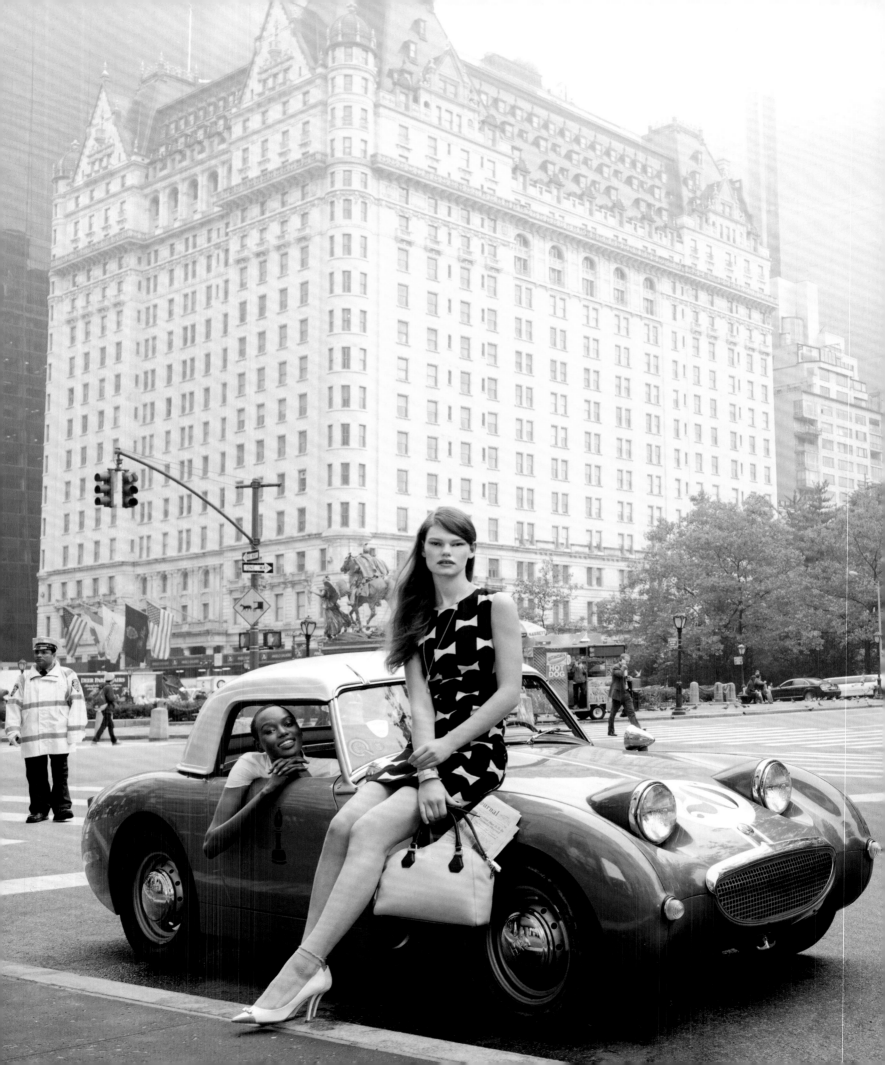

YOU'VE ARRIVED

057
françois pages / *paris match* via getty images

058
© radius images / corbis

059
© 2014 jana laurene oberan

060–061
jean-marie périer / photo12

062–063
© dean conger / corbis

063
courtesy of random house llc / photo by pete deevakul

064
hotesses de l'air, vogue, 1958
© william klein

065
© ezra stoller / esto. all rights reserved

066–067
arthur elgort / *vogue*
© condé nast publications

068
© katja rahlwes

070
photograph by pete deevakul

071
courtesy of saint james paris

072
© tim walker / art + commerce

073
© tim walker / art + commerce

074
bruce weber / trunk archive

075
photograph by pete deevakul

076–077
leombruno-bodi / *vogue*
© condé nast publications

079
david bailey / *vogue*
© condé nast publications

081
slim aarons © getty images

082
the bear and the doll: paramount pictures / photofest

083
© katja rahlwes

084
courtesy of hotel amour, paris / photograph by riccardo tinelli

085
© larry dunmire

086–087
tahiti motel, wildwood, new jersey. photograph by dorothy kresz
© 2001 pentagram design

089
photo by pete deevakul

090
clockwise from top left:
courtesy of palazzo margherita, bernalda, italy / photograph by tim beddow
aman canal grande, venice / courtesy of aman resorts
courtesy of kate's lazy desert, landers, california
courtesy of the soho house berlin

091
david oldham / *glamour*
© the condé nast publications ltd.

092
© katja rahlwes

093
from left to right:
"pineapple" pattern from studio printworks
"zebras" pattern from scalamandré
"lotus" pattern from farrow & ball
"brazillance" pattern from carlton varney / photograph courtesy of the greenbrier

094
© mike mcconnell

095
© mike mcconnell

096–097
photograph by jesper anhede / © genberg art UW ltd.

098
photograph by greg miller

100–101
illustration by leonard weisgard / courtesy of abigail weisgard photo by pete deevakul

102
robert polidori / trunk archive

103
© jason hawkes

104
white sands national monument, 1964 / photograph by garry winogrand © the estate of garry winogrand, courtesy fraenkel gallery, san francisco

105
ocean road, chile, 2010 / © 2010 josef hoflehner

106
venetia scott / trunk archive

110
clockwise from top left:
© frans lemmens / corbis
© catherine corman
© gavin hellier / JAI / corbis
© deborah camplin

111
clockwise from top left:
© charles e. rotkin / corbis
© caroline askew
© piera gelardi
© walter bibikow / JAI / corbis

113
copyright norman parkinson ltd / courtesy of norman parkinson archive

114
courtesy of caters news agency

116–117
© jerry harpur / harpur garden library / corbis